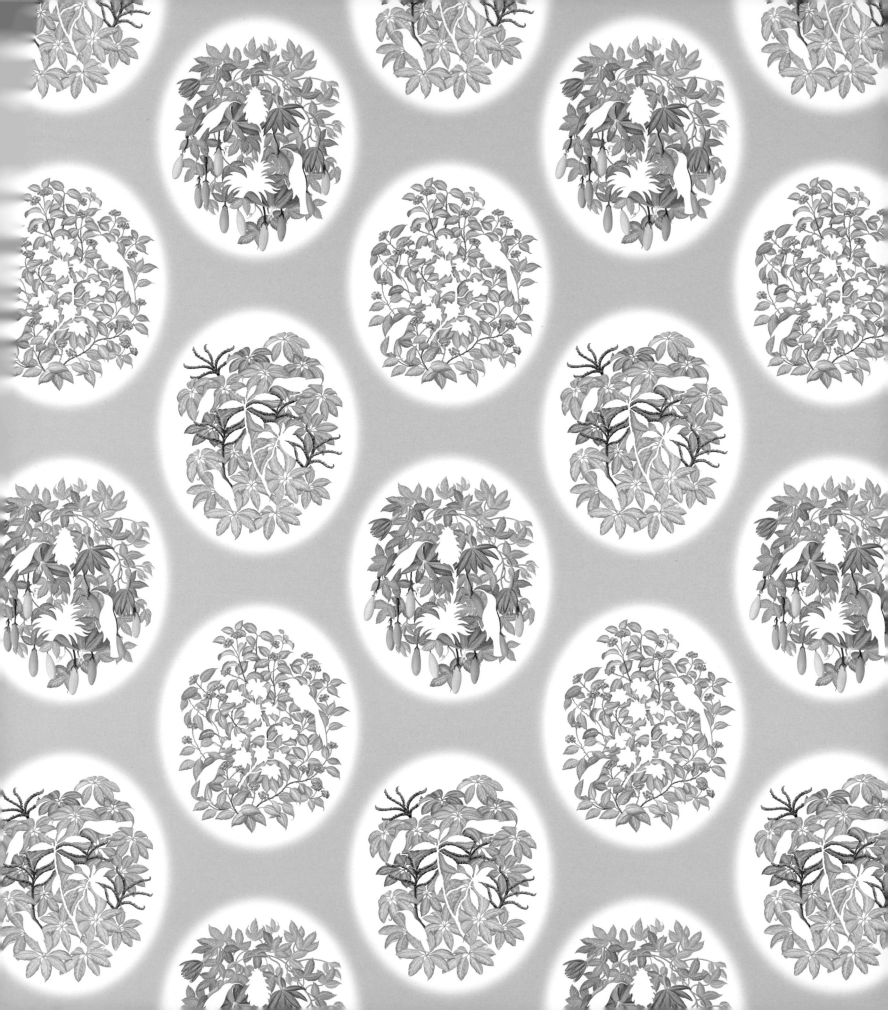

American Story

by Leslie Umberger

additional essays by Tom Patterson, Jennifer Jankauskas, Amy Chaloupka, Elsa Lenz Kothe, and Beth Lipman

John Michael Kohler Arts Center
Sheboygan, Wisconsin

John Michael Kohler Arts Center
608 New York Avenue
Sheboygan, Wisconsin 53081
920.458.6144 | www.jmkac.org

Published on the occasion of the exhibition *American Story*, curated
by Leslie Umberger and presented by the John Michael Kohler Arts
Center, Sheboygan, Wisconsin, June 21–December 31, 2009.

Library of Congress Cataloging-in-Publication Data

American story / by Leslie Umberger ; essays by Tom Patterson ...
[et al.].
 p. cm.
 "Published on the occasion of the exhibition American Story,
organized and presented by the John Michael Kohler Arts Center,
Sheboygan, Wisconsin, June 21, 2009-December 31, 2009."
 Includes bibliographical references.
 ISBN 978-0-9710703-8-7
 1. Art, American–20th century–Exhibitions. 2. Art, American-
-21st century–Exhibitions. 3. Cultural pluralism–United States–
Exhibitions. I. Umberger, Leslie. II. Patterson, Tom, 1952- III. John
Michael Kohler Arts Center.
 N6512.A61595 2009
 709.73'07477569–dc22
 2009019876

Established in 1967 by the Sheboygan Arts Foundation, Inc., the
John Michael Kohler Arts Center is nationally recognized for its
nurturing of artists in the creation of new work; for its concentration
on art forms, artists, and ideas that have received little critical
attention; and for its ability to involve underserved audiences as
well as the general public in innovative programming that helps
realize the power of the arts to inspire and transform our world.
Each year, Arts Center programming including approximately
twenty-five exhibitions curated by staff; five performing arts series;
Connecting Communities commissions to create major original
works by national dance companies, composer-musicians,
visual artists, filmmakers, and literary artists in collaboration
with the region's underserved constituencies; Arts/Industry,
an internationally renowned residency program providing
opportunities for artists to create new bodies of work and public
commissions using the technologies and facilities of an industrial
pottery, foundry, and enamel shop; a wide variety of educational
programming, from an arts-based preschool and a hands-on drop-in
program for families to national conferences; and rollicking special
events.

Photo Credits
Cover: David Lenz, *Thistles*, 2001; oil on linen; 32 x 54 in.; Collection
of Pieper Electric Inc., WI.

Page 2: Alison Moritsugu, *Invasive Repeat* (wallpaper), 2007; ink on
enhanced adhesive synthetic wallpaper; 96 1/2 x 58 in., as installed
at the John Michael Kohler Arts Center; Courtesy of the artist.

Page 8: Charlie Willeto, untitled (warrior figure), c. 1961-1964;
polychromed wood; 32 x 11 1/2 x 3 1/2 in.; John Michael Kohler
Arts Center Collection.

Project Manager: Amy Ruffo
General Editor: Leslie Umberger
Editor: Michelle Bolton King
Photography: Jeffrey Machtig, John Michael Kohler Arts Center
(unless otherwise noted)

TABLE OF CONTENTS

ACKNOWLEDGEMENTS

American Story, the John Michael Kohler Arts Center's second exhibition to encompass sixteen thousand square feet, explores and celebrates the diversity of American culture through fifteen artists who fuse personal identity and cultural heritage in engrossing and illuminating works of art. The Arts Center's 2007 seminal project, *Sublime Spaces & Visionary Worlds: Built Environments of Vernacular Artists*, introduced the personal stories of artists as an integral part of the art that each of them had produced. Their art embodied place, era, ethnicity, and individuality and allowed viewers to more fully appreciate the artistic potential within us all. Taking inspiration from that project, *American Story* reveals the lives of the artists in conjunction with the art that stemmed from those lives. Each of these artists offers personal experience as a bridge to universal understanding, using visual art as a means of telling a story.

The exhibition serves as bedrock for a wide variety of interpretive materials—from an introductory video and others focused on specific artists—to multilingual gallery activities for families. Related programming has been designed to reach out to the children of the Arts Center's own arts-based preschool and other early learners, K–12 and university students and faculty, cultural minorities, seniors, youth-at-risk programs, clients of shelters, vacationing families, and artists, collectors, and scholars across the country.

The Connecting Communities program, which brings together superb visual, performing, literary, and media artists with underserved constituencies and the general public to collaborate on major original works of art, has developed three projects. Visual artist Anne Wallace (TX) and volunteers are gathering stories from hundreds community residents who will then transform the walkways of a local park by stamping text and images into the wet cement. Performance artist Tomás Kubínek (CT) and nearly two hundred participants will create *The Big Sheboygan Shebang*, an eye-popping indoor/outdoor extravaganza. Visual artist Xenobia Bailey (NY) will work with all ages to develop a site-specific installation that investigates the community-sharing process of craft. The peforming arts department will present artists in residencies and single performances such as Rennie Harris Puremovement (PA), masters of hip-hop dance; Big Top Chautauqua (WI); and a Hmong Family Festival. Education programming will include a Teachers Institute, tours with accompanying creative writing and visual arts activities, gallery talks, camps, classes, and more. And finally, the spirited annual Art Armada on Independence Day will involve adults and children in building and racing cardboard/mixed-media, person-powered boats that visually tell an American story.

The Board of Directors and staff of the Arts Center extend their profound gratitude to all who have provided support for the *American Story* exhibition, publication, and related programming. The generosity of these donors has allowed the Arts Center to bring these extraordinary artists together to share their individual American stories:

Ruth St. John and John Dunham West
 Foundation, Inc.
Johnsonville Sausage, LLC
ACUITY
National Endowment for the Arts
Sargento Foods Inc.
Rachel Kohler and Mark Hoplamazian Family
Wisconsin Arts Board
Anonymous Donors (2)
Elizabeth Ellrodt and Scott Schweighauser
Robert W. Baird & Co. Foundation, Inc.
Lakeland College
National Endowment for the Arts' American
 Masterpieces: Dance Initiative, administered
 by the New England Foundation for the Arts
Karen and Jeff Overly
Quasius Construction, Inc.
Amy Ruffo and Howard Montgomery
Lakeside Pepsi-Cola Bottling Co.
Bank First National
Kristin and Richard Bemis
Garton Family Foundation
M & I Bank
Katy and Steve Russell

We express our heartfelt appreciation to the artists, collectors, and galleries who have lent works for *American Story*; they include: Miroslav "Mick" Anic; Barbara Applegate; William Arnett; Linda and Daniel J. Bader; Xenobia Bailey; Helen and Ned Bechthold; José Bedia; Karen Johnson Boyd; Marilyn and Orren Bradley; Jane and Steve Chernof; Susann Craig; Elizabeth and Shel Danielson; Louise Erdrich and Birchbark Books & Native Arts; Lisa Fifield; Marjorie and Harvey Freed; George Adams Gallery; Richard Harris; Molly Hatch; Yoshiko Kanai; Xao Yang Lee; David Lenz; Steve and Tristen Lindemann; Malone & Atchison Attorneys at Law; Donna and Jonathan Moberg; Rosemary and John F. Monroe, Jr.; Alison Moritsugu; Scott Ogden; Suzanne and Richard R. Pieper, Sr.; Pieper Electric, Inc.; Jan Petry; Greg LaChapelle and Phyllis Kind Gallery; Racine Art Museum; Kathy Regan and Bobbi Lewandowski; Ricco/Maresca Gallery; Lori Rosenthal; Jane St. Anthony and Louis Allgeyer; Barbara Stein; Techstaff, Inc.; Natalie and Dennis Wallestad; Dorian Webb; Lisa and Craig Zetley; and two lenders who wish to remain anonymous.

We also recognize with special thanks other individuals and organizations who were crucial to this exhibition and publication: Cavin-Morris Gallery for the generous gift of Vernon Burwell's untitled (leopard), and Kohler Foundation, Inc. for donating works of art by Lesley Dill, Adolph Vandertie, and Gregory Van Maanen to the Arts Center's collection; editor Michelle Bolton King who was of critical importance to this publication; Tom Patterson who wrote two captivating chapters and donated the use of his photographs; to the other photographers who donated the use of their images for this project, including Ted Degener, Veronica Davison and the Centers for Disease Control and Prevention, Ellen Denuto, Bruce Hucko, Ron Monk, Tom Moore, Stefen Petrik, Chris Ramirez, and Ed Robbins; and the filmmakers whose films help deepen public understanding of the artists' work, including Arketype, Pepito Bedia, Scott Ogden and Malcolm Hearn, and Ed Robbins.

The commitment and active involvement of the Arts Center's docents and other volunteers, as well as our Board of Directors and Community Partners, make so much more possible every day, and we acknowledge them with delight. Our boundless appreciation goes to all Arts Center staff members for their exceptional talents and dedication. We recognize, in particular, Senior Curator Leslie Umberger for her vision, scholarship, and unflagging commitment to this project. Manager of Exhibitions and Collections Amy Ruffo is responsible for the handsome design of this publication and for overseeing the enormity of the *American Story* project as a whole. Associate Curator Jennifer Jankaukas, Assistant Curator Amy Chaloupka, Community Arts Specialist Elsa Lenz Kothe, and Arts/Industry Coordinator Beth Lipman contributed chapters to this publication and helped see the exhibition through to fruition. The exhibition would not have come together without the masterful orchestration of Arts Center Registrar Larry Donoval, and the expert skills of Lead Preparator Erik Hansen were invaluable. Others particularly involved in the development of the exhibition and publication have been Jo Bjorkman, Christine End, Molly Greenfield, Jeffrey Machtig, Keith May, and James Milostan. The entire staff is listed on page 142.

American Story serves as a reminder that the United States is a country united by its faith in the individual and in each person's right to shape her or his own life. The artists' stories, brought to life in paintings, sculptures, textiles, multi-media works, and large-scale installations, tell personal stories, and yet, taken as a whole, they embody our shared American story.

Ruth DeYoung Kohler
Director
John Michael Kohler Arts Center

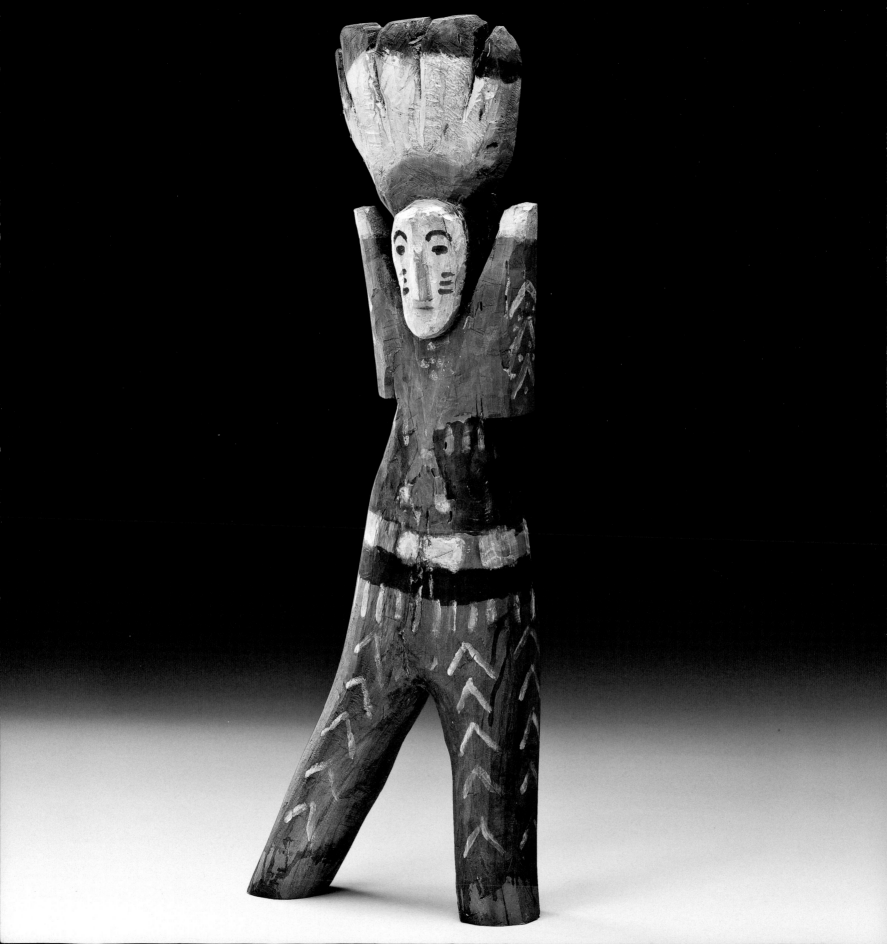

AMERICAN STORY

by Leslie Umberger

There are only two or three human stories, and they go on repeating themselves as fiercely as if they had never happened before.

Willa Cather (1944)

What does it mean to be an American? In the early days of 2009, the United States welcomed a new president with unprecedented zeal. Becoming America's first African American president, Barack Obama invigorated the country with a renewed faith—not necessarily in politics, but in the extraordinary power of the individual: the power of the individual to stand up for what s/he believes in, the power of the individual to succeed against the odds, and ultimately the power of the individual to achieve ends unencumbered by race, class, or creed, and, in so doing, to embody the American dream.

In America, every person has a story both shared and unique. Our personal histories are so widely varied as to defy boundaries of any kind. And yet, Americans communally identify with the democratic ideals that set this country in motion and that propel it into the future. At its heart, the American dream is about the ability to shape one's own path in life, to chart a course tailored to one's beliefs, strengths, and dreams. It is about intention, perseverance, and pride. Within this richly textured nation, individual stories encompass identity, family, experience, and place. Personal stories are interwoven with shared experience and, while Americans share many fundamental beliefs, the tapestry of our overall culture is woven from countless distinct and resilient threads.

American Story asks us to rethink the eighteenth century metaphor of America as a "melting pot," or a place where a new culture would become an even blend of all its ingredients. Americans' reverently held tenets of freedom and democracy worked, to a large degree, against the merging of cultures, and, instead gave rise to a country where individuals could retain communal beliefs and folkways and, at the same time, craft

distinctive American identities. The artists included in *American Story* by no means represent every cultural or ethnic group comprising this complex and expansive land. They do, however, represent a sampling of the astonishing diversity in our midst.

Before the outcome of the 2008 presidential election was even known, Barack Obama gave an important speech addressing issues of race in America. He noted that the United States Constitution, signed by the Founding Fathers in 1787, was born of paradox. In a country striving for democracy and equal citizenship under law—formed by those who had suffered much to escape tyranny and persecution—they signed into existence a document that allowed slavery to continue. Obama brought to the race no bitterness rooted in America's past misdeeds. He did not dwell on the racism and bloodshed that are indelibly etched into the history of this land, nor on a survival instinct bonded to what European settlers had believed was a God-given destiny. Embodying the character that delivered him to this day, Obama focused on the present and what one person can do to take steps toward a new day. He reflected on his own story, an American story that is simultaneously unique and ubiquitous in a patchwork country:

> *I am the son of a black man from Kenya and a white woman from Kansas. I was raised with the help of a white grandfather who survived a Depression to serve in Patton's Army during World War II and a white grandmother who worked on a bomber assembly line at Fort Leavenworth while he was overseas. I've gone to some of the best schools in America and lived in one of the world's poorest nations. I am married to a black American who carries within her the blood of slaves and slave owners—an inheritance we pass on to our two precious daughters. I have brothers, sisters, nieces, nephews, uncles, and cousins of every race and every hue, scattered across three continents, and for as long as I live, I will never forget that in no other country on Earth is my story even possible.*

It's a story that hasn't made me the most conventional of candidates. But it is a story that has seared into my genetic makeup the idea that this nation is more than the sum of its parts—that out of many, we are truly one.[1]

Obama's humanizing tale of personal experience embodies the storyteller's gift. When the personal is revealed, the storyteller extends the possibility that each individual's own tale—complex and challenging as it might be—contains the potential of success; the personal becomes universal. As the American writer and consummate storyteller Willa Cather has noted, "There are only two or three human stories, and they go on repeating themselves as fiercely as if they had never happened before."[2] Cather reflects on a varied but largely universal human narrative that begins with a status quo, moves into a time of change or difficulty, and, through strength and determination, produces a new awareness and/or a different status quo. Folktales, fables, and myths are used to educate, retain tradition, and even impose social order. However the true story, the personal story, captivates the heart and, through that path, navigates a way to the mind that is lasting and powerful.

The fifteen artists in *American Story* offer their stories as backdrop for the art that emerged from lives lived. They remind us that stories are not always told expressly in words, but are just as powerfully contained in objects, images, and all-encompassing expressive spaces. Sometimes images depict a story, using a narrative device that is closely kindred to the spoken word. Sometimes the stories are embedded in handmade things—secrets to be unraveled. For example, the embodiment of time, knowledge, and cultural history are innately contained in a Hmong flower cloth just as they are in a hobo-style ball-in-cage whimsy stick. Sometimes the stories are even more personal, more arcane: row upon row of smooth stones painted as skulls or all-seeing eyes relay a story of the ritual engagement of a Vietnam War veteran. An installation made almost entirely of yarn creates a space of color and texture that magically conjures a cultural aesthetic. And the poignant figurative sculptures of a blind man bear witness to his desire to protect himself and his family's well being.

Most of the raconteurs in *American Story* are still living; a few remain through their art. Their stories speak of this country as a place where diversity is so far reaching that our neighbors live largely secret lives in plain view of mainstream America. These shared stories shed light on differences, but also illuminate the experiences and emotions that humans have in common.

Charlie Willeto (1897–1964) was a Navajo medicine man who spent his entire life learning and practicing the traditional healing ways of the *Diné* people, including the use of the "illness doll," a ceremonial sculpture that was meant to take on the sickness of a particular person. Once the doll had drawn the affliction away from the patient, it was removed to a remote location where the sickness, finding no human prey, would return to nature. In the last four years of his life, Willeto carefully subverted the tradition of the illness doll in several hundred carved and painted figures. Effectively breaking a Navajo taboo, Willeto's daring innovation eventually earned him respect as an artist of vision and power. His story is a fusion of respect for ancient ways and individual determination to follow one's own star.

As a young boy in Wisconsin, Adolph Vandertie (1911–2007) became enamored with the wanderlust lifestyle of the American hobo. Hobo culture burgeoned between World War I and World War II, with men who were down on their luck riding the rails in search of short-term labor and a decent meal. Vandertie started visiting the hobo "jungles" in the early 1920s, and it was there that he first witnessed the hobos practicing their shared art of fancy whittling. Watching an old carver cut a small sphere loose from the interior of a "ball-in-cage" design first caught his eye, striking the impressionable boy as an amazing feat of skill and mystery. He vowed to learn the folk art for himself, and his love for hobo culture never flagged. By the time Vandertie passed away in 2007, he had mastered numerous whittled forms and made several thousand pieces of his own. Vandertie traded countless pieces of his work for the work of fellow hobos, and left a rare first-hand written account of the fading oral culture he so dearly cherished.

Hawkins Bolden (1914–2005) of Memphis, Tennessee, was blinded as a child. Of mixed ethnicity and suffering from epilepsy—

an illness greatly misunderstood in his time—Bolden was held at arm's length from society. Nevertheless, he discovered a niche for himself within the structure of his large, impoverished family, making sculptural figures he called "scarecrows" to guard the family's vegetable garden. His garden environment addressed the practical while embodying spiritual traditions of African American "yard shows" and graveside rituals. Using pots, pans, discarded clothing, cast-off garden hoses, and whatever else he could find, Bolden gave his figures multiple eyes—perhaps bestowing them with the vision he lacked.

Living in an era that recalled the Civil War and witnessed the Civil Rights Movement, Vernon Lee Burwell (1916–1990) was raised by a community of North Carolina sharecropping families after being orphaned at thirteen. Retiring in 1976, Burwell decided to reflect on the dramatic change that he had witnessed during his lifetime, and a nascent pastime of making animals and figures in painted concrete grew into a passionate full-time engagement. Around his home, he installed tableaux that paid tribute to African American heroes including Martin Luther and Coretta Scott King, Sojourner Truth, and North Carolina's first black sheriff. His sculptures encompassed moments from the Vietnam War, American politics, the Bible, and animals of whimsy as well as icons of freedom and strength.

Xao Yang Lee (b. 1947) tells her stories in stitches. She and her five children were among over 100,000 refugees who escaped from Laos in the aftermath of the Vietnam War. Like most Hmong girls, Lee was taught traditional styles of *paj ntaub* embroidery and sewing by her mother. Hmong textiles traditionally used entirely abstract designs to symbolically represent the tribe's belief system, history, and group identity. During and following the Vietnam War, however, Hmong women in Thai refugee camps began to record their individual and collective stories with pictorial imagery. For Lee, the traditional arts she learned in Laos became her primary link to the homeland she lost, but they also became a source of income in the United States and a practical means of survival.

Ceramist Jack Earl (b. 1934) immortalized Middle America in sculptural tableaux drawn straight from his life in rural Ohio.

Earl became a seminal figure in American ceramics by elevating the importance of family life and humor into the realm of fine art. A natural-born storyteller, he embraced his instinct for the narrative and the quotidian even when art-world fashions would have deterred it. His scenes range from deadpan portraits to quirky tall tales wherein a dog might walk on stilts or a person might find some of their body parts replaced with vegetables. Frequently intermingling fantasy and daily life, Earl is a master at reminding us that within the things we take for granted, there are moments of never-ending mystery and wonder.

Gregory Van Maanen (b. 1948) paints daily on boards, stones, found animal bones, and other oddments in order to process and maintain a healthy relationship with the souls that have lived inside his head ever since he was left for dead in the war fields of Vietnam. Plagued with vivid memories, Van Maanen found that peace came only when he used art to release the scenes that haunted him. His paintings—thousands of images featuring skulls, all-seeing eyes, open palms, glowing hearts, and a plethora of personalized symbols of protection and "good magic" peppering both front and back sides—are images of refuge, of solace, of bargaining for every day. For some forty years now, Van Maanen has used art and ritual as a medicinal regimen, charting an internal dialogue with visions of the past.

In large-scale photographic images and constructions, Lesley Dill (b. 1950) draws on the complex role that language played in her formative years. Growing up with a paranoid schizophrenic father who had an acute sensitivity to words and worried over their pliable meanings, Dill, from a young age, was acutely aware of the metaphorical nature of language. Dill's mother, on the other hand, was a speech teacher who believed in the integrity and precision of words and language. Dill has devoted her adult life to art that explores the poetic nature and flexible interpretations of words, while suggesting that that we are the very words that we say, or, perhaps, a composite of everything we have ever heard.

Originally from Seattle, Washington, and now living in Harlem, New York, Xenobia Bailey (b. 1955) brings African American roots music into visual terms with vibrant room-size installations of

crocheted mandalas, tents, and costumes. Coming of age in the 1950s and 1960s, Bailey became increasingly aware that African history, culture, and aesthetics were not embraced in white, mainstream America. In the 1970s, she joined a wave of African American rediscovery and pride in African cultural heritage. As Bailey discovered folk cultures and the all-encompassing role that art, music, dance, food, and ceremony played in those peoples' daily life, she realized that the looks, feels, sounds, and scents of the physical spaces in which we spend our lives have a powerful impact on our psyche. Using the humble craft of crochet, Bailey began making enveloping installations that seek to uplift and inspire while establishing and celebrating an African American aesthetic. Reclaiming a traditional woman's craft, Bailey literally fabricates the world of her choosing.

Japanese-born Yoshiko Kanai (b. 1956) struggled with her artistic identity in her home country. In a culture that historically favors group identity over that of the individual and in which women artists have long struggled for recognition and acceptance among their male counterparts, Kanai became aware that if she intended to pursue her artistic path of self-discovery, she would need to leave Japan in order to do so. In the early 1990s, Kanai moved to New York. There, she has continued to explore ideas of self and identity, with the added role of immigrant layered onto those of woman and Japanese national.

Born in Milwaukee and living in Minneapolis, Lisa Fifield (b. 1957) draws on her native Oneida culture to paint in watercolor the folktales that place women at the heart of tribal life. Wisconsin was the second home to the Oneida, an Iroquoian-speaking community whose original homeland was in what is now central New York. Starting over in Wisconsin, the Oneida suffered tremendous losses, but against the odds, they have remained strong in their tribal identity—an identity that Fifield came into only as an adult. In the tradition of all storytellers, Fifield seeks to keep cultural memories alive by retelling the old tales in her own way. Translating oral stories through pictures, Fifield's images resuscitate fading clan legends that honor women as the center of the life cycle and the keepers of tribal mythology.

Born into the strife-ridden political climate of the Cuban Revolution, José Bedia (b. 1959) grew up understanding that home is sometimes a place you have to leave. Although most Cubans loved their home country, life became defined by struggle and oppression, and the idea of escape to a better life became a de facto part of the national consciousness. Belkis Padilla notes that although Cubans left home, they brought Cuba with them wherever they went, sailing "with the island through all the seas of the world."[3] Bedia was thirty-six before he left Cuba. Censorship and concerns for his and his family's safety led him to the decision that the time had come to leave Cuba forever. After a time in Mexico, he settled in Miami, just ninety miles from Havana but also a world away. Bedia's large-scale paintings and installations explore the African roots of Cuban and Caribbean culture and the idea of the quasi-exile—the nomad who must rebuild home in a new land.

Milwaukee native David Lenz (b. 1962) was raised on landscape painting. His family of artists and art dealers cultivated within him an appreciation for the great American landscape painters—the Hudson River school and the Regionalists; he was painting by the time he was in second grade. Lenz became a landscape painter of a different strain, using the landscape as an integral element in photo-realistic portraiture. In Lenz's scenes, the individual and the landscape merge into a vivid story of person and place.

Born in Honolulu, Hawai'i, Alison Moritsugu (b. 1962) left her island home to attend college and has lived on the mainland ever since. Upon return visits to Hawai'i, Moritsugu, a trained painter, witnessed the dramatic changes within the island landscape—from the takeover by invasive flora and fauna to the ancient staples of sugar and pineapple giving way to modern crops and industry. Moritsugu commenced a body of work that ruminates on Hawai'i's idealized identity—a fusion of native culture, tropical paradise, and site of opportunity and profit. She explores the colonial path that has cost Hawai'i elements of its indigenous culture and offers viewers a heightened awareness of critical issues of preservation and endangerment, water and land use, and native identity.

Molly Hatch (b. 1978) was raised on an organic dairy farm in southern Vermont. The hardworking rural lifestyle that her mother

chose as an adult was in stark contrast to the privileged upbringing she experienced in the Boston home of her wealthy and storied family. Hatch was keenly aware of the duality of her own heritage, appreciating equally the fancy and delicate antiques that filled her grandmother's home and the sturdy utilitarian domestic items that characterized the home of her parents. Wanting to reconcile the appreciation she had for both aesthetics, Hatch's ceramic installations fuse the seemingly disparate realms of the decorative and the utilitarian.

In each of these artists' perspectives we find a story that describes the American experience. Every American has a story—about family, place, identity, and what it means to belong to a homeland that is defined not as a singular heritage, experience, history, ethnicity, or culture, but rather as a complex conglomeration of all of these. Critic and writer Lucy R. Lippard reminds us that "The history of all North Americans has been one of diaspora, or dispersion. Even the Native peoples who have been here for 25,000 years were probably immigrants from Asia."[4] Indeed, the United States has been defined by ongoing change, a country built on conquest as much as freedom, on imperialism as much as refuge. With the commingling of immigrants and more than five hundred native tribes, came the presumption that American culture would eventually homogenize—become a blend of all its ingredients. Instead, diverse peoples influenced one another while simultaneously holding tight to their own ways. Lippard observes, "Immigrants, exiles, and refugees not only change the societies into which they move, but make visible aspects of that society that were previously hidden, that surface when illuminated from the perspective of a different culture."[5] Indeed, contemporary America might best be described as a medley, a long-steeping mixture of heterogeneous elements that continually view and apprehend one another through inherently subjective eyes.

American Story explores the magnitude of this nation's diversity through individual artists who have given voice to their cultural experiences through art making. Each artist embraces the ways in which personal identity and cultural heritage are retained through artistic practice. Giving voice and vision to the American experience, fifteen artists offer their personal stories through compelling and illuminating works of art. In their stories, we find echoes of our own and discover new worlds within our midst. These artists reveal their personal Americas, offering a mélange of viewpoints and realities as elements of a kaleidoscopic whole. Each uses art as a vehicle of storytelling, as a means of countering invisibility and staking claim, of valuing culture and memory, and of using history as a roadmap for the days to come. These personal narratives undermine the master narratives that might contain them and unveil the gift that multiplicity has to offer. The artists remind us that culture and history are embodied in daily life and in the handmade, that the diversity of America is a national treasure, and that the arts are curative, restorative, and redemptive. We find, in their stories, the American story.

1. Barack Obama, "A More Perfect Union," speech delivered at the Constitution Center, Philadelphia, Pennsylvania, March 18, 2008; Transcript published by National Public Radio, www.npr.org/templates/story/story.php?storyId=88478467, accessed May 9, 2009.
2. Willa Cather, written response to winning the gold medal for fiction from the National Institute of Arts and Letters in 1944, cited in Jennifer Harrison-Konz, "Willa Cather: The Author of the Human Experience," *Suite 101 Online Magazine*, www.americanfiction.suite101.com/article.cfm/willa_cather#ixzz0BWkASRNR, accessed May 9, 2009.
3. Belkis Padilla, "Two Cuban Dissidents," in Lynn Geldof, *Cubans: Voices of Change* (New York: Saint Martin's Press, 1991), 343.
4. Lucy R. Lippard, *Mixed Blessings: New Art in a Multicultural America* (New York: Pantheon Books, 1990), 105. The number of years that humans have been in North America is debated among anthropologists.
5. Ibid., 107.

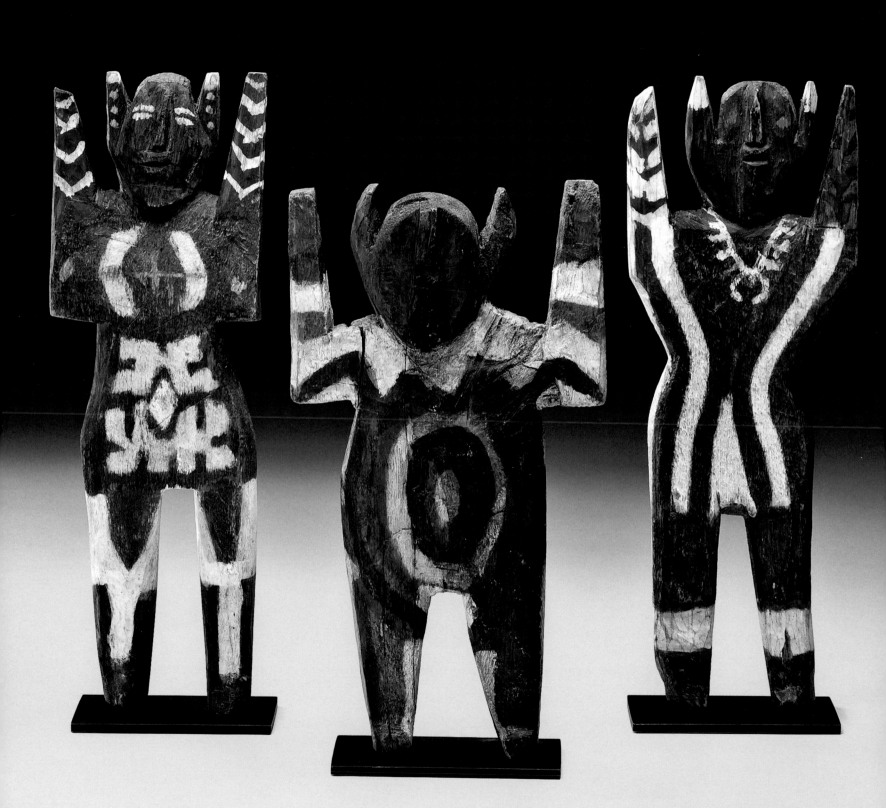

Charlie Willeto, untitled, c. 1961–64; polychromed wood; Collection of Stephanie Smither, TX; Photo: Bruce Hucko.

OPPOSITE: Charlie Willeto, untitled (medicine men), c. 1961–64; Courtesy of Greg LaChapelle and Phyllis Kind Gallery, NY.

Complete object information is available in the Catalogue of Works.

CHARLIE WILLETO (1897–1964)
The Edge of Taboo
by Leslie Umberger

Charlie Willeto came from a long line of medicine men. The cultural knowledge he possessed would eventually serve as both bedrock for his traditional identity and wellspring for his daring creativity. Comprising the largest Native American tribe in the United States, the Navajo, or *Diné*, people have survived through tenacity, adaptability, and a strong belief in their traditional ways. When hard times or illness came, a *hataalii*—a singer, or medicine man—was sought to invoke the Great Spirit and restore balance in life. Willeto knew well the ancient curative ways, but in the last four years of his life he subverted the tribal tradition of the "illness doll," making some four hundred carved and painted figures that remain unique in Navajo art.

Bordered by four sacred mountains, *Diné Bikeyah*, the Navajo Nation, covers 27,000 square miles of American land and spans sections of Arizona, New Mexico, and Utah. Willeto was born in this beloved homeland, but elders of the time would have remembered Kit Carson's cruel Long Walk of 1863–64 and the subsequent years of intense suffering while the tribe was incarcerated on a barren reservation called Bosque Redondo. These memories would be kept alive because the Navajo believe that the past plays a vital role in present-day life. By holding fast to their traditional beliefs, the Navajo did not succumb to the "grand experiment to make civilized human beings out of savages," and instead, in 1868, were restored to their tribal homeland.[1]

Willeto grew up in the Nageezi area in the eastern part of the reservation. His mother and father were both practitioners of the medicine ways, and Willeto was raised to understand numerous complex ceremonies and rituals. He became a respected medicine man, well positioned within the tribe. In 1947, at the age of fifty, Willeto married

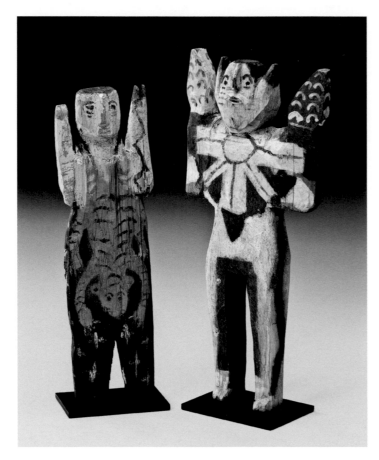

Charlie Willeto, c. 1961–64; (l) untitled (medicine man with mountain lion spirit figure), Collection of Orren and Marilyn Bradley, WI; (r) untitled (medicine man), Courtesy of Greg LaChapelle and Phyllis Kind Gallery, NY.

mortals, but the *Yei bi cheii* belong to the spirit realm and can either help or harm the living.

Traditionally, dry paintings are elements of ceremonial acts in which a shaman, sometimes with a number of helpers, employs her or his skill to create an image on the floor of the patient's home using variously colored mineral sands, powdered pigments, pulverized stones, crushed charcoal, corn meal, crushed flower petals, and pollen. The dry painting is regarded as a living entity, an active prayer, and some ceremonies entail the creation of dozens of separate works, ranging from one to twenty feet in diameter. Although dry paintings are also made for the tourist trade, wherein the pigments are permanently affixed to a substrate, the traditional dry painting is an ephemeral thing that, once it has absorbed or channeled whatever energy asked of it by the medicine man, is swept up and removed, evacuating the trouble or illness from the land of the Earth People. A similar but lesser-known tradition is that of the illness doll. A kind of effigy made of the person suffering, and painted with symbols, the doll is burdened with the illness by the medicine man, and, at the end of the ceremony, placed within medicine bundles and removed to remote caves or canyons where the illness can be absorbed back into the spirit world.

The figures that Willeto began to create around 1960 closely resembled illness dolls, but Willeto took care to alter them sufficiently to keep the sacred role of the illness doll intact. Jim Mauzy, the owner of a trading post in Lybrook, New Mexico, who sold the carvings that Willeto bartered to him for provisions, recalled that the earliest carvings closely resembled the *Yei bi cheii* ceremonial dancers and that tribal elders warned Willeto that these figures would bring misfortune to the group if he continued to carve them. Elizabeth noted that her husband hid the early carvings, fearful of anyone in the community or even the family seeing them.[3]

Writer and designer Greg LaChapelle, who first saw Willeto's work at Mauzy's, noted that Willeto seemed to get away with breaking certain traditional taboos, perhaps because of the respect he had garnered as a medicine man: "Willeto knew the Windchant, or Windway, which in Navajo religion protects against the power of snakes and the harm of storms," LaChapelle, explains. "The

Elizabeth Ignacio, a woman some thirty years his junior, but the marriage was looked upon favorably by both families as a union of *hataalii*.[2] Elizabeth's parents were also both medicine people, and she, like Charlie, had been steeped in extensive ritual knowledge. From then on, Charlie and Elizabeth practiced medicine together, performing ceremonies, creating dry paintings or sandpaintings, and making healing, or illness, dolls.

The Navajo seek harmony and a balance of opposing forces at all times and believe that illness or trouble arises when there is an imbalance somewhere within the fabric of life. When an imbalance does occur, a medicine man or woman is called upon to diagnose the problem and perform the proper ceremony to restore *hozho*, or harmony. The Navajo believe in one Great Spirit, the Holy People or *Yei bi cheii*, and the Earth People. The Earth People are mere

Windchant features snakes exclusively. It is interesting to consider whether his knowledge of the Windchant and its association with snakes gave Willeto the license to carve a number of snakes and men holding painted snakes, which are otherwise taboo."[4] Willeto, it seemed, was able to break with tradition because he so clearly respected it as well.

"In the simple times of my early childhood, when I fashioned my own toys with sandstone, clay, wood, and other found materials, I did not know that I walked on the edge of taboo," notes artist and writer Shonto Begay, also the son of a Navajo medicine man:

> *I was later taught that there were unspoken*
> *mysteries associated with the small, hand-carved*
> *wooden dolls created and reserved for healing.*
> *Illness dolls were used to trick away disharmony*
> *in a patient. Then once the illness was "locked"*
> *inside the doll, it was placed back into the earth.*
> *The snakeweed, dust, and the spirits of our*
> *ancestors reclaimed the illness for all time. As*
> *a child I was taught simultaneously to fear and*
> *revere such objects representing the life cycle.*
> *Consequently, I feared these dolls and the places*
> *where they were discarded. Illness dolls were the*
> *used medical syringes of our time.*[5]

Begay notes that he, like others in his tribe, regarded Willeto's carved people and animals with great trepidation, but believed that he must be a powerful man for the spirits to allow these carvings, which so entirely conjured a sense of ancient mystery. A true edge-walker, "[Willeto] dared me to delve into my own mystery," noted Begay. He "beckoned me to celebrate the unheralded visions of my world."[6] While others warned that ancient mysteries should not be tested, Willeto embodied a vital idea: that one must push the boundaries of mystery in order to strengthen one's apprehension of them.

The once-forbidden practice of carving figures or animals remained uncommon among Navajos until the 1970s. Lee Kogan of the American Folk Art Museum has noted that there was precedent for independent-minded artists to break with traditional ways,

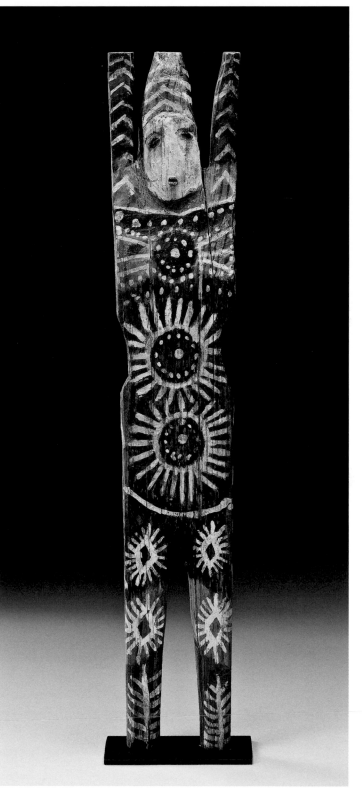

Charlie Willeto, untitled (medicine man), c. 1961–64; Courtesy of Greg LaChapelle and Phyllis Kind Gallery, NY.

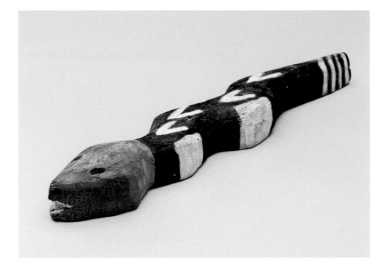

Charlie Willeto, untitled (snake), c. 1961–64; Courtesy of Greg LaChapelle and Phyllis Kind Gallery, NY.

citing another esteemed medicine man, Hosteen Klah, in the early twentieth century: "For a long time, figural weaving was taboo among the Navajos, but in 1913 Klah began to replicate religious figural sandpaintings in his woven designs. Like Klah, Willeto followed his own muse."[7] In the late 1950s, permanent versions of the dry paintings—another taboo—began to be produced for the tourist market.[8] The breaking of long-standing taboos did not undermine the durable Navajo beliefs in traditional ways. Rather, it had the effect of validating the power of the medicine man to negotiate new boundaries with the supernatural realm.

Willeto's cottonwood and pine carvings range from several inches to several feet tall and from figures with howling faces, raised arms, brandished spears, and scenes of intensity and drama, to humble animals of the region, to an almost comical tiger jumping through a hoop, inspired perhaps by a circus poster. They encompass supernatural horned deities and masked *Yei bi cheii* as well as the common vaquero and shepherd of the Earth People. Overall, even Willeto's simplest carvings seem to connect with something ancient and revered. Owls, a potent multifaceted symbol that encompasses wisdom and knowledge on the one hand and death or evil spirits on the other, were among his most revisited subjects.

In their gestures, Willeto's figures echo dancing people seen in ancient petroglyphs and pictographs. Feathered headdresses and knotted hairstyles often top complexly painted costumes sometimes mixed with Western-style clothes, suggesting ceremony, tradition, and a union between old ways and new. Willeto often portrayed his figures with arms raised to the sky, a stance common to both singers and warriors alike. His painted designs embody the Navajo aesthetic ideal of a balance that is natural, harmonious but never forced or rigid; his geometries are clearly rooted in the woven patterns seen in Navajo rugs and blankets. He often depicts traditional Navajo jewelry, such as the *yo ne maze disya gi* or "squash blossom" necklace. Male figures sometimes carry the rattle of the *hataalii*; female figures often hold the weaver's tools, a fork and batten.

Many of Willeto's early figures were colored with the vegetable dyes that Elizabeth used in her weavings, accounting for the now softened naturalistic tones. Elizabeth explained that she often suggested designs and patterns to her husband and that she sometimes painted his figures herself, accounting for a stylistic variance that can be seen in the figures. LaChapelle notes that Elizabeth's hand is distinguished by a more precisely applied pattern and greater detail, whereas Willeto, who painted with

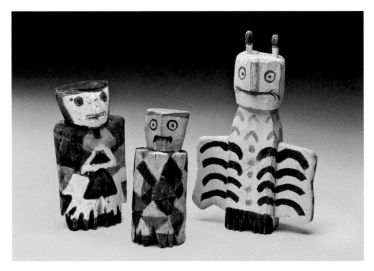

Charlie Willeto, untitled (owls), c. 1961–64; Courtesy of Greg LaChapelle and Phyllis Kind Gallery, NY.

Charlie Willeto, untitled (Navajo figures), c. 1961–64; Courtesy of Greg LaChapelle and Phyllis Kind Gallery, NY.

both sticks and brushes, tended toward bolder lines and less attention to fine detail.[9]

LaChapelle and his friend Rex Arrowsmith happened upon Willeto's carvings at Mauzy's Trading Post in the early 1960s. Willeto had been especially prolific in 1961 and 1962, and the men were utterly captivated by the mysterious and sensitive pieces. Mauzy had scores of pieces by then; LaChapelle and Arrowsmith bought them all.

Willeto created a legacy that belongs to his tribe as well as his immediate family. Of his six children, three of them became carvers themselves and, more recently, a granddaughter as well. Dozens of other Navajo carvers followed in Willeto's footsteps. "I see Willeto as an artist who braved the criticism of his people and peers to seek the visions of the sacred mandalas and the secrets of ancient petroglyphs," explains Begay. "As an artist of the new millennium, I see this contribution to Navajo folk art as having an impact far beyond my world."[10]

1. General James H. Carleton, head of the Military Department of New Mexico and Kit Carson's commander, thusly described the Navajo incarceration at Bosque Redondo. Quoted in Alvin M. Josephy Jr., *500 Nations: An Illustrated History of North American Indians* (New York: Random House and Pathway Publications; 1994). In 1868, William Tecumseh Sherman created a treaty with the Navajo that restored them to their land with the stipulations that they not bear arms or attack American troops and that Navajo children must attend white schools.
2. There is some discrepancy regarding Willeto's life dates, even among reputable sources such as the Getty Union List of Artist Names® Online, which lists them as 1906–1964, and the Smithsonian American Art Museum online, which lists them as 1900–1965. This publication is adhering to the volume *Collective Willeto: The Visionary Carvings of a Navajo Artist* (Santa Fe: Museum of New Mexico Press, 2002), which consistently uses 1897–1964.
3. Greg LaChapelle, "Charlie Willeto, 1897–1964: A Recollection," in *Collective Willeto*, 9.
4. Ibid.
5. Shonto Begay, "Willeto's Tangible Mysteries," in *Collective Willeto*, 1.
6. Ibid., 3.
7. Lee Kogan, "An Ordered Universe: The Art of Willeto," in *Collective Willeto*, 15.
8. Christian F. Feest, *Native Arts of North America*, rev. ed. (London: Thames and Hudson, 1992), 103.
9. LaChapelle, "Charlie Willeto, 1897–1964," 8.
10. Begay, "Willeto's Tangible Mysteries," 3.

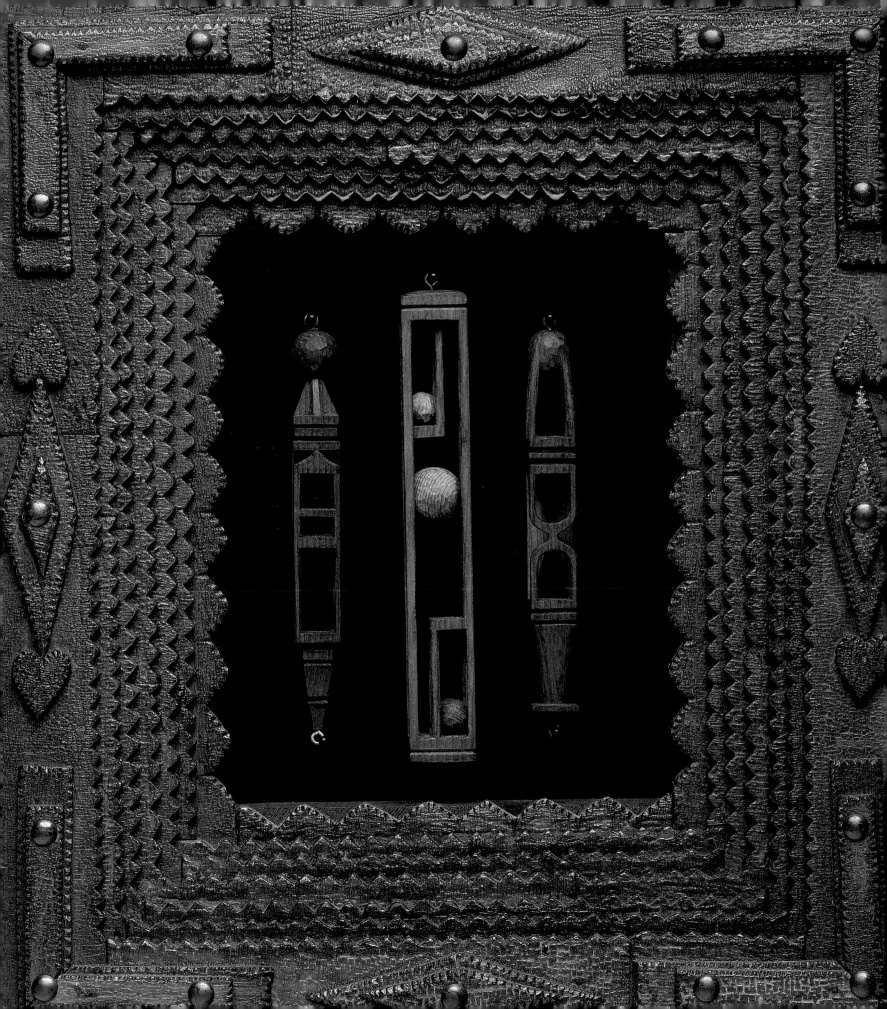

ADOLPH VANDERTIE (1911–2007)
What the Have-Nots Have
by Leslie Umberger

Adolph Vandertie, c. 1980;
photographer unknown,
John Michael Kohler Arts Center
Collection.

OPPOSITE: Adolph Vandertie,
untitled (chip-carved frame with
whimsy sticks), c. 1960–2000;
John Michael Kohler Arts Center
Collection.

**Complete object information is
available in the Catalogue of Works.**

Between the Civil War and World War II, many young boys fantasized about living the life of the American hobo. Adolph Vandertie of Wisconsin was one such boy, intoxicated by the idea of a wanderlust lifestyle riding the rails, outsmarting officials, and living a carefree and adventuresome life. The hobos' shared art form—intricate and astonishing bits of whittled wood—would grip Vandertie's imagination until the day he died. When he was young, Vandertie never imagined that the men he so admired would dub him "Grand Duke of the Hobos," and count him an honored member of their ranks. As Vandertie recalled:

> I started going to the hobo jungles when I was about twelve years old. The true hobo was, by-and-large, a very decent, honest person who was down on his luck, that's all. There was seventeen million unemployed.
> Well, see, I saw an old hobo when I was a kid; he was sittin' propped up against a tree and he was carving a ball-in-cage—I didn't know what it was, neither did anybody else—but it's kind of a universal design among whittlers, I guess, and I was fascinated with it, I saw him cut that ball loose and I thought, well, someday I'm gonna make one of them.

Vandertie was born in 1911 near Lena, Wisconsin, in a sixteen-by-twenty-foot log cabin built by his mother's family as part of her wedding dowry. The family of ten—including Adolph as one of two sets of twins—shared the tiny cabin until they moved to Green Bay around 1920. As a boy, Vandertie learned the intricate carving and whittling skills associated with the hobos from his grandfather, who had learned many of the techniques while a prisoner of war during the Civil War. The culture and the art of the hobos inspired Vandertie to search out the hobo jungles pocketed around the rail lines.

The name "hobo" evolved from the English term "hoe boys," which referred to the migrant help on wealthy farm estates. In nineteenth and early twentieth century America, hobos were wandering workers, men and sometimes women of various talents who roamed the country, intermittently working and traveling. During the Industrial Revolution, work was plentiful, but the Great Depression brought hard times and as many as a million people took to the rails, looking for any available work. Hobos formed a cultural nation of their own, whose members adhered to a special set of laws and used their own codified system of signs and

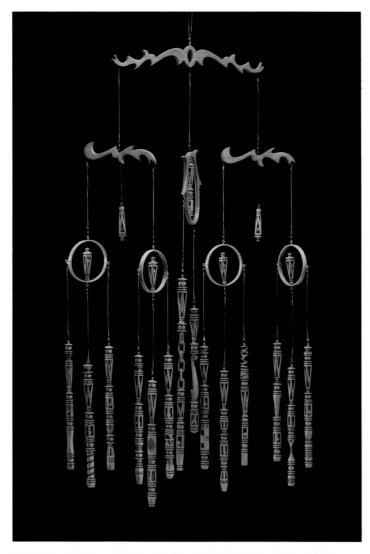

Adolph Vandertie, untitled (mobile), c. 1960–2000; John Michael Kohler Arts Center Collection.

symbols to communicate. A proud society, hobos were industrious, intelligent, and imaginative, and distinguished themselves from another clan of railway travelers: the tramps. According to Vandertie,

> Like the hobo, the tramp was a wanderer, but unlike the hobo he was not a worker. Most tramps lived by their wits, some by petty thievery and begging, some by robbery and murder. The hobo feared the tramp and was contemptuous of him as a loafer, while the tramp despised the hobo as a sucker for working.[2]

Sometimes, however, men and women had feet in both camps, working for a while and resorting to other tactics when their options ran out. The distinctions between the groups were not always clear-cut, and, out of necessity, they shared the same camps, rode the same rails, and together took part in the foraging of ingredients and in the making and eating of the motley medley known as mulligan stew. Around the campfires they told stories, sang, and carved or whittled in the distinct styles associated with their respective groups:

> There, I listened, wide-eyed, to the stories told by the hobos. These stories, that I so loved to hear, told to me by these colorful wanderers of faraway places they had been and the many adventures they had experienced were not all necessarily true, but they were magic to an impressionable young boy. It was in these hobo jungles that I ate my first Mulligan stew and learned the art and trademark of the whittler: the ball-in-cage and the chain.[3]

Vandertie's boyhood dreams gave way to working and raising a family, and many years went by before he again took up the whittling practices that had consumed him as a child. In his mid-forties—in search of a new habit after quitting smoking—he again became an avid carver. His renewed fascination with the ball-in-cage and the chain resulted in the inclusion of one or the other

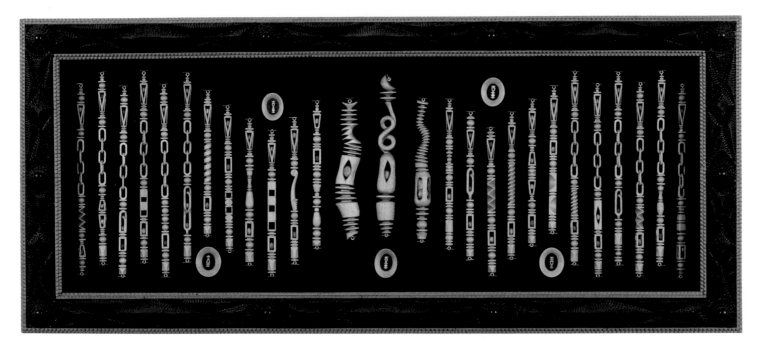

Adolph Vandertie, untitled (chip-carved frame with whimsy sticks),
c. 1960–2000; John Michael Kohler Arts Center Collection.

in almost every piece he made. Turning an adult's eye toward the hobo culture he had long revered, Vandertie realized that the last generation of Depression-era hobos was aging and that no one had ever recorded their history, stories, methods, or memories. In the mid-1950s, a fire lit within, Vandertie set off to Britt, Iowa, where the National Hobo Convention had taken place every year since 1903. Although he had been away a long time, he was welcomed as part of the family. The older hobos, some of them considered royalty within the clan, opened up to Vandertie in oral interviews. He recorded their ways, their symbols, and terms, and began to trade his own works for theirs, hoping to archive not only the history but also incredible feats of skill and artistry that were at its center. Vandertie's work remains the only known firsthand documentation of the lives of hobos. An amazing artist in his own right, Vandertie would, over the next five decades, carve and whittle thousands of pieces of tramp and hobo art.

Tramp and hobo art are both folk traditions of the wanderer, but they differ in several ways. Hobos generally carried jackknives, and leisure time was spent whittling—that is, reducing and refining, in shape and size, small pieces of soft wood (often basswood or linden) that had been cut and gathered. The resultant linked chains and "whimsy sticks" were lightweight and easy to carry and could be offered in trade for food, shelter, or as an exchange between fellow hobos. The whittled works were rarely of utilitarian value; rather they were objects made to feature the maker's considerable skill and to elicit awe from those not privy to the secrets of their creation.

Tramp art pieces, on the other hand, were most often made to be used. The tramp style is generally characterized by thin strips of wood that have been notched or "chip carved" along the edges. The works were carved (a cutting technique regarded by hobos as less refined than whittling) predominantly from cast-off cedar or mahogany cigar boxes, which, in addition to being plentiful at one time, were soft and easy to shape. Multiple layers of the notched strips were arranged in ever-decreasing size to create a structure, which might be a keepsake box, picture frame, or piece of furniture. The bold geometric patterns are frequently embellished with details such as drawer pulls, padded linings, photographs, and bits of mirror.

Between 1900 and 1925, when the practice of these styles was

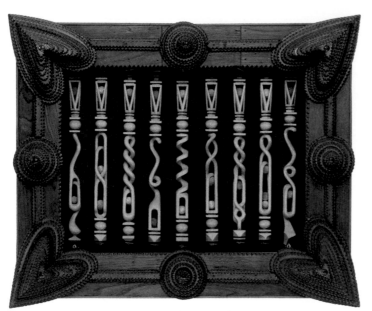

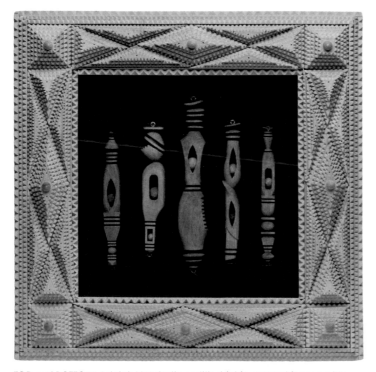

TOP and BOTTOM: Adolph Vandertie, untitled (chip-carved frames with whimsy sticks), c. 1960–2000; John Michael Kohler Arts Center Collection.

most popular, few if any makers considered themselves artists. The objects they made were about connection, an engagement with the past as well as with the viewers they would encounter and amuse or mystify; style and tradition unify, while personal artistry distinguishes. Historians and folklorists alike have noted that throughout American history, woodworking was largely a male province and needlework its feminine counterpart. While contemporary artists regularly challenge and breach such gendered boundaries, the folk styles of tramp and hobo arts are, indeed, rooted in a culture of men wherein a hard-times outlook was embodied in the very things they made: from very little, one could produce something wonderful.

Being out of work was often an emotional challenge for men raised to believe in earning one's keep. Many tramps and hobos had learned as boys to associate hand tools with industriousness and wood with the great outdoors. Later, with no work at hand, wood and tools were taken up, the creative act offering an adaptation for idle hands. The product was a source of pride—something in short supply otherwise—and the carved pieces became testimonial to a spirit of optimism and evidence of what the have-nots have. Vandertie reflected:

> *I think I started something by associating hobo and tramp art. I have a feeling that they belong together, see? Another description, probably, is a poor man's art. They were the people who did it, who practiced that. It was the poor people. And I was one of 'em most of my life. All the hobo had was an old jackknife and a piece of wood. I like to cling to the hobo philosophy. I liked the feel of that blade cutting into that nice, soft wood, too, see. It was very relaxing. I took a lot of pride in my art. I estimate I've made, actually over 4,000 pieces. It was therapy for me, see.*[4]

One of Vandertie's personal masterpieces is a 217-foot-long contiguous link chain that was carved from a single chunk of wood and weighs less than two pounds total. The chain embodies, perhaps more than any other item, the perseverance

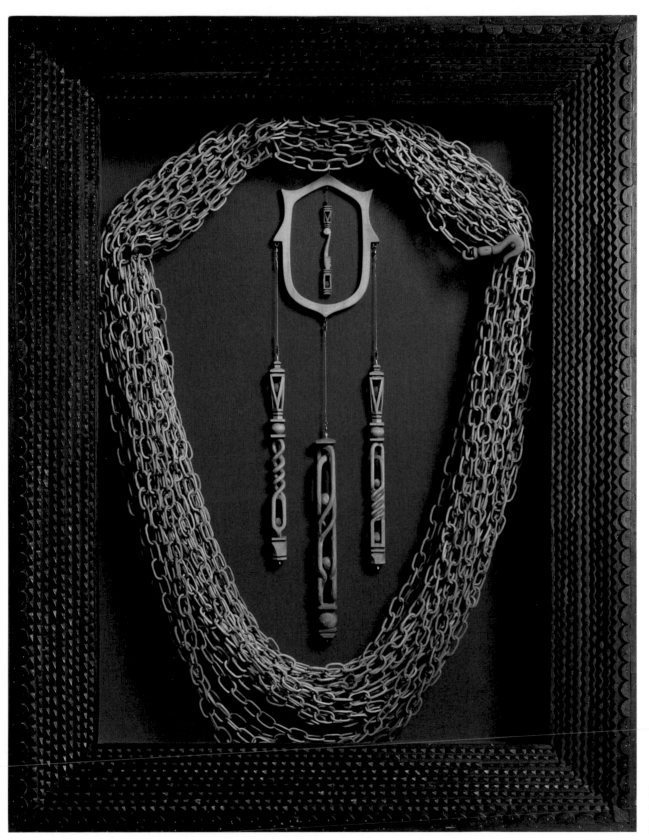

Adolph Vandertie, untitled (chip-carved frame with whittled chain and whimsy sticks), 1976; John Michael Kohler Arts Center Collection.

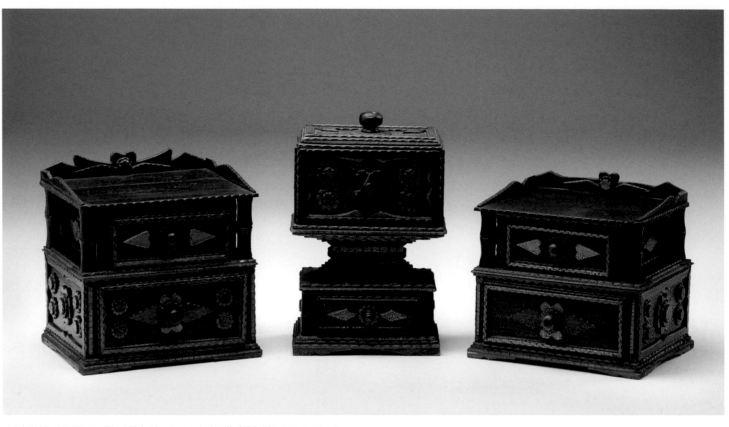

Adolph Vandertie, untitled (l) (chip-carved chest), (c) (chip-carved box), (r) (chip-carved chest), c. 1960–2000; John Michael Kohler Arts Center Collection.

and determination concomitant with the carver's art. Folklorist Simon J. Bronner has observed, "The carved chain is a result of a technical procedure the maker has mastered and personalized. Having figured out the trick and with completed chain in hand, he becomes a trickster. The chain represents more than a form to be admired: it shows style, persistence, ability. The carved chain embodies knowledge."[5]

Although Vandertie allied himself with the hobos, he practiced both tramp and hobo styles of woodworking in order to record the ways of these groups. He mastered the skills of each and documented, step-by-step, the methods and procedures of the carved chain, the ball-in-cage, the whimsy stick, and elaborate chip-carved boxes, frames, lamps, and any number of household items.[6] In 1981, Adolph and his wife, Adeline, were named "Grand Duke and Duchess of the Hobos" by the "King of the Hobos," "Steamtrain

Maury" Graham. This honor was bestowed in acknowledgment of Vandertie's lifelong devotion to making and collecting hobo and tramp art as well as for his great commitment to preserving the stories and artifacts of these cultures. Tramp art expert and author Clifford Wallach has noted that Vandertie made a critical contribution to the history of tramp and hobo carvers:

> *When we discovered Vandertie as a maker of tramp art, hobo art, folk art, it was so exciting because we were able to put a face to the hands of these makers. Vandertie was a living relic. He was a tramp artist. He was a man who made pieces for thirty, forty years. If he only would have made a dozen pieces we wouldn't be sitting here talking about him. So the fact that he made a volume of work as his legacy, it's to impress us, but it is also to say, "Hey, I was here."* [7]

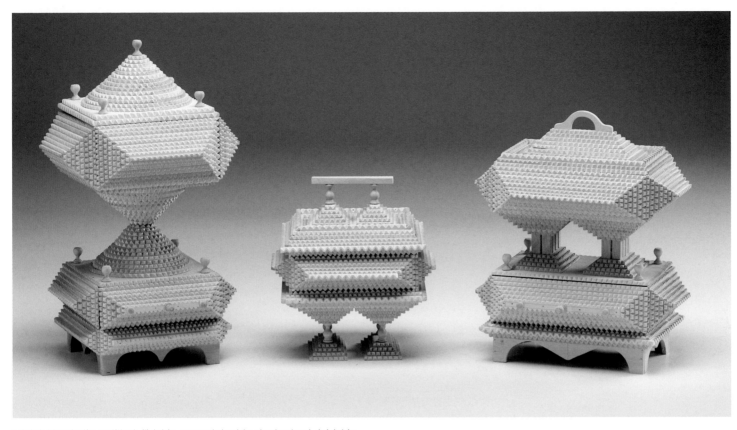

Adolph Vandertie, untitled, (l) (chip-carved double-decker box), (c) (chip-carved box), (r) (chip-carved box), c. 1960–2000; John Michael Kohler Arts Center Collection.

In 2001, Vandertie worked with Kohler Foundation to preserve the body of work that he had made, traded, collected, and cared for over the preceding fifty years. The primary body of his work is now housed at the John Michael Kohler Arts Center, with another significant grouping of objects at the Ashwaubenenon County Historical Society in Green Bay, Wisconsin. In 2007, Adolph Vandertie, as they say in Hobo vernacular, "caught the Westbound train." His life and work are commemorated in the feature-length documentary, *Westbound*.

1. Adolph Vandertie, in *Westbound*, a film by Arketype (Green Bay, Wisc.; 2009).
2. Vandertie, "History of Tramp Art," in Adolph Vandertie with Patrick Spielman, *Hobo & Tramp Art Carving: An Authentic American Folk Tradition* (New York: Sterling, 1995), 62.
3. Vandertie, "From the Author," in Vandertie and Spielman, *Hobo & Tramp Art Carving*, 10.
4. Vandertie, in *Westbound*.
5. Simon J. Bronner, *The Carver's Art: Crafting Meaning from Wood* (Lexington, Kentucky: University Press of Kentucky, 1985), 73.
6. Such practices are detailed in Vandertie and Spielman, *Hobo & Tramp Art Carving*.
7. Clifford Wallach, in *Westbound*.

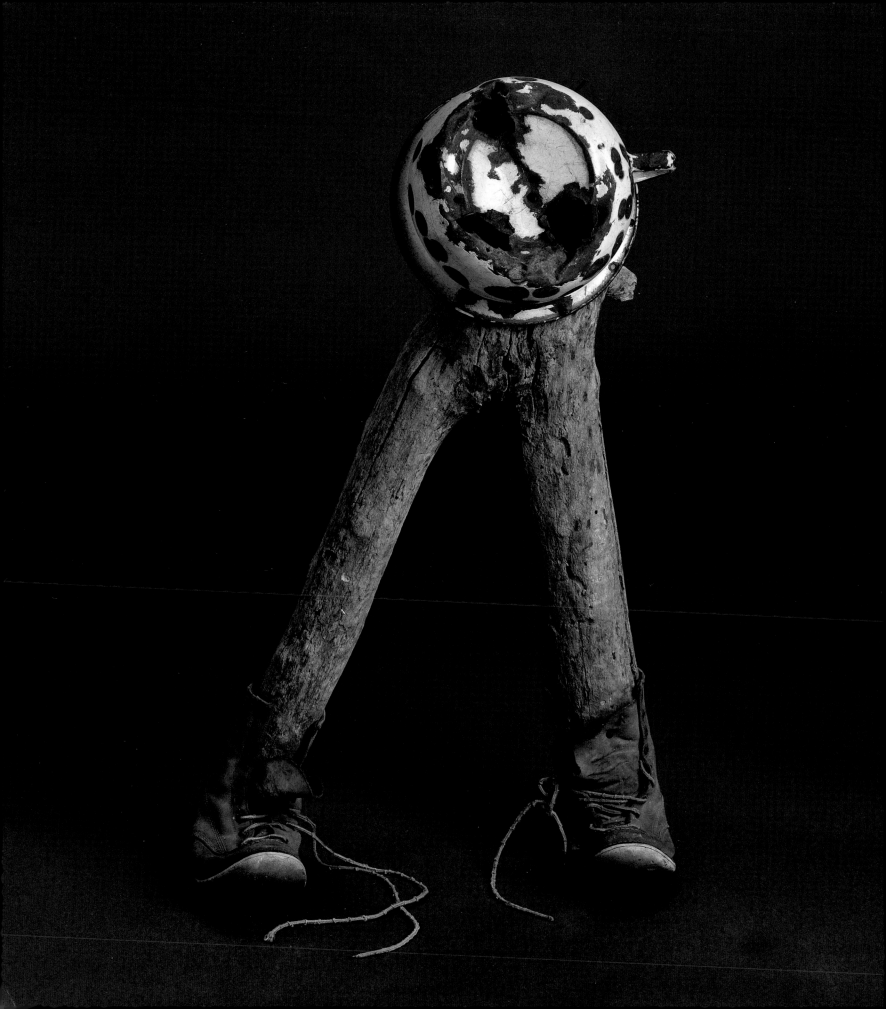

HAWKINS BOLDEN (1914–2005)
A Blind Visionary's Yard Guardians
by Tom Patterson

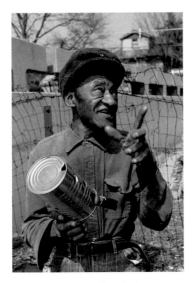

Hawkins Bolden, 1994; photo: Ted Degener.

OPPOSITE: Hawkins Bolden, untitled (scarecrow assemblage with chamber pot and boots), 1986; Collection of William Arnett, GA.

Complete object information is available in the Catalogue of Works.

During the last forty years of his life, Hawkins Bolden created and repeatedly reworked an installation of figural assemblages and masklike forms in and around the yard of his small house in central Memphis, Tennessee. A defining factor that influenced the creation of these works, like most other aspects of his life, was the blindness he suffered as the result of a childhood accident. Over time, he developed a kind of surrogate sight through a heightened use of his other senses, augmented by keen intuitive capacities. Bolden grew into a visionary who could metaphorically "see" more than his sighted contemporaries.

Of African American and Native American ancestry, permanently disabled, illiterate, and living on the economic margins in the racist South of the early twentieth century, Bolden was relegated to second-class citizenship on a variety of fronts. Nevertheless, he focused his energies on a direct, tactile engagement with the environment in his inner-city residential neighborhood. To earn a living, Bolden tended his neighbors' lawns, cleaned the streets, and picked up discarded objects and other litter in vacant lots. In the process, he became a skilled urban scavenger and made things from the items he found: "Oh, I made kites, I made tom-walkers—leg stilts—out of poles and tin cans—my daddy taught me to do a lot of them things—skate trucks. Later on I made toys for my nieces and nephews," Bolden recalled.[1] Not long after he turned fifty, Bolden began using some of the findings from his rounds to make sculptural objects and constructions loosely based on human faces and standing figures.[2]

Bolden had participated in planting and tending the family garden since he was a boy, and when his brother suggested that he employ his creations as scarecrows, he posted several of them on the periphery of the garden, implanting them in the ground or securing them to the

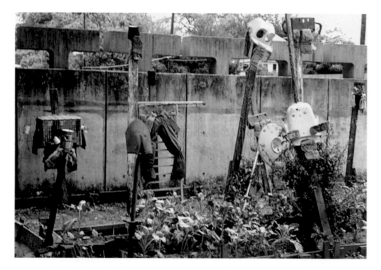

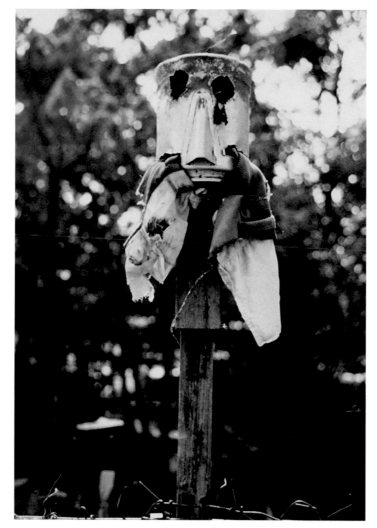

TOP and BOTTOM: Untitled sculptures in Hawkins Bolden's yard (site views: Memphis, TN), c. 1980; photo: William Arnett.

surrounding fence with wire. "My brother told me how to do that, though he said, 'get some tin cans, old paint buckets, all that, go and make 'em and put them out there on a limb or something out in the yard. That'll scare the birds away.' And that's what I've been doin' it, ever since, long time."[3] Thereafter, Bolden continued to embellish the garden with additional constructions, so that they became more numerous than the cultivated plants among which they were stationed. Perhaps inadvertently at first, Bolden and the works he made became the guardians of the family's vegetables, and the idea of creating a protected personal space firmly took root.

Born in Memphis, Bolden and his twin brother Monroe were among six siblings in the Bolden family, and the two played together often as children. Tragically, it was one of the twins' play sessions that cost Bolden his eyesight. An avid baseball fan, Bolden was holding down the catcher's position in an informal neighborhood game when his brother accidentally hit him in the head with a baseball bat. Seven years old at the time, he began to suffer seizures soon after the accident. Doctors diagnosed epilepsy and unsuccessfully tried to alleviate the problem by drilling a hole in his skull, according to his older sister, Elizabeth Williams: "At the time the family was told his brain had grown too large," Williams recalled.[4] A seizure he suffered about a year after sustaining the blow resulted in his permanent blindness. Many years later, recalling the very last thing he saw in the throes of that experience, Bolden said, "I couldn't stop looking at the sun. I just looked and my eyes went dark. I never did see nothing after that."[5]

Even after he went blind, Bolden continued to join his twin brother in activities they both enjoyed. Using readily available materials, they made toys for themselves and demonstrated similar resourcefulness in pursuing their mutual interest in electronics. Hawkins and Monroe managed to surreptitiously extend electrical wiring to their home at a time when the family was unable to afford the luxury of electric power, and subsequently started building radios from spare, often found, components—an activity Bolden continued to enjoy as an adult. Evidently deriving as much pleasure from listening to radios as he did from building them, he harbored

a special fondness for broadcasts of gospel music and baseball games, particularly those involving his favorite major-league team, the St. Louis Cardinals.

In 1930, when Bolden was in his mid-teens, he moved with his family into the small house where he would live out the rest of his life, in a midtown Memphis neighborhood that would eventually be overwhelmed by commercial development. Bolden never married or fathered children, and in his later years he shared the modest family home only with his older sister. Assessing his blindness and alluding to the capacities he possessed in spite of it, Williams said, "He couldn't see at all. He just always knowed things, see or not."[6]

In his forays through his neighborhood's streets, sidewalks, and alleys, Bolden picked up and brought home with him a wide but fairly consistent variety of stray items he came across—cast-off furniture, worn-out clothes, discarded toys, broken tools, appliance parts, weathered lumber, carpet scraps, used kitchenware, hubcaps, empty bottles and cans, buckets, oil-drum lids, tractor seats, grilling racks, chain links, tree limbs, drainpipes, wire, and rubber hoses, not to mention the electronic components he used to make his homemade radios. In scavenging these cast-off objects and materials for reuse, he was engaging in a practice that is virtually universal in economically marginal communities—"folk recycling," as scholar Julius Stephen Kassovic has characterized it, whereby "junked and industrially produced items are somehow reworked to produce 'new' items performing altered functions."[7]

But unlike his legions of similarly resourceful counterparts who recycled discards to purely utilitarian ends, Bolden directed the recycling impulse toward an ongoing project of transformative expression. The slapdash totems he made from his street-salvaged junk were designed to visually establish his presence while simultaneously conjuring a protective aura around his garden and his home. In commenting on the way Bolden and a couple of his artistic contemporaries employed this folk recycling practice, art historian Richard J. Powell wrote, "You could almost call it 'art-ecology.'" Powell attributes special significance to salvaged items, to "the object which has been discarded, thrown aside and ignored by society as a whole."[8] He notes the centrality of such objects to

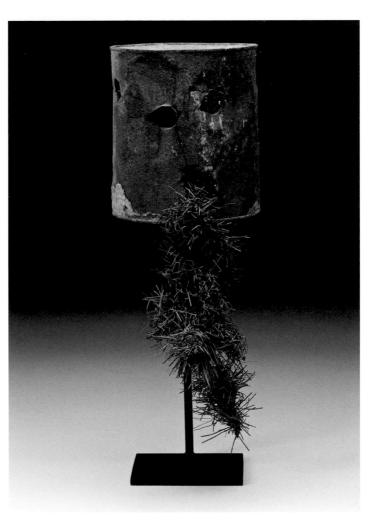

Hawkins Bolden, untitled (assemblage with paint can and garland), c. 1965–2005; Collection of Scott Ogden, NY.

Bolden's work, and draws a critical parallel between the person who feels marginalized from society and the concomitant need to prove—time and again—the usefulness and unseen potential of the rejected item.

On returning home from his pedestrian ventures, Bolden typically stored his latest finds in an unlighted, dirt-floored crawl space under the house. Any time he was of a mind to make an assemblage, he returned to this stash site and felt his way among the varied materials to select whatever he thought might prove useful on that occasion. Then he manipulated and altered his salvaged components in a variety of ways—cutting, piercing,

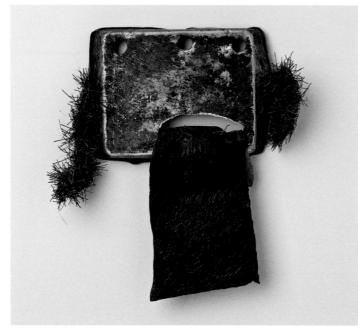

Hawkins Bolden, untitled (assemblage with cake pan and carpet), c. 1965–2005; Courtesy of Ricco/Maresca Gallery, NY.

the spiritual, especially in conjunction with ideas of vision and protection. Bolden openly discussed his deep connection to God and his thanks for being watched over, perhaps feeling especially vulnerable because of his disabilities:

> *I pray, man, every night before I go to bed. I talk to the Lord and next morning I give him my thanks for watching over me last night while I slept. I tell him nobody in this world has been nice or kind to me—you're the only one keeping me alive, you've been mother, father, sister, brother—everything in this world; I couldn't have done nothing without you.*[10]

One of the most consistent motifs in Bolden's work is the container or flat object repeatedly cut or pierced with holes, typically to indicate a head or face with eyes and mouth. The number of eyes and other orifices he chose to indicate, however, varied substantially from piece to piece. Often there are more than three or four holes in a given head/face; sometimes as many as ten, or more. About this Bolden said, "Those buckets: I make eyes on them. They have four eyes; some have three—a middle eye. I make them so they can see good: two eyes here, and one way up on top of the head. The third eye sees a whole lot, you know."[11]

It is not surprising that a blind man would indicate a special interest in eyes, but the multiplicity of the cutout eyes in Bolden's figures, coupled with his reference to the acuity of the "third eye," also hint at an overt interest in visionary consciousness, often symbolized (in both traditional and contemporary art) by many-eyed forms. Another part of the human anatomy to which Bolden paid special attention in his facial depictions is the tongue, the organ of speech and song—no doubt particularly important to someone especially reliant on sound to communicate and through which to experience the world he could not see. To indicate his figures' tongues, Bolden employed shoe soles, sections of rubber hose, tire tubes, strips of carpet, or other fabric scraps, usually threaded through the cutout mouths and tied in place. Because the original purpose of scarecrows is to scare, it is likely that

bending, scraping, drilling into, or rubbing them—to create what his nimble, sensitive fingers told him were the desired effects. Using bits of wire, fabric, or other materials, he strategically interconnected these components to create evocations of the human figure, which he then placed among and around his plot of cultivated vegetables. Wired to the surrounding fence, implanted directly into the ground, or otherwise affixed to their appointed spots, his quasi-figurative works stood guard and protected the site until or unless they were knocked down by the elements or removed by the increasing numbers of collectors who visited Bolden in his later years.

Bolden's sculptures have been compared to protective objects and embellishments traditionally employed in parts of Africa and the Afro-Atlantic region, including bottle trees, grave decorations, and Kongo *minkisi* charms, as well as to other African American art forms. Evidently, some of Bolden's neighbors also sensed such a connection, as indicated by his sister's comment, "They thought it was a voodoo garden but they were just scarecrows."[9] Williams, however, may have underestimated her brother's engagement with

Bolden's approach to rendering eyes, mouths, and tongues was driven by his desire to render his creations frightening to their beholders, whether birds or people. The heads of his figures often suggest skulls or jack-o-lanterns, themselves ersatz skulls. Some of them appear to be shouting, perhaps singing, or at least talking, and many of them seem to aggressively taunt viewers with their outthrust tongues.

Bolden is known to have sometimes used articles of his own clothing or other personal effects in creating his sculptures, and a number of the pieces bear some likeness to the artist himself. Among those who have proposed that Bolden's works are sometimes self-portraits is William Arnett, the principal collector of Bolden's art: "A hairy growth on [Bolden's] face near his mouth is represented on some of the faces he makes, created of artificial Christmas tree pine needles, a patch of shag carpet, or whatever else fits the roles."[12] Arnett's observations are grounded in the fact that Bolden, not able to see others, had an innately self-referential perspective on the human form.

Bolden's garden of scarecrow sentinels was a personalized exponent of the African American yard show tradition. This tradition links creative expression and spiritual protection with the idea that if the land is protected, the land, in turn, will protect the people who live there. Art historians Grey Gundaker and Judith McWillie argue that the practice plays an integral role in the maker's personal renewal as well, noting that yard shows "emphasize the dynamics of transformation from seed into garden, from raw material into art, from existence into well-lived life, from willful individual into responsible adult, from burden into affirmation."[13] In his reliance on scavenged street detritus as his raw material, Bolden shares common ground with a number of other black vernacular artists who transformed their personal spaces, among them Curtis Cuffie (New York; 1955–2002), Asberry Davis (South Carolina; born 1918), Lonnie Holley (Alabama; born 1950), George Kornegay (Alabama; born 1913), and Emmer Sewell (Alabama; born 1938). Such artists share in making work that is relatively ephemeral, especially when left outdoors as it was originally intended to be. Often subtle, personal, fragile, and not recognized as art worth saving by the larger community, African American yard shows have a poor record of surviving their creators for more than a short time.

Bolden had been engaged in this process of creative recycling and spatial marking for fifteen to twenty years when his "scarecrows" started to attract the attention of art scholars and collectors. Judith McWillie, a professor of drawing and painting at the University of Georgia, grew up in Memphis and attended a high school near Bolden's home. She recalls that he had been "a legend in Memphis for years" when she visited him for the first time around 1980.[14] She began photographing him and his work in 1984

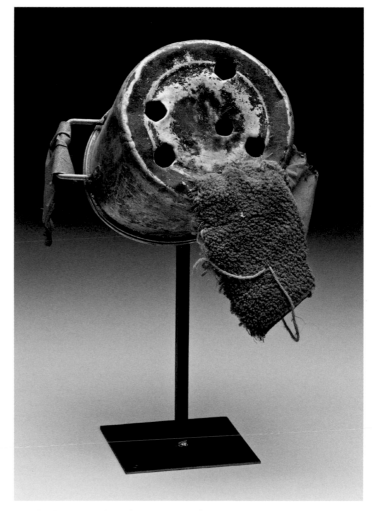

Hawkins Bolden, untitled (assemblage with cooking pot and carpet), c. 1965–2005; Collection of Harvey and Marjorie Freed, IL.

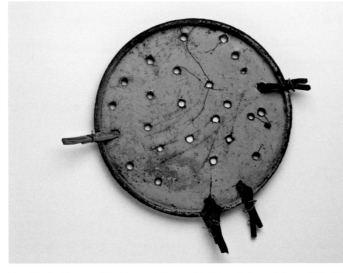

Hawkins Bolden, untitled (assemblage with blue oil drum lid), c. 1965–2005; Collection of Scott Ogden, NY.

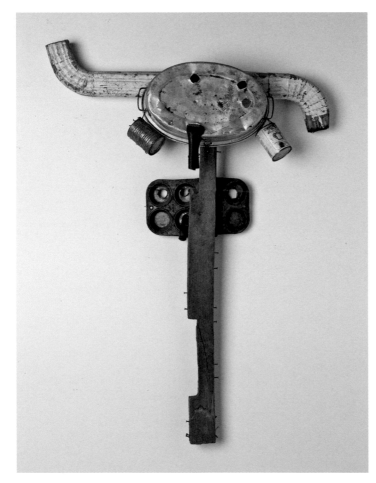

Hawkins Bolden, untitled (scarecrow assemblage with gutter pipe), 1988; Collection of William Arnett, GA.

and videotaping interviews with him in 1986, the same year she introduced Bolden to Arnett, the pioneer collector of his art. McWillie also curated the first exhibition to include examples of Bolden's work, *Another Face of the Diamond: Pathways through the Black Atlantic South*, which opened in 1989 at New York's INTAR Latin American Gallery.

The interest in Bolden's yard coincided with the expansion of Memphis and urban renewal that impacted Bolden's scavenging forays. As the city became cleaner and more gentrified, Bolden found fewer materials to work with. He commented on the intensive commercial development of his neighborhood and its effect on his working process at the time, telling Arnett:

> I used to find stuff in the streets, in the alleys, where people throwed it away. People don't throw nothing away no more. Everything is worth money now. I can't go in the streets; too many cars now. The garbage men used to give me stuff 'cause they knowed I would make use of it. They don't give me nothing no more. I used to get the children around here to find me stuff. They won't do that now.[15]

In the absence of the kinds of materials he had been accustomed to finding or otherwise acquiring from nearby sources, Bolden began to accept materials brought to him by some of the other collectors and art dealers who visited him after his art-world debut, according to Arnett, who continued to visit Bolden into the early 1990s but stopped acquiring new examples of his work. Arnett also recalls that at least one other member of Bolden's family began to assist in assembling the sculptures during this late period. These developments radically changed the look of the work, leading to the apparent emergence of a "new, postmodern Bolden," in Arnett's words.[16] Works at least attributed to Bolden continued to be produced for a few more years after Arnett's last visit to the artist's home around 1993, at which time Arnett recalls observing that Bolden's physical strength was clearly diminished and the pace of his activities noticeably slower.[17]

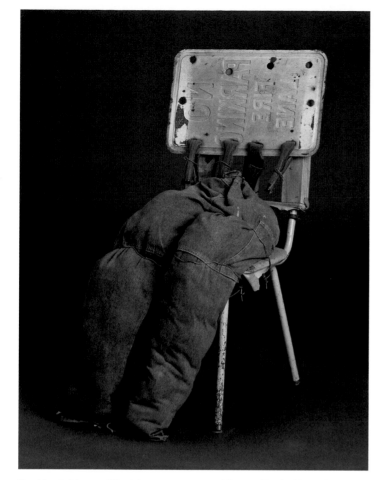

Hawkins Bolden, untitled, (scarecrow assemblage with chair), c. 1987; Collection of William Arnett, GA.

The inherently ephemeral nature of Bolden's work eventually sentenced his organic, outdoor installation to the common fate of yard shows and none of his figures remain there today. Thanks to international interest in his work during his late years, individual masks and figures that were originally part of the environment have been preserved in a number of collections and included in numerous exhibitions.

Bolden evidently enjoyed the attention of visiting insiders from the contemporary art world, and he no doubt appreciated receiving money in exchange for his "scarecrows," but he knew nothing of visual art and literally lacked the capacity to perceive it. But by the same token, he had taught himself to "see" an internal world that was equally inaccessible to even the most receptive viewers of his work. With their multiple, empty, hole-punched eyes and their wagging, ragged tongues, Bolden's rough-and-ready creations speak forcefully of the singularity and power of his perceptive abilities. These stark sentinels bear striking witness to the words of his sister Elizabeth: "He just always knowed things, see or not."

1. Hawkins Bolden, quoted in William Arnett, "Hawkins Bolden: Insight," in William Arnett and Paul Arnett, *Souls Grown Deep, Vol. II* (Atlanta: Tinwood Books, 2000), 151.
2. Biographical information on Hawkins Bolden referenced herein is distilled from the following published sources: *Another Face of the Diamond: Pathways through the Black Atlantic South* (New York: INTAR Latin American Gallery, New York, 1989), 45, 61; *Next Generation: Southern Black Aesthetic* (Winston-Salem. N. C.: Southeastern Center for Contemporary Art, 1990), 11, 131; and William Arnett and Paul Arnett *Souls Grown Deep*, 17, 148–61.
3. Hawkins Bolden, in *MAKE*, a film by Scott Ogden and Malcolm Hearn, 2008. See www.makedocumentary.com. Elsewhere Bolden recounts a different version of this story, attributing to a niece the suggestion that he place his constructions in his garden to keep the birds out; see William Arnett, "Hawkins Bolden: Insight," 148.
4. Elizabeth Williams, quoted in William Arnett, "Hawkins Bolden: Insight," 148.
5. Bolden, quoted in Ibid.
6. Williams, quoted in Ibid., 151.
7. Julius Stephen Kassovic, "Junk and its Transformations," *A Report from the Center for Folk Art and Contemporary Crafts* 3, no. 1 (1992): 1.
8. Richard J. Powell, "Traditions and Tributaries," in *Next Generation*, 27.
9. Williams, quoted in Robert Farris Thompson "The Circle and the Branch: Renascent Kongo-American Art," in *Another Face of the Diamond*, 45. Thompson compares Bolden's work to African and African American yard and grave decoration. Also see Maude Southwell Wahlman "David Butler: Spirit Shields," in William Arnett and Paul Arnett, *Souls Grown Deep*, 144. Wahlman observes that Bolden's use of cut and twisted metal—like Butler's—resembles traditional Caribbean metal work. Also see William Arnett, "Hawkins Bolden: Insight," 158, for the comparison to Kongo *minkisi* (plural form of *nkisi*) charms.
10. Bolden, in *MAKE*.
11. Bolden, quoted in Thompson "The Circle and the Branch," 61.
12. William Arnett, "Hawkins Bolden: Insight," 158. Also see Paul Arnett, "Facing X Tradition," in *Souls Grown Deep*, 17.
13. Grey Gundaker and Judith McWillie, *No Space Hidden: The Spirit of African American Yard Work* (Knoxville: University of Tennessee Press, 2005), 153.
14. McWillie, e-mail exchange with Tom Patterson, April 21, 2009.
15. Bolden quoted in William Arnett, "Hawkins Bolden: Insight," 158.
16. William Arnett, phone conversations with Tom Patterson, April 21 and 22, 2009.
17. Ibid.

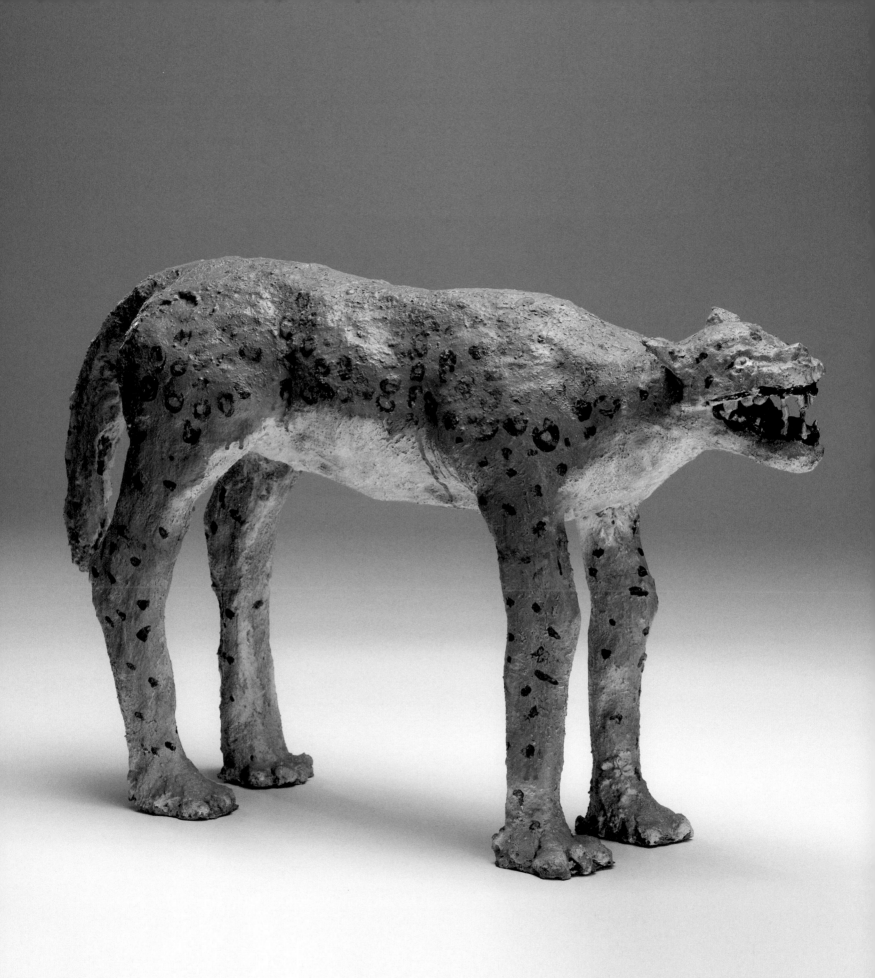

Vernon Burwell, 1985; photo:
Tom Patterson.

OPPOSITE: Vernon Burwell, untitled
(leopard), c. 1982; John Michael
Kohler Arts Center Collection, Gift of
Cavin-Morris Gallery, NY.

**Complete object information is
available in the Catalogue of Works.**

VERNON BURWELL (1916–1990)
Celebrations in Painted Concrete
by Tom Patterson

Vernon Lee Burwell was born to African American parents who
sharecropped a farm in Edgecombe County, North Carolina, between
Rocky Mount and Tarboro. With its dense river swamps, sparsely
populated towns, and vast stretches of low-lying sandy farmland, this
eastern part of the state is a region of haunting beauty and widespread
economic deprivation. Growing up in such an environment was a
challenging experience for Burwell, especially after he was orphaned
at thirteen. His life would be defined by hard work, but in his retirement
he turned his strong work ethic to artistic purposes, creating for himself a
small domain of painted concrete sculptures.

During most of Burwell's life, the counties between the Atlantic
Coast and Raleigh were economically sustained primarily by tobacco
farming and textile manufacturing. That began to change dramatically,
however, during his final years, when the emergence of globalization, job
outsourcing, and smoke-free environments exacerbated the economic
hardship that had long been a problem in this part of the state.[1] As in
most of the American South, black citizens in eastern North Carolina have
historically felt the effects of economic hardship disproportionately; it is
one of the plantation-era slave-holding system's more enduring legacies,
symptomatic of the white racism that remains culturally entrenched in
the region.

After slavery's abolition and the post-Civil War Reconstruction era,
several generations of rural-dwelling African Americans in North Carolina
and the other former Confederate states were relegated to lives of
glorified enslavement as sharecroppers, destined to spend their lives
pinching pennies while planting and picking tobacco and other crops by
hand in exchange for modest shares of the harvest. Breaking that

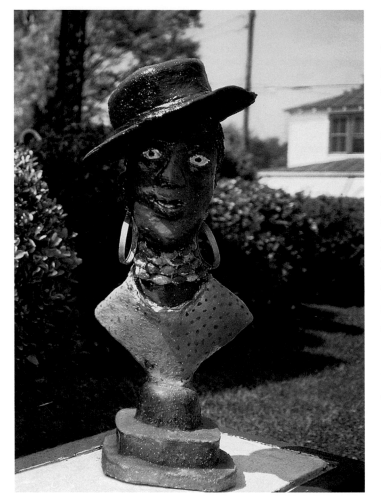

Vernon Burwell, untitled (lady in a red hat) (site view; Rocky Mount, NC), 1985; photo: Tom Patterson.

Burwell was twenty-six when he married in 1942. Attention to his new responsibilities as a husband and soon-to-be father probably drove his decision to seek employment with the Atlantic Coast Line Railroad, which hired him as a maintenance worker in 1943. It turned out to be a practically beneficial move, freeing him forever from farm labor and yielding a career that would provide financial support for his growing family in subsequent decades; he and his wife eventually raised five children together. After repeated workplace demonstrations of his self-acquired mechanical aptitude and other manual skills, Burwell exchanged his janitorial job for a position as a mechanic's assistant. The new position gave him valuable experience maintaining and repairing diesel-train engines and locomotives, as well as welding and pipe fitting. This specialized work brought him and his family to Waycross, Georgia, where he extended his previously rudimentary formal education by attending night school. In 1966, he was promoted to the rank of mechanic in the railroad's diesel locomotive shop, eventually advancing to become a master mechanic—a post he held until diabetes forced his retirement in 1976.

By that time, Burwell and his wife had returned to North Carolina and settled into a modest, red-brick ranch house on a corner lot in an all-black suburb of Rocky Mount. With unaccustomed time on his hands as his first post-retirement Christmas approached, Burwell decided to decorate their yard for the holiday with a three-dimensional Nativity scene. Using only wet cement, he fashioned crude effigies of Mary and Joseph on their knees alongside the baby Jesus. Having presumably derived some special satisfaction from the effort, he set about making additional sculptures. Because the Nativity figures proved to be fragile, he began experimenting with internal armatures to render his subsequent pieces more durable. Wet cement, applied over rough skeletons of wire and metal pipes, would remain the primary material of his latter-day art career.

After the cement cured and hardened, Burwell painted his sculptures with naturalistic shades of auto-body enamel. His manual skills and his close observation of the world around him served him well in this new endeavor, making up for his lack of art training. His

pattern—escaping the farm for a more exciting life and rewarding line of work—was a bottom-line life goal for many Southern blacks of Burwell's generation.

After the deaths of his parents, Burwell had no fixed home for the remainder of his teenage years, during which he lived for varying periods of time with seven different farm families in the area. Under the circumstances, he may have found the concept of an immortal heavenly father and an ultimate heavenly home particularly attractive. He committed himself early on to Christianity and at sixteen joined the Missionary Baptist Church, an institution to which he would remain devoted and in which he would serve as a deacon during the last half of his life.[2]

figures are rough and cartoonish, but they reflect an intuitive grasp of basic anatomical structure as well as the nuances of posture and facial expression. They also evidence Burwell's sense of humor and the sheer pleasure he evidently took in making them. The well-known individuals who are often the subjects of his portraits are usually quite easy to recognize, indicating the extent of his observational powers and skill at manipulating his materials.

Some of Burwell's earliest sculptures became focal points of an outdoor display he created soon after beginning his art career. In the center of the yard in front of his house, he installed a pair of bald-eagle effigies with outstretched wings, as if they were about to take flight from the homemade pedestals to which they were affixed. In the side yard next to the driveway, he installed four larger pieces—full-figure portrait sculptures of Sojourner Truth, Martin Luther King Jr. astride a rearing horse, Jesus holding the Lamb of God, and Abraham Lincoln wearing a stovepipe hat—arrayed in close proximity and facing the street, like sentinels watching over the neighborhood.

Burwell's outdoor display shared common thematic ground with the installation of commemorative roofing-tin paintings by Sam Doyle (1906–85) surrounding Doyle's house in Frogmore, South Carolina, as well as the environment known as the "African American Heritage Museum & Black Veterans Archive," created by Dr. Charles Smith (b. 1940) in and around his home in Aurora, Illinois.[3] Although Burwell's yard never became as densely installed as Doyle's or Smith's, he similarly used his more modest yard display to celebrate African American history, including portraits of Truth, King, and the slave-emancipating Lincoln. In keeping with this theme, Burwell likely intended the pedestal-mounted eagle sculptures in his front yard to be icons of freedom.

Like the portrait sculptures in his yard, many of Burwell's freestanding works depict historical or mythological figures he considered heroic or otherwise exemplary. In addition to celebrating African American life, he paid tribute to President Ronald Reagan and other twentieth century leaders. Other subjects included a Crucifixion sculpture roughly half life size; a standing full-figure portrait of an anonymous Vietcong guerrilla soldier;

sports heroes; and women wearing bikinis or fancy hats.[4] In addition to his figural sculptures, Burwell made a few concrete tombstones and experimented with concrete furniture, although the furniture pieces proved to be impractically heavy. To reduce the weight of his freestanding sculptures, he sometimes employed plastic soft-drink bottles in the armatures, but that option did not provide the strength required for the furniture.

In addition to the eagles he sculpted for his front yard and a small kangaroo he incongruously installed alongside Christ and Lincoln in the side-yard tableau, Burwell created a number of freestanding animal sculptures, including several chickens, a

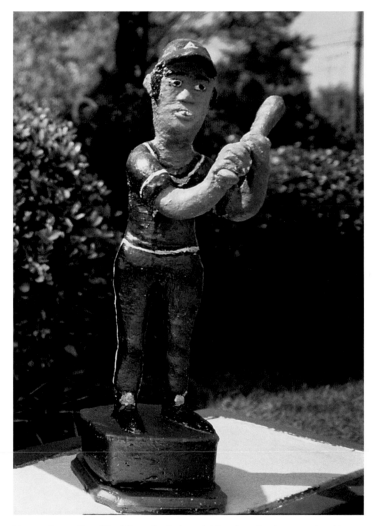

Vernon Burwell, untitled (baseball player) (site view; Rocky Mount, NC), 1985; photo: Tom Patterson.

39

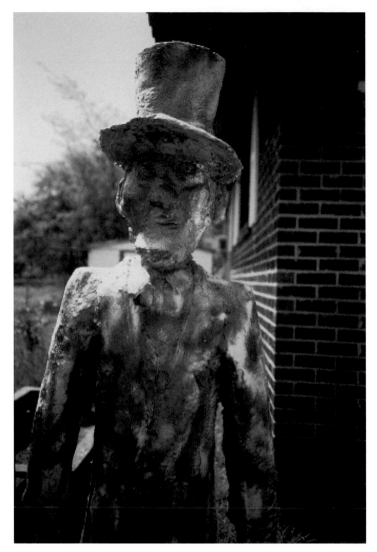

Vernon Burwell, untitled (Abraham Lincoln) (site view; Rocky Mount, NC), 1985; photo: Tom Patterson.

As with the leopard and his other freestanding pieces, Burwell initially used naturalistic colors to paint the group of figures alongside his driveway. This display attracted his first collectors, who began visiting him and buying his work in the late 1970s. In the 1980s, Burwell turned his garage into a veritable gallery of freestanding pieces made to sell. After one collector showed him photoreproductions of iconic bronze sculptures in an art book, Burwell repainted his yard sculptures, uniformly covering them from head to toe in metallic gold paint, evidently to mimic the bronzes, as if thereby to ensure their status as serious works of art. Eventually Burwell returned to using more varied naturalistic color schemes in painting his works, but he let the gold paint remain on the sculptures alongside his driveway.[6]

The jungle cat motif—one of few he repeated—may have struck a chord with Burwell as a symbol of African heritage and pride, an animal of strength, perseverance, and a kingly domain over the land. Thornton Dial Sr. (b. 1928), an African American artist from Bessemer, Alabama, found the symbol of the African tiger to be so powerful that it became a recurring theme in his densely expressionistic relief paintings: the agile cat who will always land on its feet.[7] Burwell, however, never made any such claims and generally had little to say about his work. Nonetheless, he clearly delighted in making his sculptures and showing them off to collectors and other appreciative visitors. He also recognized that his artistic endeavors set him apart from his neighbors. As he told one visitor, "Rocky Mount don't know too much about what I'm about."[8]

The outdoor sculptures that initially attracted visitors to Burwell's home remained in situ at his death nearly twenty years ago, but their subsequent fate is unknown even among the most dedicated collectors of his work. Attempts in recent years to contact members of Burwell's family for information about these sculptures have proven unsuccessful.

monkey wearing red overalls, and a number of cats—house cats and jungle felines such as the black-spotted orange leopard in this exhibition.[5] Burwell's treatment of his animals' postures and features is so nuanced and animated that each of them—the cats in particular—projects a sense of individual personality. The leopard's distinctions include its sturdily elongated legs, big-toed feet, and relatively small head, tilted to one side as it flashes an open-mouthed grin that would make it look tame and friendly if not for its long, menacingly fanglike teeth.

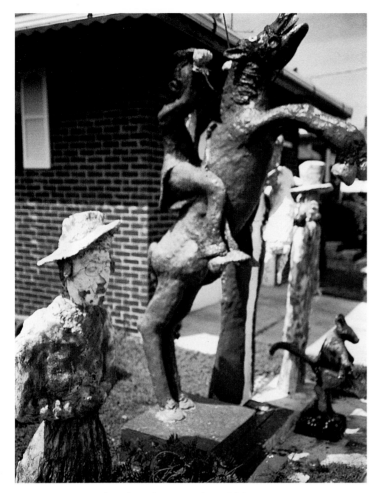

Vernon Burwell, untitled (Martin Luther King Jr.) (site view; Rocky Mount, NC), 1985; photo: Tom Patterson.

Vernon Burwell, untitled (Jesus) (site view; Rocky Mount, NC), 1985; photo: Tom Patterson.

1. Economic development statistics maintained by the North Carolina Department of Commerce indicate that the part of the state west of its coastal counties and east of Raleigh (the state capital) lags far behind more populous sections of the state in per-capita income and other economic indicators. Information on the department's Web site ranks Vernon Burwell's native Nash County as one of the state's poorest. See www.nccommerce.com/en/CommunityServices/FindDataWithEDIS/.

2. Biographical information on Burwell referenced herein is distilled from conversations between Tom Patterson and the artist during several visits to Burwell's Rocky Mount home between 1984 and 1988 as well as from the following published sources: Roger Manley, *Signs and Wonders: Outsider Art Inside North Carolina* (Raleigh: North Carolina Museum of Art, 1989), 21; Jonathan Williams, "Le Garage Ravi de Rocky Mount: An Essay on Vernon Burwell," in *Souls Grown Deep*, vol. 1 (Atlanta: Tinwood Books, 2000), 124–25; and *A Stranger to Himself*, the unpublished manuscript for an illustrated collection of writings by and about Robert Lynch (1947–89), edited and introduced by Roger Manley in 1990 on commission from North Carolina Wesleyan College in Rocky Mount, which purchased the Lynch Collection of Outsider Art shortly before Lynch's death. Lynch was a pioneering collector of works produced by Burwell and other self-taught artists in eastern North Carolina.

3. Lynne E. Spriggs, *Local Heroes: Paintings and Sculpture by Sam Doyle* (Atlanta: High Museum of Art, 2000); Leslie Umberger, *Sublime Spaces & Visionary Worlds: Built Environments of Vernacular Artists* (New York: Princeton Architectural Press, in association with the John Michael Kohler Arts Center, 2007), 358–79.

4. Burwell's Crucifixion and his Vietcong guerrilla are among his works in the Lynch Collection of Outsider Art at North Carolina Wesleyan College in Rocky Mount.

5. Dating from the early 1980s, Burwell's monkey wearing overalls stands upright and open-mouthed as he devours the peeled banana he holds in one hand. Titled *Happy*, this piece is in the collection of the late poet-publisher Jonathan Williams, as are a pestered-looking black and white housecat and a bust of a black sheriff, both also sculpted by Burwell. (The Williams collection is now owned by poet Thomas Meyer.)

6. The anecdote about the collector who inadvertently prompted Burwell to repaint his outdoor sculptures of Sojourner Truth, Martin Luther King Jr., Jesus, Abraham Lincoln, and the little kangaroo in a uniform gold coating offers a cautionary example of the influence—sometimes entirely unintended—that collectors can exert on self-taught artists with scant exposure to the art world. After seeing the newly gold-painted outdoor pieces for the first time, the collector deeply regretted showing Burwell the art-book images. This account came from another early collector and scholar of Burwell's work, folklorist-photographer Roger Manley, in e-mail correspondence with Tom Patterson, December 13, 2007.

7. See Amiri Baraka, Thomas McEvilley, Paul Arnett, William Arnett, et al., *Thornton Dial: Image of the Tiger* (New York: Harry N. Abrams, 1993).

8. Williams, "Le Garage Ravi de Rocky Mount: An Essay on Vernon Burwell."

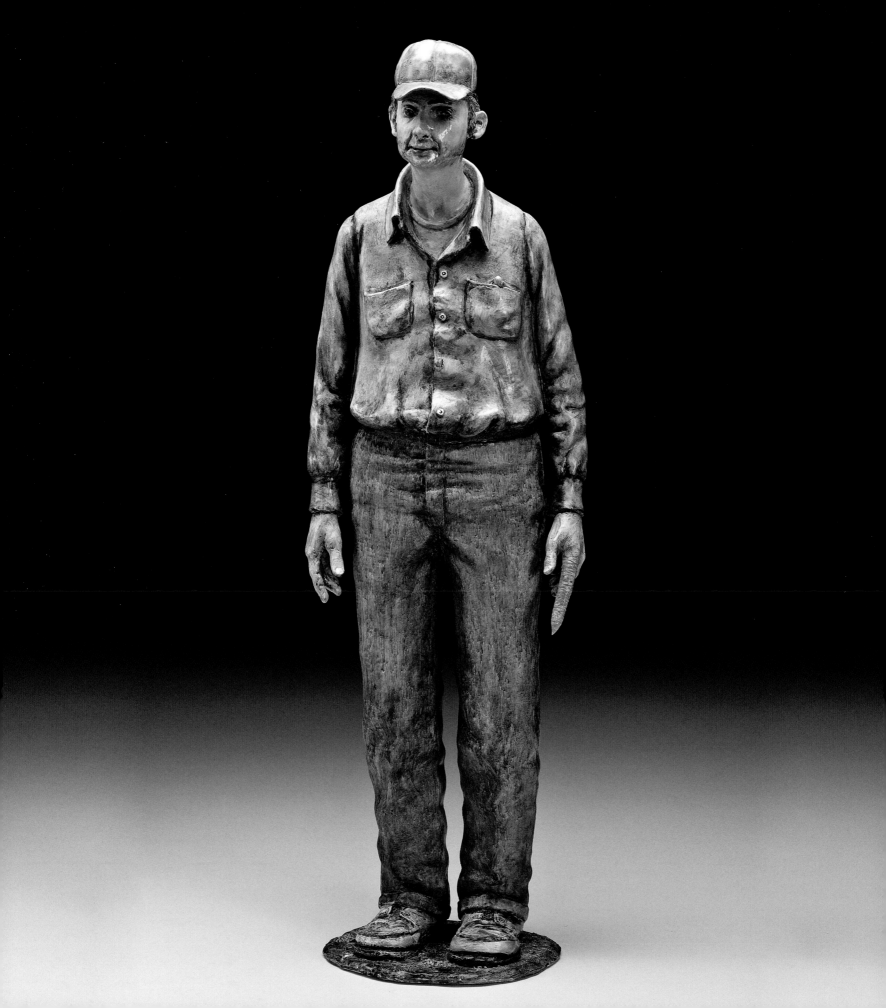

Jack Earl, 1976; photo: John Michael Kohler Arts Center.

OPPOSITE: Jack Earl, *Carrot Finger*, 1981; Collection of the Racine Art Museum, WI, Gift of Karen Johnson Boyd.

Complete object information is available in the Catalogue of Works.

JACK EARL (born 1934)
No Place Like Home
by Leslie Umberger

Jack Eugene Earl is an American original. The self-dubbed "Ohio-boy" became a seminal figure in the world of American ceramics simply by staying true to his rural roots and honing his skills as a keen observer of people. A natural-born storyteller, Earl did not allow art-world fashions to deter him from celebrating the narrative in his sculptures. His genre scenes and situation portraits range from insightful portrayals to fablelike scenes in which a person might discover that a body part had somehow become a vegetable. Frequently intermingling fantasy with common experience, Earl is a master at reminding us that within the events we take for granted are moments of never-ending mystery and wonder.

Earl, the middle of three children, was born in Uniopolis, Ohio, in 1934. His father was a welder in a school bus factory and his mother stayed at home and raised the family. Art was not a part of the family scene, but Earl took to drawing as a boy, mostly copying illustrations in adventure novels or comic books.[1] In high school, he met an art teacher who encouraged him to pursue a career in art education. Earl says he took the recommendation seriously, as art "was the only thing that everyone said I could do well."[2] Earl biographer Lee Nordness has observed:

> A fractious journey to "understand art" awaited: years passed heavily before Jack, sequestered in a Midwest aboveground underground, frustrated that no one could "explain art," would discover himself what initially could never be conceivable: the meaning and reality of art (nonverbal states) lay in the meaning and reality of himself (nonverbal states).[3]

Despite the fact that art was uncharted territory for the family, the Earls supported their son, believing that teaching might offer a better life than

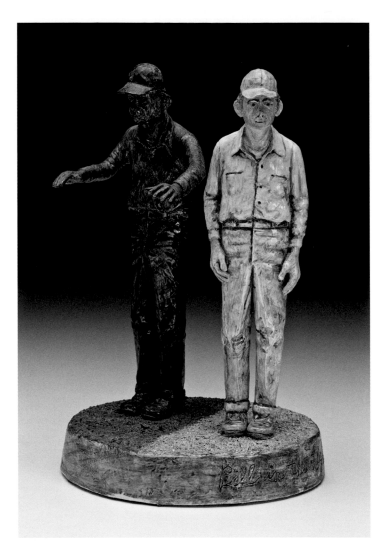

Jack Earl, *Bill in the Light and Bill in the Dark*, 1981; Collection of the Racine Art Museum, WI, Promised gift of Karen Johnson Boyd.

Roy Hanson, would become an iconic character in the narrative oeuvre that had yet to blossom. When Earl graduated, he was offered a job teaching art and English at New Bremen High School. Earl barely kept ahead of his students on the English front but was excited at the prospect of initiating the school's first art department. The tiny department became a creative center for Earl and a number of students. "Working with young people made Jack aware of the fragility of the creative impulse, how readily inventiveness dissipates when performance formulas are rubberstamped on the young," Nordness noted.[4] It was at New Bremen that Earl's respect for the spontaneous over the intellectual began to clearly emerge.

Five years, three children, and a second high-school teaching position later, Earl had begun to ponder his own practice as an artist. He felt isolated and undereducated in the field of ceramics; his desire to return to school became acute. Earl enrolled in extension classes at Miami University in Oxford, but they did not satisfy his thirst to learn the history of ceramics as well as to be introduced to new directions from other serious artists. He took non-credit classes at the Dayton Museum of Art but met with similar disappointment. Leaving his young family behind for three months, Earl enrolled in a summer course of study at Ohio State University in Columbus, a trial that would serve as his entrance exam for its graduate program in ceramics.

Tackling the work that was in vogue in university ceramics programs, Earl became conversant in the making of Japanese-style tea bowls and pots, saki cups, and other Zen-influenced functional wares. He was accepted into the graduate program, and the family relocated. In graduate school he was exposed to visiting artists who would become lasting names in craft media. Harvey Littleton, better known for his work in glass in later years, Toshiko Takaezu, and Peter Voulkos brought their ideas to the table. Earl was impressed by the range and dynamism of the artists working in ceramics.

Earl's thesis work was largely naturalistic, Japanese-style stoneware with several pieces tending toward the sculptural over the functional—an idea that Voulkos had implanted. In 1964, Earl was offered a position at the Toledo Museum of Art's School of Design. He continued to meet cutting-edge ceramists and was

factory work. In 1952, Jack Earl enrolled in Bluffton College near Lima, Ohio. His professor introduced him to various artistic practices, but it was ceramics that struck a chord. Earl learned to throw pots on a handmade wheel composed of a washing machine motor and a belt that had two speeds: on and off. College-level ceramics courses would not become commonplace until the 1960s, so Earl felt fortunate to have stumbled upon the experience Bluffton offered.

Before graduating, Earl married the daughter of a preacher he had long respected, a man who had recently divorced and subsequently felt obliged to leave the ministry. His father-in-law,

Jack Earl, *The Midway Diner*, 1981; Collection of the Racine Art Museum, WI, Gift of Karen Johnson Boyd.

Jack Earl, *The Midway Diner* (detail), 1981; Collection of the Racine Art Museum, WI, Gift of Karen Johnson Boyd.

particularly impressed by the fresh work of Rudy Autio, yet Earl still felt his own voice lay dormant.

Around 1966, at a time when narrative work was the anti-fashion in craft practices, Earl came to a turning point. He began to carve, in plaster, small realistic scenes drawn from everyday life. The scenes captured a moment—a couple after an argument, a seated man, thinking. He had a small exhibition of the genre scenes that, to his surprise, commanded a great deal of notice. Much like Earl's drawings—sketches of everyday occurrences accompanied by written narratives—his sculpted genre scenes transformed a simple observation into something contemplative, poetic, even profound. Earl liked the abstract whiteness of plaster, but it was not the right material for the refined result he wanted. Trepidatious of porcelain's reputation as a difficult material, Earl knew he had to take the challenge.

Investigating porcelain led Earl into interesting terrain. He was ignited by the collections of Chinese and European porcelain at the Toledo Museum of Art and believed that he had finally found his niche. He became enamored with the precisely detailed hand-built ships, lions, Buddhas, birds, horses, cottages and milkmaids—all made in a durable material that fired bright white and allowed minute detail. Earl did not ponder how narrative sculpture fit, or did not fit, into the cutting-edge ceramic works that were receiving attention; he simply knew he found a direction that felt natural.

To learn the mechanics of working in porcelain, Earl began with the coil-formed vase shapes he knew well. He was pleased enough with his first two pieces—a vase with handles shaped as a girl's face and a dog's head, and a lidded jar with bas-relief flowers—to submit them to an exhibition at the Everson Museum of Art in Syracuse, New York. The Everson was the first institution to set the goal of establishing an American ceramics collection that ranged from colonial to contemporary. Its juried exhibitions served as a basis for selecting work for the collection. Both of Earl's pieces were accepted into the exhibition; the jar was acquired for the Everson collection and received the Award of Distinction.[5]

In 1968, Nordness had contacted the S. C. Johnson company about supporting a traveling exhibition on the artist/craftsperson. S. C. Johnson's involvement with the arts had already proven to be groundbreaking through a 1963 project with Nordness that had launched a trend and became known as the "American businesses-in-the-arts movement."[6] Paul Smith, then director of the American Craft Museum, partnered with Nordness on the traveling exhibition titled *OBJECTS:USA*, traveling far and wide to unearth the art for the exhibition. Smith remembered Earl from a craft fair that he had judged, although at that time Earl had not yet begun to work in porcelain. Nordness and Smith visited Earl and immediately offered to include his narrative porcelain scenes in the show. The seminal *OBJECTS:USA* opened in 1969 at the National Museum of American

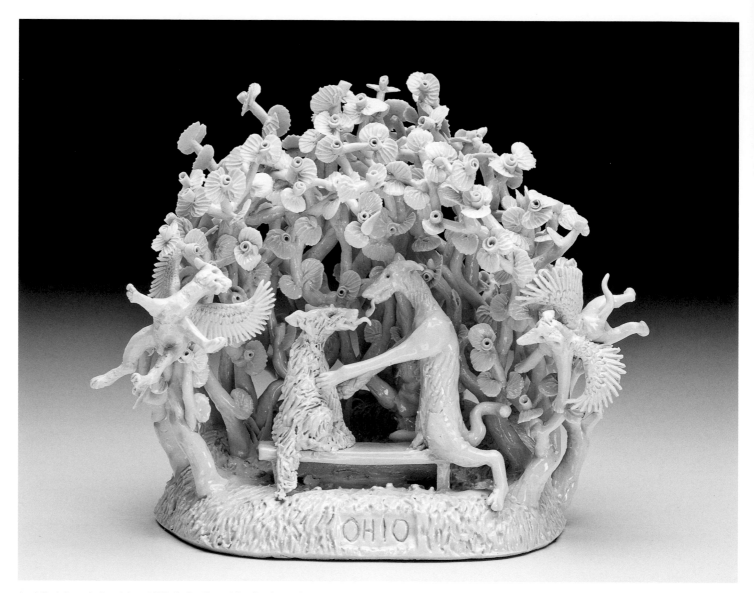

Jack Earl, *Love in the Arbor*, 1975; Collection of the Racine Art Museum, WI, Promised gift of Karen Johnson Boyd.

Art in Washington, D.C., and Earl's *Figure with Bananas* (1968) was on view alongside works of the preeminent ceramists in America—Littleton, Takaezu, Voulkos, and Autio among them. The exhibition was a turning point for the recognition of American craft. "Jack was something else. I remember feeling that actually very few people—if anyone—really understood what he was up to, and later I don't even think they grasped him at the Toledo Museum School—except as a teacher," Smith noted. "There he was in Ohio, figuring it out all by himself."[7]

In 1971, Smith organized a solo exhibition of Earl's work at the American Craft Museum. That same year, then-assistant director of the John Michael Kohler Arts Center, Ruth DeYoung Kohler, curated an exhibition of Earl's work. Kohler ended up driving to Toledo herself to pick up the work directly from Earl, where they spoke of Kohler Co. and the intriguing possibilities of industrial ceramics.

Earl's sculptures had evolved into complex works that ranged in size, scale, and sometimes even color. Although the works were highly descriptive in expression and form, Earl's ebullience

overflowed into long narrative titles such as this one accompanying a portrait of a young lady (1969–70):

> I met Marsha in a bowling alley over in Belle Center about two years ago. I don't remember how we really first met but anyhow she showed me a few pointers about bowling and we had a couple beers. She ask if I wanted to take her home and I ask her where she lived because I didn't have much gas and I didn't have one dollar left to buy any. She said she lived over on 51 and I thought I ought to have enough for that so I said okay. She set real close to me all the way and she put her hand inside my shirt ... that felt real good and I kept thinking about whether I'd have enough gas to make the trip and then I had to pick up the guy that gone bowling with me in the first place and take him home.
>
> I got her home and she ask if I wanted to sit in the car for awhile and I said I'd like to but I had to get back before the bowling alley closed and pick up Tom and take him home. She took her hand out, gave me a pretty long kiss, thanked me a lot and went in the house. After I saw her at the alleys a couple more times we started dating and after a couple of months I figured we ought to get married and we live in a house trailer now and I still got the same job. She is going to have a baby in three months and after we get the trailer paid off we are going to use it for a down payment on a nice house ... until then we store the stuff we don't have room for in her dad's barn.[8]

By 1972, the serious and extensive attention that the narrative sculptures had received resulted in an offer to Earl to head the craft department at Virginia Commonwealth University in Richmond. His long-time goal of living and working among serious artists was coming to pass. He took Ohio with him to Virginia; the Ohio scenes continued to form the basis of his work, and Earl became a master at what Nordness has called "uncomplicated realizations of complicated psychological states."[9] "My stuff is very human," Earl explained. "I get as much human in it as I can. I suppose there are other subconscious comments. And these scenes—they're not necessarily things that happened to me, but they could have happened to me."[10] Therein lies their compelling quality: Earl's scenes are so deeply rooted in the common experience of Middle America that they encompass us all.

At Virginia Commonwealth University, Earl enjoyed the arts community, but ultimately he was put off by the faculty fixations on the conceptual side of art making. He found himself trying to keep up by reading rather than by looking at work, "but it wouldn't matter how many magazines I'd read, I just didn't know how—or even want to learn to speak the language. ... I felt no need to learn it."[11] His long-held dream of dwelling among serious makers was severely tempered by the discovery that a decided preference for the intellectual over the sensory and visceral reigned supreme among his colleagues. Earl turned inward and pondered how he might further his knowledge of porcelain. He recalled his conversation with Ruth DeYoung Kohler about the Kohler Co. Pottery.

Kohler had become director of the John Michael Kohler Arts Center in 1972, and almost immediately she began to curate *The Plastic Earth*, a large-scale survey of contemporary American sculpture, including Earl's work. Kohler Co. funded the exhibition as part of its centennial and collaborated with the Arts Center on demonstrations and discussion about the industrial ceramic processes for the artists attending the 1973 exhibition opening. Although Earl could not participate, he knew about the events and soon after he and Kohler renewed their conversations about the Kohler Pottery. Kohler wanted to begin a residency program in the factory, and she believed that Earl would be the ideal artist to give it a trial run. The Kohler Co. artisans were top-notch, and she knew that the success of any engagement was rooted in their being treated as respected teachers, not assistants to elite artists. Kohler made a proposal to Kohler Co. president Herbert V. Kohler Jr. and found him responsive to the idea.

A four-week pilot residency was arranged for Earl and Louisiana sculptor Tom LaDousa for August 1974.[12] LaDousa

recalled, "When we walked through on the first tour I was a little uneasy looking at all these fine pieces of ceramics and all this wonderful color. A-1 quality everywhere—any blemish whatsoever and the piece was discarded. That high level of achievement was almost scary to me.[13]

Slip-casting expert Clayton Hill became the designated liaison between the artists and the Pottery associates. The rapport between artisan and artists was established quickly. Earl and LaDousa decided to concentrate on the leather-hard plumbingware forms, cutting, carving, reassembling, and adding hand-built parts. They were given an unlimited supply with which they created over one hundred works such as a rocketship fashioned from two toilets and a tooth fairy wagon made from a urinal. "In the beginning the workers, the crews at the driers and sprayers would look at us more than speak to us," Earl recalled. "Later we heard 'Whatcha gonna do with that stuff?' I said we were going to sell it. They understood that."[14] The learning curve was steep for Earl and LaDousa, but their experience was transformative for them and for the Kohler Co. associates. Earl explained:

> Things soon changed. Men would come to us
> saying that they were now seeing the pieces they
> worked with as more than just functional shapes.
> They were developing different kinds of visual
> attitudes. ... Our work became personal to the
> workers because of their involvement with the
> forms we were working on. Soon kiln loaders
> and casters and grinders were making
> suggestions. ... I don't see how a man could
> compete with the factory as a teacher. Not only
> the technical knowledge, but also the pace, the
> life, the energy. I don't feel that the sculpture is
> the most important thing I got out of this
> experience. That was sort of a by-product. The
> important thing was the whole experience,
> something bigger and more important than
> making a sculpture. The effect the workers had
> on us was not minimal, and they certainly gave
> us a lot more than we could give them.[15]

The associates became so engaged that the company asked Ruth Kohler to invite the artists for a second residency over the Christmas holiday, during which Earl used the Japanese Mishima technique to draw scenes on the factory "setters," flat slabs of clay used to prevent warpage in the firing process. Hill's consummate mold-making abilities inspired Earl to ask for a third residency, this time to learn to make molds and slip-cast forms instead of working with those that already existed. In 1976 he was granted a four-month residency. In addition to the complex sculptures he learned to make, Earl made a witty nine-by-thirteen-foot tile mural of the Pottery for its lunchroom that is still in place today.[16] The history of the Arts/Industry residency program owes much to Jack Earl, a program that grew to encompass residencies in the Foundry as well as the Pottery and continues to flourish today.[17]

Not long after his 1976 residency, Earl resigned from Virginia Commonwealth University and the family returned to Ohio. He had not felt comfortable in that intellectual climate, and, moreover, he wanted his kids to marry and settle in Ohio. "I am not a thinker," Earl mused. "I feel things out and do them. I've never sat down and figured out intellectually what I'm saying. When I do sit down to think about what I do, it's a really emotional experience."[18]

At home in Ohio, Earl's genre scenes came into their own. A recurring character called "Bill"—clearly inspired by his

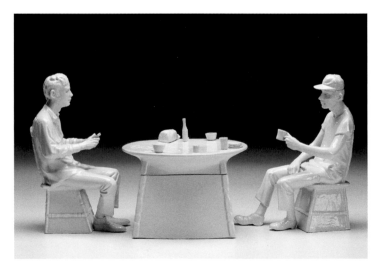

Jack Earl, *Saturday Night in Ohio*, 1976; John Michael Kohler Arts Center Collection.

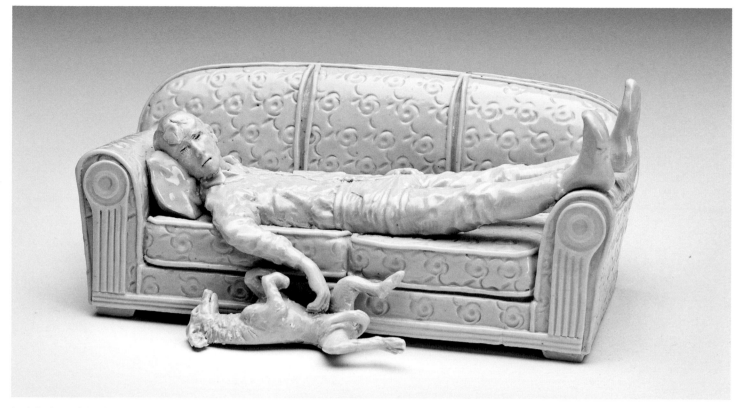

Jack Earl, *Be Right There!*, 1975; Collection of the Racine Art Museum, WI, Promised gift of Karen Johnson Boyd

father-in-law—became an icon of the American individual whose character flaws and idiosyncrasies are precisely what make him special and unique. Earl's scenes borrow in equal measure from the living room and the rarefied world of fine art, as contrasted in two of his much-beloved dog scenes: *Be Right There!* and *Dog Descending the Staircase* (both 1975). Earl's search led him on a circuitous route back to his own backyard. Refuting art-world fashions and, instead, following his heart and mind, Earl has become a living testament to the strength of the individual to succeed on her or his own merits and uniquely embody the American dream.

1. Lee Nordness, *Jack Earl: The Genesis and Triumphant Survival of an Underground Ohio Artist* (Chicago: Perimeter Press, 1985), 11.
2. Ibid., 12
3. Ibid., 220
4. Ibid., 31.
5. Ibid., 65–66.
6. Ibid., 70. Also see Mija Reidel, "Karen Johnson Boyd and the Art of Stealth Philanthropy," *American Craft*, December–January 2009, 46–54. Nordness first worked with Herbert Fiske Johnson and the S. C. Johnson Company on *Art USA Now*, in 1963 and then in 1969 on *OBJECTS:USA*. During these projects, Nordness met Johnson's daughter, Karen Johnson Boyd. In the 1970s, Boyd and Nordness began co-curating a corporate collection for the S. C. Johnson Company council house. In 1982, Boyd founded Chicago's Perimeter Gallery and became a representative of Jack Earl's work.
7. Paul Smith, in Nordness, 69.
8. Nordness, plate 8, 234.
9. Ibid., 89
10. Jack Earl, in Nordness, 94.
11. Ibid., 95.
12. This particular residency was funded in part by a grant from the National Endowment for the Arts.
13. Tom LaDousa, in Nordness, 105
14. Earl, in Nordness, 109.
15. Ibid., 111.
16. Exact measurements are 107 1/2 by 160 inches; the mural consists of 40 tiles at 21 1/2 by 20 inches each.
17. Artists' residencies generally vary in length but average from two to six months. The John Michael Kohler Arts Center and Kohler Co. partner in hosting fifteen to twenty-two artists annually.
18. Earl in Nordness, 220.

General information was drawn from *Ohio Boy: The Ceramic Sculpture of Jack Earl*, exh. cat. (Sheboygan: Wisc.: John Michael Kohler Arts Center, 1987) and *8 Artists in Industry*, exh. cat. (Sheboygan: Wisc.: John Michael Kohler Arts Center, 1977).

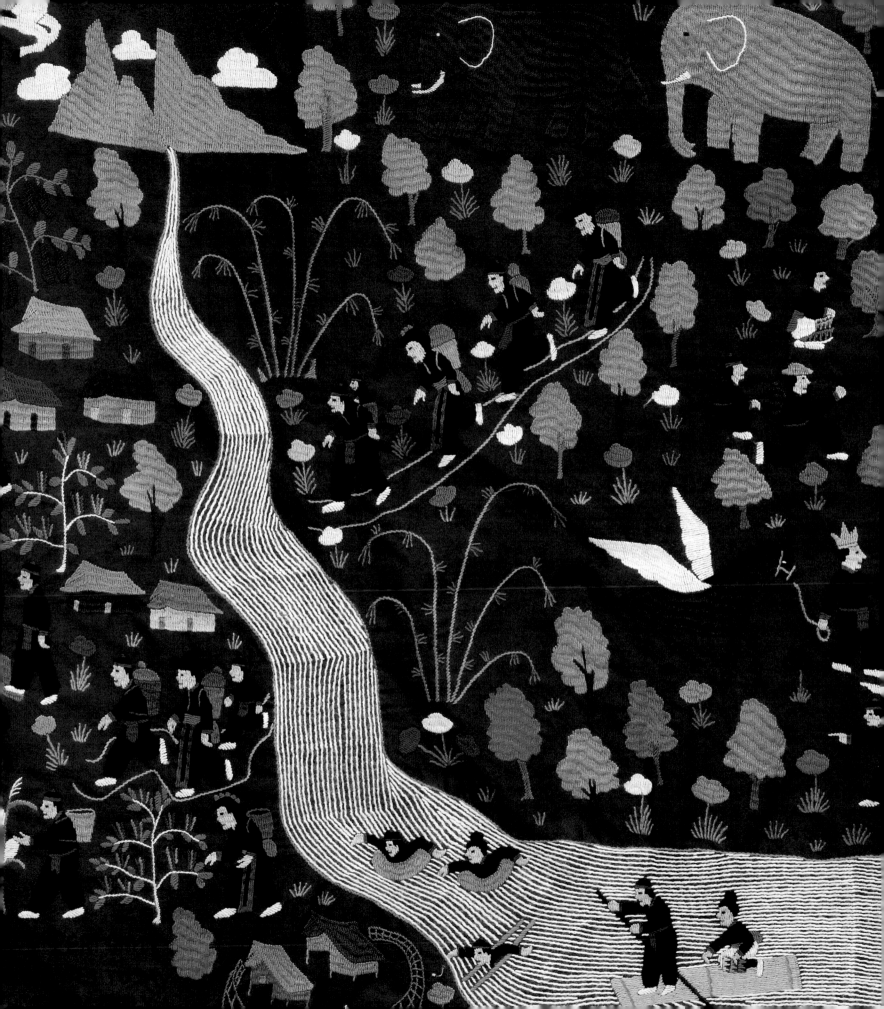

Xao Yang Lee, 2009; photo: John Michael Kohler Arts Center.

OPPOSITE: Xao Yang Lee, untitled storycloth (escape from Laos) (detail), c. 2000–09; Collection of Miroslav "Mick" Anic, WI.

Complete object information is available in the Catalogue of Works.

XAO YANG LEE (born 1947)
A World Away
by Leslie Umberger

In 1977, Xao Yang Lee and her family, along with thousands of other Hmong refugees, escaped from Laos in the aftermath of the Vietnam War. Living in Thai refugee camps for the next eighteen months, Lee, along with many other Hmong women, put their traditional needle-working skills to a new use and began to create "storycloths," embroidered textiles that pictorially described life before and during the war and the Hmong people's subsequent persecution and harrowing escape from remote mountain villages.

For years after the war in Vietnam had officially ended, Laos remained entrenched in battle. Laotian Hmong, called Hmong Lao, had aided the United States during the war, and when Laos fell to Communist rule in 1975, the Hmong faced life in prison camps and worse. Historically, the Hmong were accustomed to being unwelcome in the place they considered home. Their five-thousand-plus-year history in China was marked by discrimination and endless territorial disputes. Mass migrations into Southeast Asia in the 1800s spawned Hmong populations in Vietnam, Thailand, Southeast Burma (Myanmar), and Laos. They lived on lands considered impossible by most, eking out an existence as farmers in high-altitude villages.

The Hmong who settled in Laos were set apart from the myriad other ethnic and language groups who lived in the area. They were regarded as intruders, and their animistic religion—Shamanism—further marginalized them among the largely Buddhist population. They tried to keep to themselves in the highlands but their practice of swidden farming caused them to move with relative frequency to find newly fertile soil.[1] The Hmong way of life in the mountains of Laos remained relatively unchanged for some one hundred fifty years. During World War II, the Hmong supported

the French in defending Laos against the Japanese, but their involvement in modern politics escalated dramatically in 1959 when, in a prelude to the full-scale Vietnam conflict, the United States began recruiting Hmong agents to gather intelligence on the movements of the North Vietnamese.

The United States Central Intelligence Agency (CIA) convinced Hmong Lao that the Communists meant to exterminate or subjugate them, playing into their long-held fears of persecution. Between 1959 and 1973, the CIA secretly backed a Hmong army against the Communist Pathet Lao. America withdrew from Vietnam at the 1975 fall of Saigon and ceased to support the Hmong forces; soon after, Communist forces won control of Laos, and the Hmong became enemies in their own home. The Pathet Lao established "re-education camps," actually prison camps of torture, starvation, and countless atrocities where an estimated one million Hmong, Cambodians, and Laotians were put to death.[2] Villages were bombed with chemicals that killed people slowly and painfully. The Hmong who were able took to the jungle to hide, many of them staying on the move and in hiding for years. Between 1975 and 1980, some 130,000 made it south to the Mekong River, the Thai border.[3]

Xao Yang Lee's husband, Vang Lee, was among those who worked for the CIA, training soldiers and commanding Hmong Lao troops. When Laos fell, Lee lost touch with her husband, whom she never saw again. "I don't know what happened to him; I never saw his body or heard anything about what happened to him."[4] Ber Lee and Tou Moua Lee, Vang's brothers, had already emigrated to the United States and urged Lee to leave Laos with her five children before the situation worsened. The brothers secured help in ushering Lee and the children out; they made it to the Mekong river in 1977 and, clutching bamboo rafts, made it across into Thailand.

For the next year, Lee and her children lived in Nong Khai, a Thai refugee camp. With the little money she had, she was able to buy fabric and thread and resume the needlework she had made her entire life. The material culture of the migratory Hmong was rooted in easily transportable items including clothing, jewelry, weapons, baskets, and musical instruments. Lee, a member of the White Hmong sect of the tribe, learned the traditional Hmong

Xao Yang Lee, untitled *paj ntaub* (red and black flower cloth), c. 2000–09; Courtesy of the artist.

sewing skills when she was just a child. Hmong textile art requires advanced skills in the techniques of embroidery, appliqué, reverse appliqué, and batik, which are passed down from mother to daughter at a very early age. The *paj ntaub* (pronounced "pän dou"), or flower cloth, refers to the brightly decorated costumes

of the Hmong people or the handmade panels that characterize them. Invisible and even stitching, an intricate and symmetrical pattern, striking color combinations, and innovative design motifs are a source of pride for the whole family. Traditionally, the Hmong base their views on a cycle of life, death, and rebirth. This central idea of a continuous life cycle is reflected in the repetition of pattern in concentric abstract designs. Color and pattern are used in tandem to create a figure-ground relationship that visually vibrates, symbolizing the idea that life itself is a balance of opposites: life/death, light/dark, joy/sorrow, bounty/dearth. Geometric and botanical motifs are rooted in a metaphorical connection between the tribe, the natural world, and the spiritual realm.[5]

In refugee camps, food was scarce and, unlike in the mountains, there was no possibility of farming or hunting for more. The missionaries who worked in the camps saw a marketability in the women's needlework pieces and encouraged them to make *paj ntaub* pieces that were larger than those used for the garment panels. Lee was among those who benefited from the income that the saleable flower cloth works brought; it afforded her the ability to purchase both additional materials as well as to acquire, in Thai markets, the additional food her family needed.

Lee does not know which Hmong woman first decided to use her embroidery skills to tell the story of their tribe in pictures, but the idea spread like wildfire among the women in the camps. The story of oppression and persecution that had plagued the Hmong since the prelude to the war had been brimming over in all of them. In the camps, life was hard and their losses were great, yet they were able to speak freely about what they had experienced, compare stories, and share in one another's grief. Storycloths emerged as a strong and lasting record of their experiences, told in visual terms with embroidered images that superceded language to convey meaning.

Hmong refugees lived in the camps for years on end in what could be considered preparation for the dramatic lifestyle changes that would be incumbent on the Hmong to accept in the Western world. Their traditional self-sufficient ways were lost within the regimented confines of the camps; the Hmong were rendered

dependent and idle. Discord arose among family members, especially between generations. Traditionally a patriarchal society, Hmong men were effectively disempowered as the heads of their families. Children, not required to work in the field with their parents all day, ran around together, and respect for their elders diminished. Women still had to look after the children, and they continued to practice their traditional needle arts. These skills would become another way in which the men were distanced from a position of authority in the family, for the women's textiles began to bring in some money—sometimes all the family had. Scholar and historian Lillian Faderman explains:

> *The relief workers convinced the women to sew*
> *for Western buyers who were especially excited*
> *by storycloths that recorded the harrowing exodus*
> *from Hmong villages into Thailand. Sewing*
> *provided about ninety percent of the family's*
> *income in the camps. It gave some occupation to*
> *the husbands who sometimes made preliminary*
> *sketches for the cloths or handled the business*
> *involved with their sale. But it was the women*
> *who were the most profoundly affected by this*
> *commercialization of a skill they had taken for*
> *granted. Their money earning capacity had the*
> *potential of giving them at least a modicum of*
> *uncustomary independence, and thus it was one*
> *more prefiguration of the life they would come to*
> *in the West.*[6]

Lee was more fortunate than most. After a year in Nong Khai she and her children were transferred to the Ban Vinai camp. Since her husband had been well connected to the CIA, the U.S. Government expedited her paperwork and just six months later she was allowed to join her husband's brothers in Fresno, California. In the United States, many Hmong received government aid while trying to find ways to become self-sufficient. Settling in enclaves, predominantly in California, Minnesota, and Wisconsin, Hmong immigrants banded together and organized local organizations that could pool resources, offer mutual support, vocational training,

Xao Yang Lee, untitled storycloth (escape from Laos), 2000–09; Collection of Miroslav "Mick" Anic, WI.

and job placement services, and, ultimately, help keep the older generations—for whom the life change was nothing short of epic—from sliding too deeply into despair.

"The shtetl my mother left in 1914 was in many ways not so different from the Hmong villages of Laos a half-century later," notes Faderman, the daughter of a Jewish immigrant:

> Though the Hmong crossed the Pacific in modern airplanes, they too came from villages where technology had remained unchanged for generations. The strange sights that greeted them when they arrived were multiplied well beyond those of my mother's day: not only did the marvels and intimidations of plumbing and electricity await them, but also large supermarkets stuffed with food, automobiles everywhere, television sets, VCRs, answering machines, compact discs, computers.[7]

Xao Yang Lee, untitled *paj ntaub* (red and yellow flower cloth), c. 2000–09; Courtesy of the artist.

Many accounts from Hmong immigrants tell of family members who could navigate the dense jungle but who thought every corner of a city street looked identical. Lee concurred: "In the mountains I knew my way around. Here I could not find my way."[7] Still, Lee adapted as best she could. She moved to Sheboygan, Wisconsin, to live with a cousin and to be closer to her husband's middle brother, Tou Moua, who was attending school in Chicago. In Hmong traditional culture, a widow is often married to the deceased's brother closest in age—a way of keeping families together and caring for the children and wife of the lost family member. In 1981, Lee and Tou Moua married and settled in Sheboygan. After finishing college in California, Tou Moua's youngest brother, Ber, also relocated to Sheboygan to keep the family together.

Lee began to take English classes and to sell her needlework in the basement of the Episcopal church that sponsored her relocation. Lee's skills served her well; in 1983 she began to participate in art and craft fairs throughout the region. Her skills caught the eye of many, and she began to receive awards and honors for her outstanding skills. "I don't want to lose my culture,"

says Lee, explaining that the textile work is the most vital link she retains.[8] Her husband takes pride in her accomplishments, helping her iron the pieces to ready them for shows and proclaiming that she is the most skilled Hmong artist in Wisconsin.

The younger generations grew into Hmong Americans, caught between two worlds but maneuvering easily enough in each. Lee adapted better than many in her generation. She drives, gets by with English, and participates regularly in craft and art fairs where she sells storycloths as well as discrete sections of the traditional *paj ntaub*. In the United States, Hmong textiles have become steadily more marketable as awareness of the Hmong community has increased. For Hmong American women, easily attainable and affordable materials including cotton and synthetic fabrics, plastic beads, and aluminum have facilitated greater production of works for sale, yet these same factors often make the divide between items made for the market and items made for family quite distinct. Lee explains that she has taught her daughters

Xao Yang Lee, untitled *paj ntaub* (cream and white flower cloth), c. 2000–09; Courtesy of the artist.

wants the tradition to survive."[10] Most days, Lee spends eight hours on her needlework, wanting to do as much as she can while she is still able. She misses traditional life in Laos but is grateful that her children have been able to become educated and successful people in America. "I'm really happy, but I'm really homesick too," Lee explains.[11] Lee would like to go home to Laos for a visit but admits that she probably never will. In her large-scale storycloths, Lee records her memories over and over; the details vary but the storyline stays the same. She has given her children and grandchildren numerous works of art and articles of traditional dress that she has made for them. Lee hopes that after she is gone, the culture will somehow live on, a world away from home.

1. Swidden refers to a slash-and-burn technique wherein the practitioners clear a section of land with fire and farm it until it becomes fallow, at which point they move on and begin with a new piece of land.
2. Ahn Do, Tran Phan, and Eugene Garcia, "Millions of Lives Changed Forever with Saigon's Fall," *Orange County* (California) *Register*, April 29, 2001. Reprinted online, "Camp Z30-D: The Survivors," Dart Center for Journalism and Trauma, www.dartcenter.org/dartaward.org/2002/hm3/01.html.
3. Lillian Faderman, with Ghia Xiong, *I Begin My Life All Over: The Hmong and the American Immigrant Experience* (Boston: Beacon Press, 1998), 10.
4. Xao Yang Lee, conversation with Leslie Umberger, March 27, 2009; curatorial files at the John Michael Kohler Arts Center. General information taken from this conversation and from an interview with Leslie Umberger for the John Michael Kohler Arts Center, April 3, 2009; curatorial files at the John Michale Kohler Arts Center. Xao Yang and Vang Lee were married in 1961.
5. For more information, see *Hmong Art: Tradition and Change* (Sheboygan, Wisc.: John Michael Kohler Arts Center, 1986).
6. Faderman, *I Begin My Life All Over*, 70.
7. Ibid., 83.
8. Lee, conversation with Leslie Umberger.
9. Lee, interview with Leslie Umberger.
10. Ber Lee, acting as facilitator during the taping of the Xao Yang Lee interview with Leslie Umberger, April 3, 2009.
11. Xao Yang Lee, interview with Leslie Umberger.

the traditional skills of cross-stitch and embroidery, but that they tell her the appliqué techniques are too hard for them to master. Her granddaughters have learned some of the skills as well, but prefer to use their sewing machines when they can, and will likely never learn the complex needle skills required for the *paj ntaub*.

Ber Lee notes that his sister-in-law is gravely concerned about the loss of these skills following her generation: "She believes the needlework is the only thing keeping Hmong culture alive; she

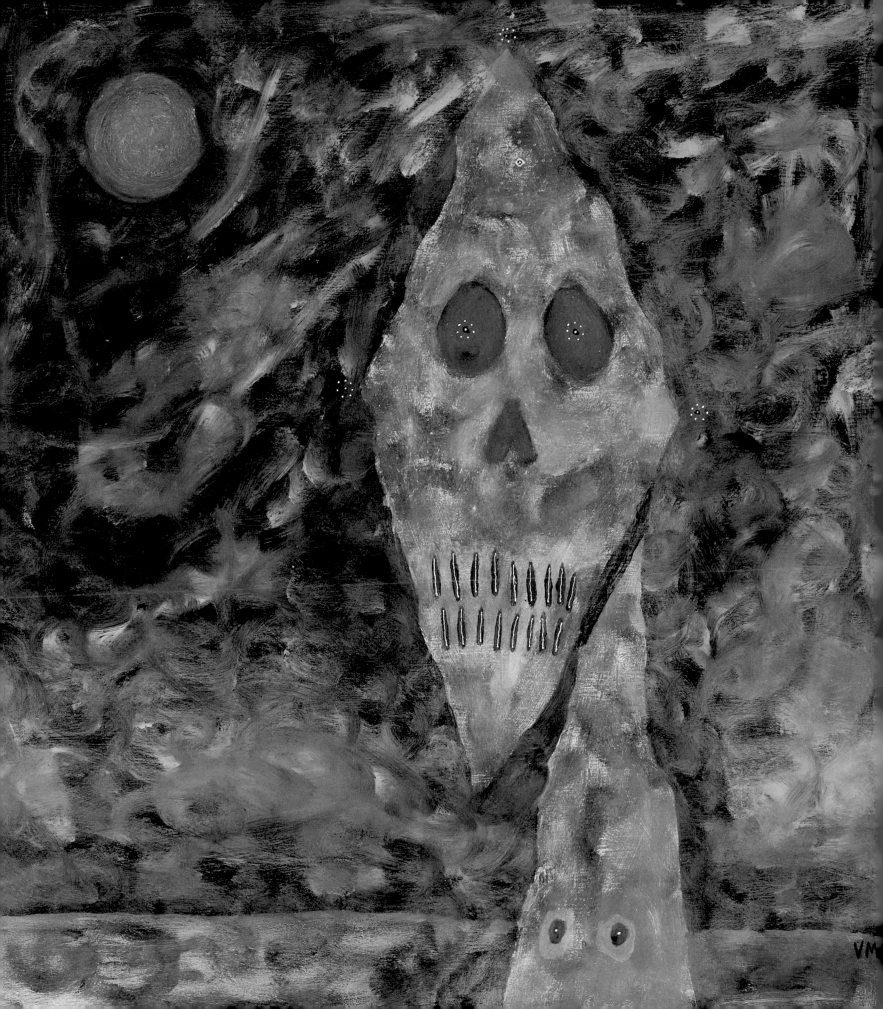

GREGORY VAN MAANEN (born 1948)
House of the Mind
by Leslie Umberger

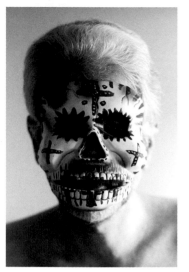

Gregory Van Maanen, 2004; photo: Ellen Denuto.

OPPOSITE: Gregory Van Maanen, *Warrior of the Ashes / Night Spirit with Red Full Moon*, 2000; John Michael Kohler Arts Center Collection.

Complete object information is available in the Catalogue of Works.

Living through war is not the same as surviving. Physical battles give way to internal struggle, and survival is achieved heartbeat-to-heartbeat, hour-to-hour, day-to-day, month-to-month, and year-to-year. Gregory Van Maanen became a master of survival through decades spent negotiating with haunting spirits that accompanied him home from Vietnam. Plagued with bloodied memories, Van Maanen found that peace was attainable only when he used art to release the faces that dwelled deep inside his mind. His paintings—thousands of images featuring skulls, all-seeing eyes, open palms, glowing hearts, and a plethora of personalized symbols of protection and "good magic" peppering both front and back sides—are images of refuge, of solace, of bargaining for every day. Van Maanen has called his artistic practice a "suicide prevention program," an arsenal of tools for keeping harm at bay and the house of his mind clear of shadows.[1]

A carefree and sometimes troublesome youth, Gregory Van Maanen chose Vietnam over jail. The decision would irrevocably alter life as he had known it. Born in 1947 in Glen Rock, New Jersey, into a family of Dutch and Iroquois heritage, Van Maanen had an awareness of the spiritual world from the time he was three, sensing and sometimes visualizing what he could only describe as "fluid, humanoid spirits" in his family's home.[2] He shares his story openly, knowing that some will not believe him and others might question his sanity. But skeptics do not rattle Van Maanen; his experiences are deeply personal.

Much of Van Maanen's boyhood was spent in a wood near his home. There he explored and caught toads, snakes, turtles, and bugs, gathering and arranging bones and skulls left behind by the small forest mammals and birds. Hunting and trapping were part of the culture he knew, and in

those early years he did not think twice about taking an animal's life. Van Maanen saw the choice of going to Vietnam with the United States Army as an exciting opportunity to see a real jungle. Then he got there. "I thought I'd go on the big hunt," he recalls, "hunt the V. C., ya know? Changed my mind in the first two seconds I was there, I fucked up, I had to get out. Didn't belong there, the energy was wrong."[3]

American soldiers sent to Vietnam were ill prepared for what they encountered. "You don't *know* spooky till you been there," writes fellow veteran Tim O'Brien. "Jungle, sort of, except it's way up in the clouds and there's always this fog—like rain except it's not raining—everything's all wet and swirly and tangled up and you can't see jack. ... You just go with the vapors—the fog sort of takes you in. ... And the sounds, man. The sounds carry forever. You hear stuff nobody should *ever* hear."[4] Sondra Varco of the National Vietnam Veterans Art Museum in Chicago, Illinois, explains, "They slept in mud, heat, and monsoon rains. Often they barely got enough to eat; to survive they tried to stay awake through long periods, and often they wore their clothing until the jungle rotted it off their bodies."[5] And then there was the killing: young men face-to-face with an enemy equally young, all of them displaced from the safe or familiar. Varco notes that not all soldiers make it through

Gregory Van Maanen, untitled (altar) (site view; Patterson, NJ), 2006; John Michael Kohler Arts Center Artist Archives.

this kind of continual pressure; some die, some go insane. "Others manage to get through it, though they will never be the same again. Still others develop a fire in their mind that consumes them, and they ingeniously hold onto it for a later time, vowing to themselves that if they live they will fulfill a destiny."[6]

A pivotal event would cause Van Maanen to commit to such a destiny, one of gratitude and expression. Van Maanen traces the course he is on to its fountainhead: February 27, 1969. That night, Van Maanen and squad were on night patrol in Cu Chi, a Vietcong stronghold northwest of Saigon, when they came under heavy fire.[7] Van Maanen ran out of ammunition as the dirt surrounding him exploded with bullets. "Then the mortars started," he recalls: "They came in right on top of us, some as close as four feet away. The soldier next to me was killed immediately. He was right next to me, a nice guy from Newark, a kid, really, like me. Another soldier was pinned beneath him and wounded in the legs. I couldn't get his body off the other soldier, and the mortars kept coming, along with small arms fire and grenades."[8] Van Maanen was hit in the shoulder, an event he would live through only because the Vietcong thought he was dead and did not return to finish him off.

> I was shot into a different dimension. ... Yeah, I, ah, went into a world of light, white light, and it was off the battlefield, total silence, and I heard a male voice—this is during a major battle, right— mortars, small-arms, everything, right on me. And I disappeared off earth into a world of white light, and I heard a male voice very calmly say to me, "Don't worry, you'll talk about this tomorrow," and then I was back. I've never been the same, ever since.[9]

After months of recovery in Japan, Van Maanen was sent back to New Jersey. He made several attempts at holding a job, but the signs of post-traumatic stress disorder (PTSD) that would plague Van Maanen from then on were coming on strong. He was increasingly prone to panic attacks; he was edgy, nervous, and unable to keep his mind or body at ease. In America, the returning

soldiers found no solid ground; blamed by some for fighting and by others for losing—there was no shelter for their private traumas. An artist friend encouraged Van Maanen to take up art as a way of letting the demons out of his head.

The hunter in Van Maanen had died in Vietnam; the man who came home was an avid pacifist. About that night Van Maanen says, "It was also my rebirthday. It turned me from a nasty, stupid kid into a spirit person."[10] O'Brien, who similarly had a near-death experience in Vietnam, has used writing as a way to exorcise the demons ever since he came home. He, too, came into touch with what he, like Van Maanen, calls the "spirit world," acknowledging that once the darkness takes hold of your mind, the imagination takes over. The lucky ones find a release valve.

Van Maanen had made art since he was a child, particularly altarlike arrangements with the feathers and bones he gathered in the forest. The spirits he had glimpsed as a child returned en masse with the spirits of the war dead residing inside his head. Pouring their visages out onto paper, canvas, board, and all manner of objects evolved into an all-consuming obsession. His image-making became both journal and intense therapy. Beginning a practice he continues today, an image of any size first gets a date—it will be a record of thoughts, images, names, demons, memories, and hopes. He works the backs and fronts of his images almost concurrently, sprinkling the shamanistic documents with "magic" in the form of his unique symbolic forms. His initials V and M are interwoven into a personal mandala that visually forms the face of a wolf, his personal totem. Van Maanen calls the work "medicine."

With the support of the GI Bill, Van Maanen went to San Miguel de Allende, Mexico, and enrolled in college. He attempted a normal course of study but PTSD prevented him from being able to focus, crowds often incited panic in him, and he increasingly sought solitude. He was allowed to study independently and, in a challenging time, found the experience rewarding. Throughout the 1970s and into the early 1980s, Van Maanen traveled around Mexico, the United States, and Canada, restless and ever-aware of the spirits of the dead he sensed all around him. In Mexico, he relished the culture's attitude about death, that the dead were

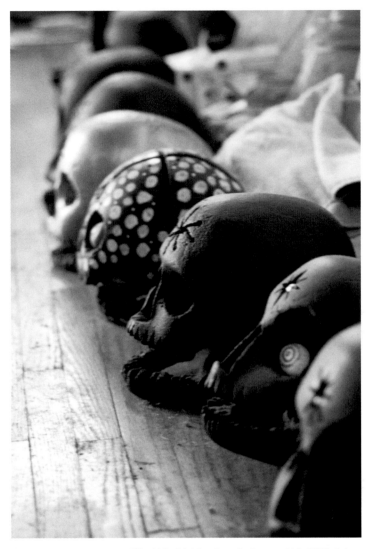

Gregory Van Maanen, untitled (skulls) (site view; Patterson, NJ), 2006; John Michael Kohler Arts Center Artist Archives.

not far away nor were they to be feared; the condition was simply another facet of life.

In 1983, Van Maanen decided to settle near his mother in New Jersey. He found a loft apartment in the town of Paterson, near the bottom of the Great Falls of the Passaic River and an old mill. The place became art studio, bunker, and cocoon. In some ways, Van Maanen never stopped living like a soldier, sleeping on a cot with his clothes in his army duffel bag at the foot of his bed; creature comforts nonexistent. But the energies there soothed him, and over

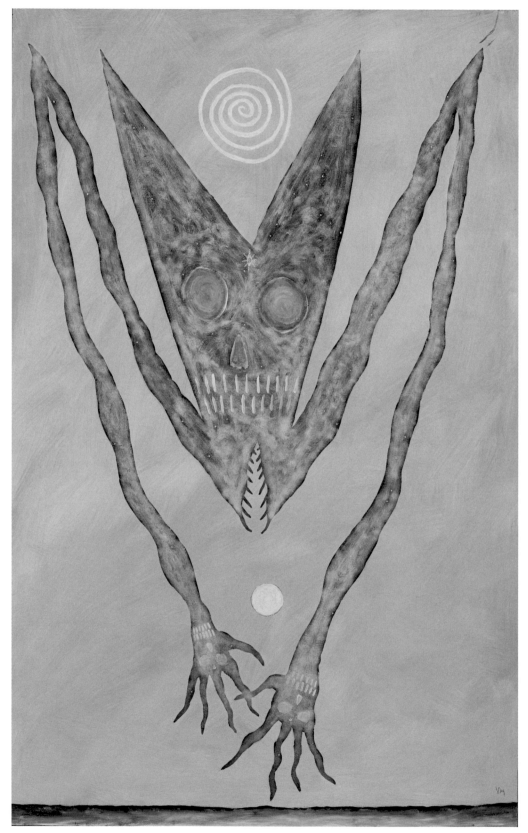

Gregory Van Maanen,
*Wolf / Bat / Loud Spirit with
Moon, Stars, and Symbol,*
1992; John Michael Kohler
Arts Center Collection.

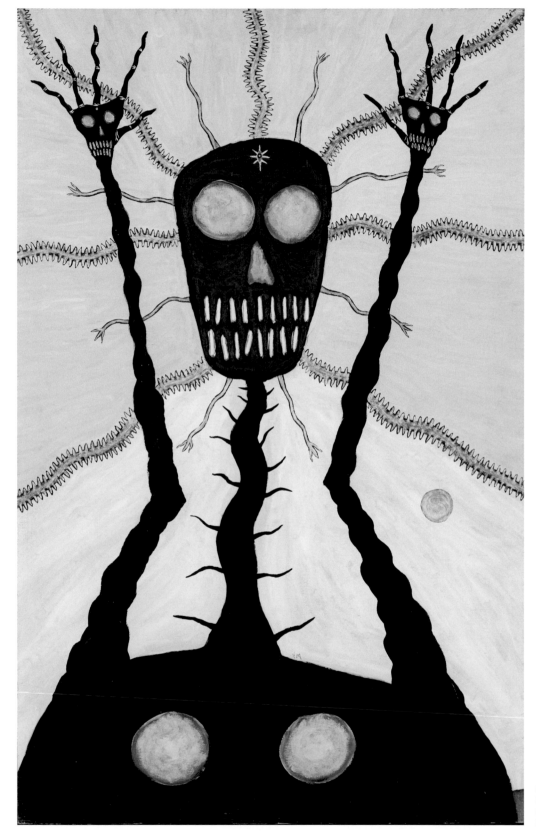

Gregory Van Maanen, *Live Now for Death Takes Care of Itself*, 1992; John Michael Kohler Arts Center Collection.

time, the apartment transformed into an environment dense with altars, symbols, and some four thousand paintings and sculptures.

The positive outlook on death that Van Maanen experienced in Mexico became a critical tool in his daily fight with PTSD. He came to view death as a "time zone," a place of mystery that we all visit at our appointed time, but not a place to fear.[11] While painting, Van Maanen, in a sense, visits that time zone; he feels the spirits travel through him onto canvases that range from haunting to serene. For Van Maanen, these images are cathartic; they are images of forgiveness and letting go. He forgives the bullet that is still fragmented inside his body, and he forgives the enemy soldiers who permanently shattered his peace. The struggle that plagues him still is that of forgiving himself for surviving while comrades did not.

Central to most of Van Maanen's imagery is the skull. Throughout time, skulls have represented mortality. Arguably the most iconic of human symbols, skulls have appeared in art for tens of thousands of years, metaphorically embodying both life and death. A symbol that seems integral to his life, Van Maanen recalls having a fake human skull as a kid, and that, among the bones he collected in the forest, skulls were the clear prize. But after the war, and particularly in Mexico where skulls (*calaveras*) and jovial skeletal forms of the dead figure prominently in the art and culture, the symbol crystallized into something of lasting meaning—the house of the mind.

For almost thirty years, Van Maanen has been charting a dialogue with the visitors in his mind, recording associations, thoughts, and related events on the back of his images to retain those connections in keeping with the image on the front. These writings are accompanied by arcane, painted, magic symbols that are part road map, part dialogue, part record, and part medicine. Van Maanen explains that the inscriptions sometimes describe an event or a memory, and sometimes they name the spirit he understands has arrived in the image.[12]

The environs near the seventy-seven-foot-tall Great Falls became a place of ritual visitation for Van Maanen too. On shores carved by ice some thirteen thousand years ago, near the churning current, he resumed his childhood hunt for bones, feathers, turtle shells, stones, even oddments of trash. Taking his finds home, the ritual of bestowing protection and magic on things burgeoned as he painted each treasure and laid them out in highly regimented arrays. Altars grew in corners, on chairs, on top of the refrigerator, and on shelves in the closet. Thousands of round stones and tiny bones became all-seeing eyes or tributes to amorphous creatures. Ritual became a way of life, a way of charting and processing each day, and a mode of quelling his own restless soul and acknowledging the precious things that had once been flesh and blood. Plain river stones were honored as ancient amulets, polished by immeasurable caresses of the timeless water. In his home, cigarette butts were habitually crossed like crucifixes in the ashtrays, spirit heads in paintings were all turned to face the wall—their voices too loud in concert—objects organized like battalions on counters, windowsills, appliances, closet shelves, and furniture.

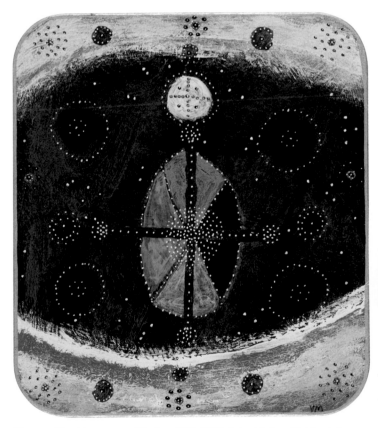

Gregory Van Maanen, untitled, c. 1983–2007; John Michael Kohler Arts Center Collection.

Gregory Van Maanen, untitled (painted stones), c. 1983–2007; John Michael Kohler Arts Center Collection.

PAGES 66–67: Gregory Van Maanen, untitled, 2007; untitled, c. 1983–2007; John Michael Kohler Arts Center Collection.

The act of painting occurred in a ritualized zone in the middle of the floor, a gateway of sorts from which Van Maanen warns guests away: "It's not a place to hang out."[13]

With skulls and bones central to a body of work, one might expect to experience a chilling darkness, something eerie or foreboding. Instead there is a sense of enthralling magic. While a room filled with Van Maanen's art does seem to be crowded with intangible beings, the energy is scintillating, almost thrilling. Colors pulsate, eyes spiral, hearts glow. Sometimes, the image is only a fog, an ethereal haze tinted orange or green; sometimes it is inky black. The skulls are, indeed, a place within which the mind dwells, and Van Maanen's portrayals of them are befittingly architectural, endless variations of a theme akin to both houses and humans. Protruding tongues serve as paths into the interior, stairways into a realm of mystery where one feels, ironically, a welcome guest. "His outlook is tough. His is a feral forgiveness," notes gallerist and writer Randall Morris. "The veteran has survived his anger, gone through the questions with no answers, and has become old enough and wise enough to crack through the fear and loathing with answers of his own. The dead have become buried in the kinder shrouds of memories and the bitter mists they died in have begun to dissipate."[14]

In 2007, Van Maanen decided to move on from the Paterson home that had sheltered him for nearly a quarter century. The PTSD, still an omnipresent reality, was softened by a healthy relationship and subsequent marriage. The Paterson apartment had given itself over to the high order of arranged works of art; Van Maanen was ready to move out of the space that had offered protection for so long and begin anew with his wife. The work contained therein comprised an enormous diary, a chronicle of pain and healing. With the goal of keeping this body of work intact, Kohler Foundation worked with Van Maanen to inventory and document his Paterson home before he and his wife moved to Rochester, New York, later in 2007. The Foundation acquired the entire contents of Van Maanen's Paterson apartment, has since completed the collection's cleaning and conservation, and has given the entire body of work to the John Michael Kohler Arts Center. Van Maanen continues to converse with the spirit world and make art every day.

1. Gregory Van Maanen, quoted in Rebecca Rafferty, "'The Happy Survivor': Exorcising the Demons of War," *Rochester* (New York) *City Newspaper*, February 4, 2009. Accessed online, *www.rochestercitynewspaper.com/entertainment/art/2009/02/ART-REVIEW-The-Happy-Survivor/*, February 5, 2009.
2. Van Maanen, quoted in Stewart Low, "Vietnam War Firefight Brings Out The Spirit of an Artist," (Rochester, New York) *Democrat and Chronicle*, February 1, 2009. Accessed online, *www.democratandchronicle.com/article/20090201/ENT01/902010312/1052/ENT*, February 5, 2009.
3. Van Maanen, interview with Randall Morris for the Kohler Foundation, December 16, 2006; Transcript on file in the John Michael Kohler Arts Center Artist Archives (JMKACAA).
4. Tim O'Brien, *The Things They Carried* (New York: Broadway Books, 1990), 72.
5. Sondra Varco, "Foreword," in *Vietnam: Reflexes and Reflections*, ed. Eve Sinaiko (New York: Harry N. Abrams with the National Vietnam Veterans Art Museum, 1998), 9.
6. Ibid.
7. Van Maanen was a member of the U.S. Army's 1st battalion of the 505th Infantry Regiment, 82nd Airborne Division.
8. Van Maanen, quoted in June Avignone, "The Cure We Wait For," *Sun Magazine* no. 327 (2003), 44.
9. Van Maanen, interview with Randall Morris, JMKACAA.
10. Van Maanen, in Stewart Low, "Vietnam War Firefight Brings Out The Spirit of an Artist."
11. Ibid.
12. Van Maanen, interview with Amie L. McNeel, November 11, 2006; Transcript on file in the JMKACAA.
13. Ibid.
14. Randall Morris, "Gregory Van Maanen: The Wolf Survives," *Chemical Imbalance Magazine* 2, no. 2 (1990): 50–55.

Additional information in this article was drawn from conversations between Gregory Van Maanen and Leslie Umberger between 2006 and 2009.

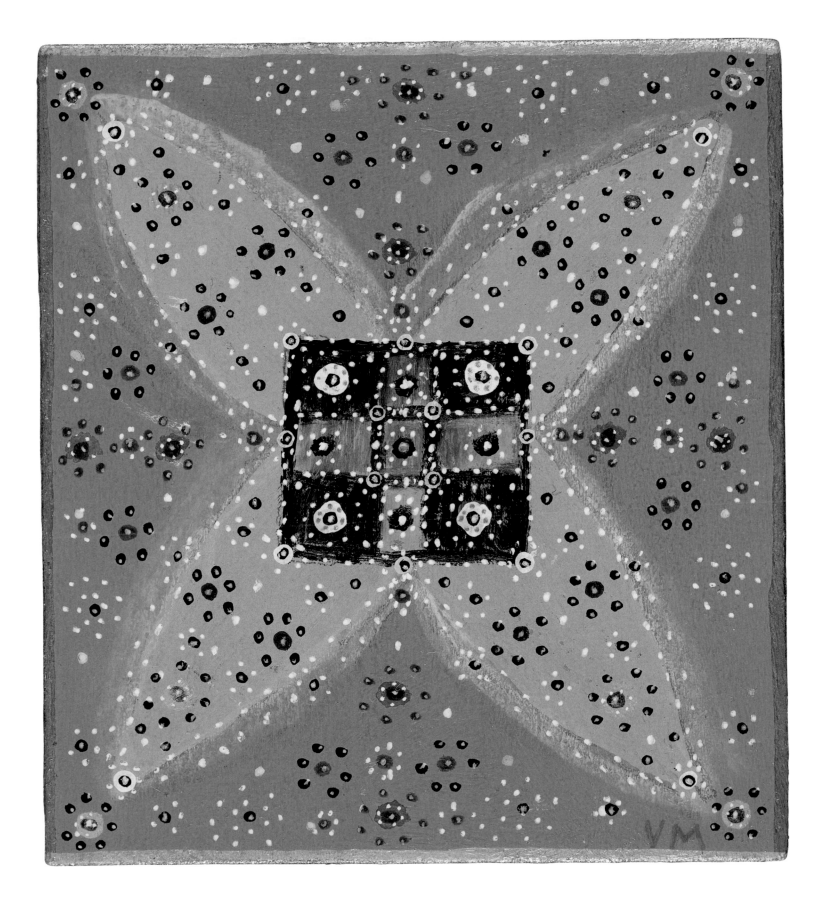

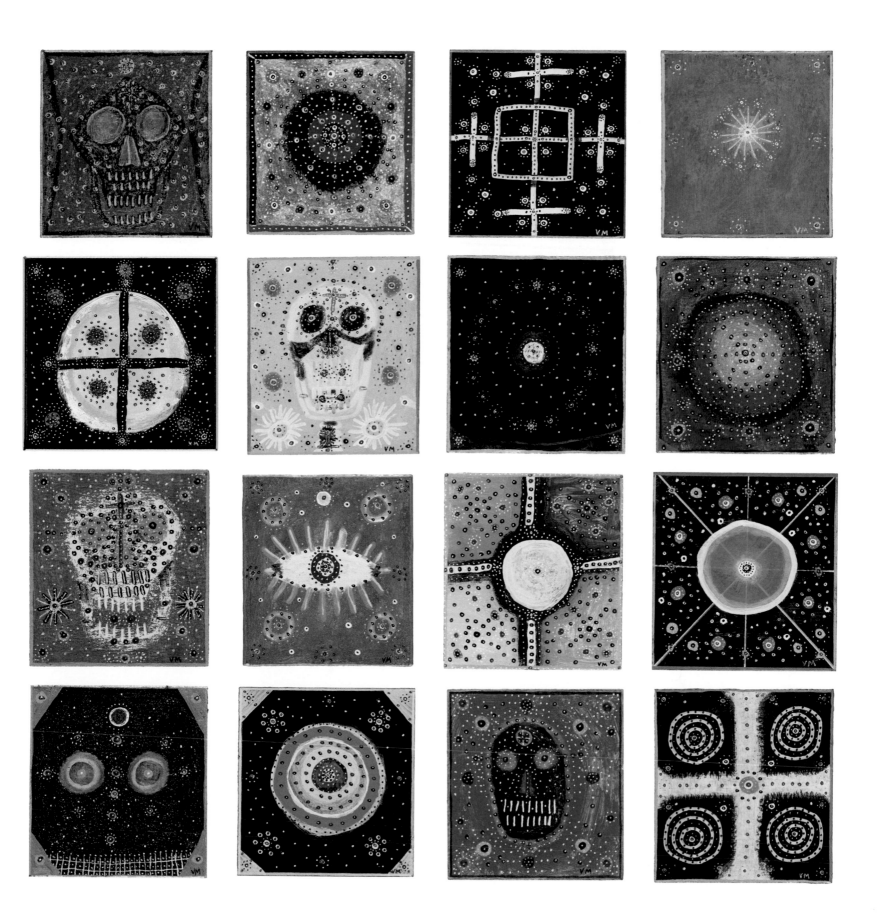

Lesley Dill, 2008; photo: Ed Robbins.

OPPOSITE: Lesley Dill, *Upside Down Silver Girl* (detail), 2005/2009; Courtesy of George Adams Gallery, NY.

Complete object information is available in the Catalogue of Works

LESLEY DILL (born 1950)
Words Lie Sleeping Inside Our Bodies
by Jennifer Jankauskas

Evoking a sense of wonder, Lesley Dill's mixed-media images and sculptures mix the personal, the universal, and the sublime. Mysticism, language—both direct and metaphorical—lightness and darkness, and fragility and strength are essential components in works of art that mirror the complex workings of the mind. Dill's work, close kindred to the poetry that inspires it, examines language as the crossroads of human contradiction and understanding. "I think that words are wings," says Dill. "Words lift us the way wings lift animals."[1]

Born in New York in 1950, Dill grew up in a small rural town in Maine surrounded by an Atlantic coast geography that she remembers as "shimmering, black and white."[2] The wooded Adirondacks where she spent many summers paralleled this cool-toned, watery landscape. The stark contrasts between summer and winter, the bright crisp light of the coast, and the full darkness of the woods captivated Dill as a girl, and the idea of contrast in general became a lasting touchstone in her work.

In addition to geography, the complexity of language was another early influence. Literature was Dill's first love, and she was an insatiable reader. Language, however, was contested terrain in her childhood home. Her beloved father, a biology teacher, was also paranoid-schizophrenic and acutely sensitive to words and their nuanced multiple meanings. His anxiety instilled in her an early awareness of the flexibility of language, and Dill became very careful about what she said. In a simple phrase such as "let's go to the store now," her father might fixate on the word "go" and vanish for a week. Dill looks back on this experience as one of living in a "psychologically bilingual family."[3]

By contrast, Dill's mother was a speech teacher and drama coach who believed in the possibility of precise communication. While in high

school, Dill participated in all of the plays her mother directed and thus learned proper diction. She also encountered the distinct language of playwrights such as Shakespeare. To Dill these types of words, meant for speech but existing on the page first, were different from everyday language. They needed translation in order to move from print to sound and would "go out into the world in an athletic-tongue way."[4]

Dill's interest in craft practices came from elsewhere in the family. Her grandfather, a part-time ceramics teacher, acquainted her with clay and her grandmother showed her how to hook rugs from old clothing. Dill's aunts (her heroes) taught her weaving, a process still integral to her work today. Although creativity and making things by hand were part of her upbringing, Dill's own artistic practice did not emerge for some time. Instead, she pursued an English major at Trinity College in Hartford, Connecticut, followed by a master of arts degree in educational philosophy from Smith College. Perhaps fatefully, the position she secured upon graduating was in teaching—not English or literature, but art at a public high school. Daily immersion in art led her to explore painting, and she found the creative outlet highly rewarding. By the time she was thirty years old, Dill had obtained a second master's degree, this time in fine arts from the Maryland Institute College of Art.

A turning point in Dill's works of art came when, for her fortieth birthday, her mother gave her a book of poems by Emily Dickinson. Poetry had not captivated Dill before, but Dickinson's evocative lines brought imagery rushing to mind. Suddenly, ideas for works of art came to her freely; language was central to them all. "Reading is a trigger," Dill explains. "An intuitive, open kind of thing that wakes up some sort of electrical sense."[5] Poetry became the touchstone for objects and images that perfectly echoed the private nature of thought.

For seven years, Dill used only the words of Dickinson in her art. Later, she branched out and drew inspiration from writers including Salvador Espriu, Franz Kafka, Pablo Neruda, and Rainer Maria Rilke. Her photographic images and sculptural installations reference human forms composed of densely interwoven letters, words, and phrases. In these layered works, Dill suggests that

through language we not only reveal who we are but also clothe, armor, and disguise ourselves.

In 1990, Dill joined her husband, photojournalist and filmmaker Ed Robbins, in India for his work. Living in India for the following two years made a dramatic impact on her aesthetic approach. Dill began to rethink the ideals of beauty so deeply ingrained in the American subconscious. She became increasingly aware of how it felt to be different, to want what others had. The intense, vibrant hues of clothing, the contrasting femininity and strength of women dressed in saris, the practice of painting language on skin with henna, and the sweeping architectural forms impacted her personally, and, in turn, became visible in her work. Perhaps most importantly, the spirituality that infused everyday life in India reverberated within her and made her reflect deeply on a mystical encounter that she had experienced as a girl.

At age fourteen, while getting ready for school and looking through the window at the dark oak leaves remaining at the start of an early winter, Dill had a vision. She recounts:

> Without preface, I was inside a world. There were light lines and vague imagery against a big dark hugeness. Part of that vision, which I didn't understand at the time, was of the inclusion of war, pestilence, ravaging into an enormous complexity. This was language I had never used. The vision had such big sorrow in it, but also bliss and rapture.[6]

Afterward, Dill went downstairs and had breakfast; life continued as it had. Dill pushed the vision back in her subconscious until seven years later when, in a college course titled "Ecstasy," the memory came flooding back. Considering her vision a "recovered spirit experience," Dill was leery about discussing it with others, fearful that the family history of mental illness would cast a shadow. In 2000, however, she bravely decided to share her experience and used it as the cornerstone of a community project at the Southeastern Center for Contemporary Art in Winston-Salem, North Carolina. By bringing her experience to light and asking others to divulge their own mystical experiences, Dill embraced

and promoted visions as conduits of transformative power, a pure moment when time stood still and offered hope.

Throughout her residency in Winston-Salem, Dill made a point of collecting the stories told by her collaborators. These intense, intimate words and phrases have become integral to her work, lending it a spiritual, transcendent dimension. In *Tear Lick* (2001), Dill relates one man's story about a poignant moment, one she describes as embodying "startling compassion."[7] He related how, after the death of a friend, another friend came to weep with him. Her interpretation captures the primal quality of the engagement. In her image a woman licks tears off a man's face. The woman's response is animal-like, an instinct to demonstrate comfort through physical action. The nine-panel *Tongues on Fire* (2001) literally depicts the title. Paired with the words "vision, ecstasy," each photograph portrays a man and his outstretched tongue pulled and grabbed by an anonymous hand. Here Dill elicits both curious aversion and attraction, while metaphorically investigating how we "hold our tongues." The repetition of images and text suggests a repeatedly spoken mantra bringing a meditative quality to the reading. Dangling threads sewn onto the image represent Dill's version of the tongue of God—ribbons descending from the peaks of temples she saw in Nepal, down to the ground, meant to carry the words of wishing and lament upward to God's ear.[8] The tongue imagery also brings to mind the Christian holy day of Pentecost and the practice of "speaking in tongues," a manner of communicating believed to transcend language barriers. As Dill became more enthralled with ideas of the mystical, she became interested in American Transcendentalism, a philosophical movement of the mid-1800s espoused by Ralph Waldo Emerson, Henry David Thoreau, Walt Whitman, and others. Born as a reform movement in the Unitarian Church, Transcendentalism aimed to restore the mystical ideal to daily life. The practitioners believed that spirituality transcends the physical by residing in intuition, and it becomes manifest in the intellectual and artistic realm. Primarily an American East Coast phenomenon, Transcendentalism was aligned with a cultural surge in artistic output in literature, poetry, music, art, and architecture.

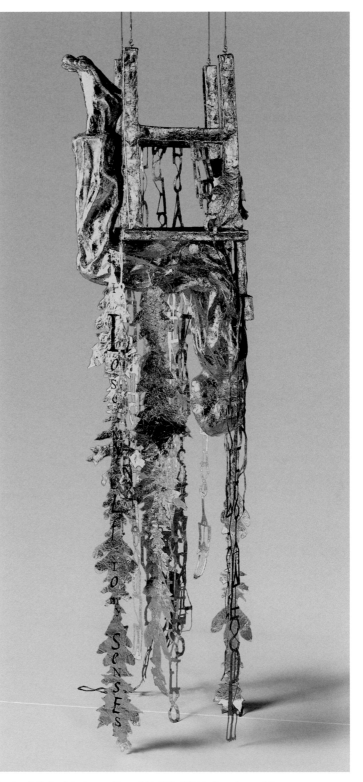

Lesley Dill, *Upside Down Silver Girl*, 2005/2009; Courtesy of George Adams Gallery, NY.

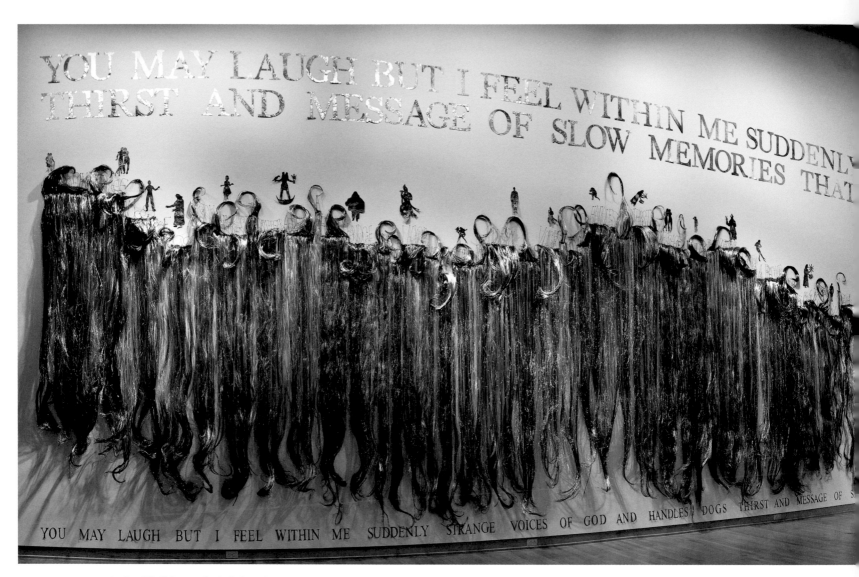

Lesley Dill, *Shimmer* (installation view, John Michael Kohler Arts Center), 2006–07; Courtesy of George Adams Gallery, NY.

While not a specific religion, the spiritual ideals of the Transcendentalists infiltrated the Presbyterian Church and other traditions of worship—a thread that fascinates Dill. Clearly evident in Dill's creative approach is the idea of an interior life, cultivated by intuition and mystical intervention. By combining language and visual imagery, Dill evocatively alludes to introspection and the poetry of personal reflection.

Although she practices Buddhist mediation and is interested in Judaism along with Transcendentalism, Dill does not consider herself to be a conventionally religious person. She believes "the

soul to be a hot place in the body," a center that encompasses the breadth and breath of emotional life. Somewhat of a skeptic, yet open to new experiences, Dill explains that as a "passive receiver of trance and ecstasy," she is consistently surprised by the personal revelations and experiences these practices offer and that now continually feed her artistically.[9]

In her research and study, Dill has explored how Transcendental thinking evolved, particularly after the Civil War. Finding parallels between the ideas and ideology that developed at that time to what is happening in our world today, as we cleave to

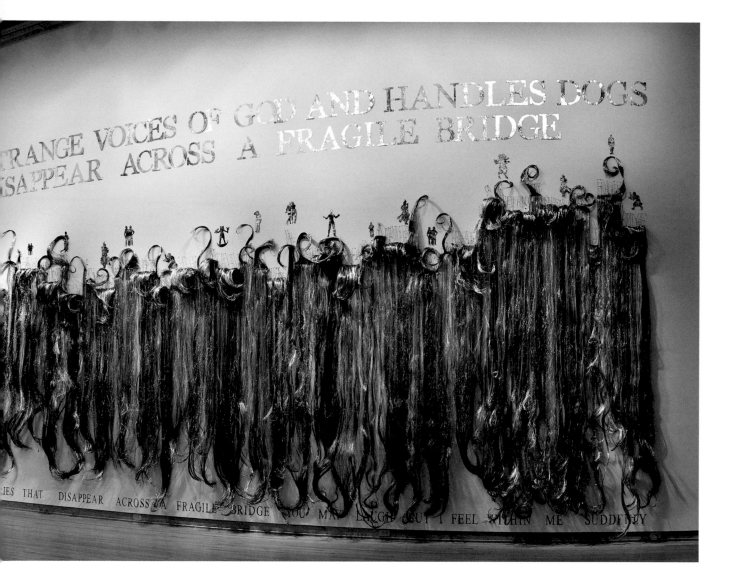

hope and strive toward change, Dill sees the connection as being a search for inner meaning. In particular, the war in Iraq directly touched her life when her filmmaker husband became entrenched in the country and survived an attack.

This terrifying incident, in tandem with her Buddhist beliefs about living life fully, led to the creation of *Dress of War and Sorrow* (2006). The couture-styled gown is armless, a luxurious garment that simultaneously indicates a level of powerlessness. Stylistically reminiscent of eighteenth century apparel that requires corseting, the dress again underscores the idea of disempowerment while

contrasting the concepts of freedom and captivity. Skulls form the fabric of the dress, a symbol of mortality that here pay homage to the toll of war. Language is secretly embedded; the title is enmeshed within the ruffled collar, and poetic excerpts interlace the fabric. The messages are cryptic, not easily found, but reference the thoughts and ideas that keep the innermost self afloat during journeys through darkness.

Another figurative sculpture, *Upside Down Silver Girl* (2005/2009) is the literal illustration of the title. Silver, a color Dill considers "changeable, transcendent, and metaphysical," covers

the figure.[10] Silver is also the first word she remembers reading as a child. While traveling in the backseat of the family car, she saw it on a sign and was able to translate the letter-symbols into a meaningful word, a magical and memorable connection. The hanging tendrils spill from the seated figure spelling out a phrase culled from her residency at the Southeastern Center for Contemporary Art: "I lose myself to my senses." The girl, hanging precariously upside down, has lost her rational intellect to her swooning senses, emotions reign supreme.

Analogous to this sculpture is the large-scale installation, *Shimmer* (2006–07). This mixed-media installation picks up the narrative thread that Dill presents in *Upside Down Silver Girl* and brings it to its zenith—a pure, sensory experience regarding the importance of language. In *Shimmer,* Dill simultaneously portrays the contrasting notions of poignant tenderness with unsentimental strength. Its epic scale alludes to great expanses of possibility. The creation of *Shimmer* became a meditative act unto itself. To uncoil and section more than two million feet of wire, Dill made a room-size spool that she walked around, unrolling the wire, back and forth, loop by loop for eight hours a day. The process took more than three quarters of a year. Evoking the brilliant winter light that reflects on Maine's Atlantic coastline, Dill created a waterfall of wire that cascades from the poetry of Salvador Espriu: "You may laugh, but I feel within me, suddenly strange voices of God and handles, dog's thirst and message of slow memories that disappear across a fragile bridge."

The vein of almost-musical language that runs consistently through Dill's art is the catalyst for her creativity as well as the key to understanding her process. With language sometimes clear and concise and other times arcane, intangible, and secretive, Dill mirrors the linguistic duality that defined her childhood home. Dill explains that she is constantly striving "to reach out and understand the inflection and the intention of language."[11] By making language visual, Dill bridges a gap to sensory experience that encompasses both body and mind. Her lovingly crafted objects of paper, foil, wire, silk, thread, and other evocative textures and surfaces deftly touch emotions and trigger memory.

"We are all animals of language. All the words that were and all the words that will be lie sleeping inside our bodies," says Dill.[12] Evoking the past, present, and future, Dill touches upon a nerve that connects human experience. Encompassing her own experiences and apprehensions of the spiritual and physical world, Dill's images unfold like the pages of an introspective pop-up book. The words we say, so easy to take for granted or choose carelessly, find their due gravity in Dill's investigations of life's contrasts and complexities and the poetic nature of the human soul.

1. Lesley Dill, quoted in *We Are Animals of Language,* documentary film by Ed Robbins, 2007.
2. Dill, conversations with Jennifer Jankauskas, February and March 2009; curatorial files at the John Michael Kohler Arts Center.
3. Ibid.
4. Dill, quoted in Dede Young, "The Gesture of an Open Hand," in *Tremendous World* exh. cat. (Purchase, New York: Neuberger Museum of Art, 2007), 22.
5. Dill, conversations with Jennifer Jankauskas.
6. Dill, quoted in Dede Young, "The Gesture of an Open Hand," 26.
7. Dill, conversations with Jennifer Jankauskas.
8. Dill, quoted in *We Are Animals of Language.*
9. Dill, conversations with Jennifer Jankauskas.
10. Ibid.
11. Ibid.
12. Dill, quoted in *We Are Animals of Language.*

OPPOSITE: Lesley Dill, *Dress of War and Sorrow,* 2006; Collection of Richard Harris, IL, Courtesy of George Adams Gallery, NY.

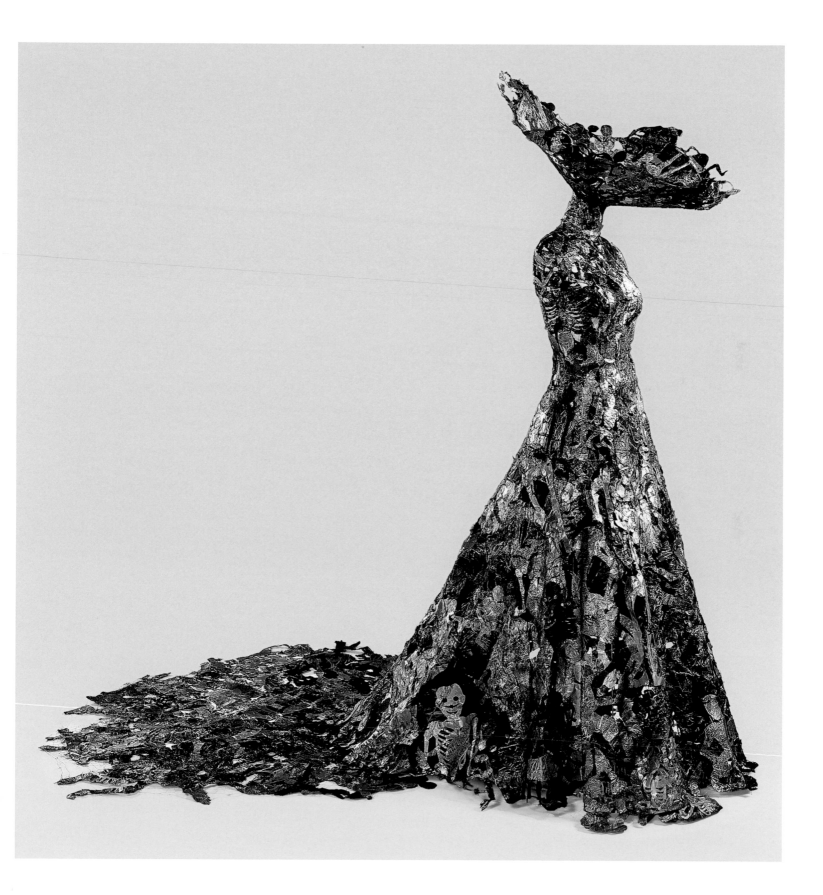

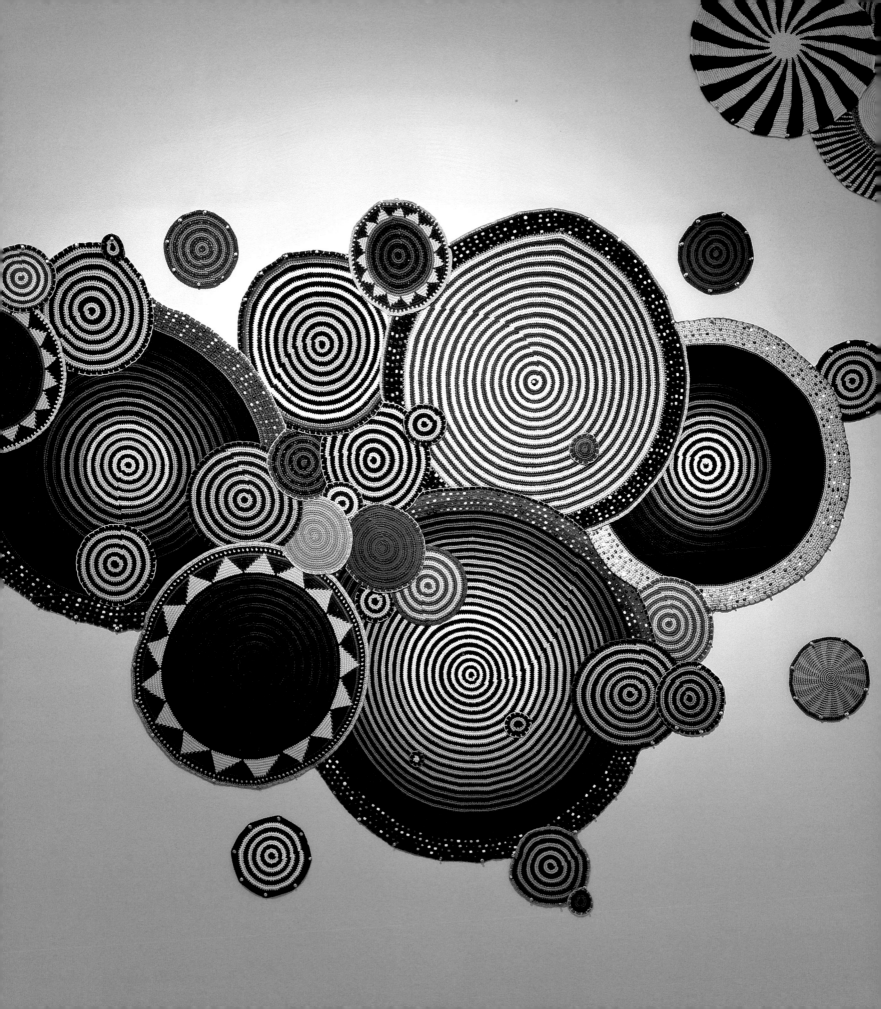

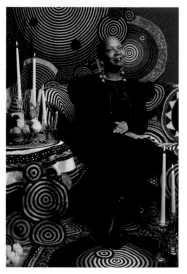

Xenobia Bailey, 2005; photo:
Ron Monk.

OPPOSITE: Xenobia Bailey,
(Re)Possessed (installation view,
John Michael Kohler Arts Center),
1999–2009; Courtesy of the artist.

**Complete object information is
available in the Catalogue of Works.**

XENOBIA BAILEY (born 1955)
Repossessing the Crown
by Amy Chaloupka

Xenobia Bailey believes there is no such thing as a creative block; there
are only underutilized imaginations. Through her crocheted objects and
installations, Bailey seeks to present a physical space that opens up the
creative potential in others. She recalls a time, when traveling, that she
was caught with only one of her signature crocheted hats and had to rely
on her own ingenuity: "I had to be at three different events, three nights
in a row, and I took that hat apart three times. … I had just one hat and
my crochet hook."[1] Reinvention and reimagining have come to define
Bailey, and she believes that if people inspire themselves, the creative
impulse can bloom. Bailey has become known as an artist who transforms
physical space and traditional crafts into vehicles of cultural equity and
spiritual transformation for the African American community.

Bailey grew up in Seattle, Washington, in the late 1950s and 1960s.
Her father had relocated to the Pacific Northwest for the military while
her mother had moved from Oklahoma looking for work at the Boeing
shipyard. They met in the port city, married, and began a family. Bailey
describes her childhood with her siblings as one filled with resourceful
scavenging and imaginative play, building tree forts and go-carts from
fruit crates and soap boxes or any material they could haul out of the
woods or find laying about the neighborhood. Her mother sewed and
kept a bag of scrap cloth in the home. Bailey considered the scraps to be
a goldmine for her own innovative fiber concoctions, and as her mother
allowed her to give up "plain" clothes and venture forth into the world
in her own outlandish and brightly colored creations, Bailey felt her own
identity begin to emerge.

Bailey had also come to appreciate the power that an environment
can hold. Helping her parents with their cleaning business as a girl, she

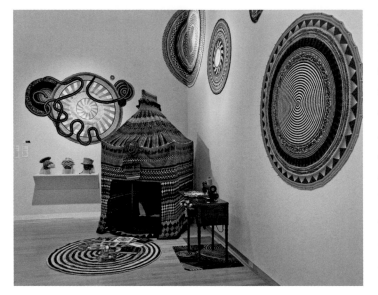

Xenobia Bailey, *(Re)Possessed* (installation view, John Michael Kohler Arts Center), 1999–2009; Courtesy of the artist.

realized early on that the aesthetics of a given environment made all the difference in how a person felt and behaved: cleaning the restaurants that were nicely decorated felt rewarding while cleaning the "dumps" was just depressing.[2] Environment would become one of the ongoing themes in her work.

Bailey's childhood home was located near the Museum of History and Industry, a place the family frequently visited. She recalls playing around the vignettes and dioramas that illustrated early Seattle scenes of settlers clearing the land to build the city, indigenous groups that inhabit the area, and the great Seattle fire. At the time, Bailey's intrigue was not drawn from the stories but from the construction of these miniature tableaux. She was amazed by the tiny garments made for the figurines and the diminutive houses replete with upholstered wooden furniture and electricity. Bailey admits it took her a long time to realize that there was a profession called "artist," yet early on she had a respect for what it meant to make something from scratch. She admired the handmade objects around her and the skills of those who had made them.

Bailey's high school lacked a strong visual arts department, and toward the end of her time there, she found herself skipping class to go to a neighboring high school to learn. This foreshadowed Bailey's college experience as well: an insatiable appetite for learning in a

young woman who was not sure what she wanted to do. In 1970, Bailey enrolled in the University of Washington. A school so large and with so many different colleges provided Bailey with many options, but it also left her fractured when it came time to choose a career path. She dabbled in the arts, taking classes with legendary African American painter Jacob Lawrence, but found the media that comprised visual arts curriculum at this time—sculpture, painting, and drawing—too limiting when it came to creative expression. Enthralled by the myriad avenues of study available, Bailey would often sit in on classes in medicine, anthropology, and science. She could not resist giving herself access to what the future doctors, anthropologists, and scientists were learning.

It was the department of ethnomusicology that utterly enchanted Xenobia Bailey. She had always loved music but had never been exposed to anything but mainstream Western genres. Although she was still an undergraduate, the chair of the ethnomusicology department, Abraham Dumisani Maraire, allowed her to take the graduate-level courses he offered. For the first time, Bailey was exposed to astonishing cultural diversity, and it opened up a world of discovery for her. Maraire introduced Bailey to musicians, their instruments, and their stories from all over the world. A Shona ensemble from Zimbabwe sang to choreographed folktales. Musicians from the Philippines rang chime-like gongs in synchronized patterns. Artists from Venezuela played the *cuatro* and harp. And a family from India danced to the echoing strings of the sitar. But it was more than just the music that captivated Bailey: it was the sum total of the beautifully decorative inlay of the wood instruments, the skill of the musicians, and the ornate ceremonial costumes in concert with the singing, dancing, and storytelling. She wondered how she could turn this holistic presentation of culture into a career.

Bailey found the textiles and masks used for different rituals and the layers worn for these performances particularly moving, and thoughts of textiles and music blending began to take shape in her mind. While the presentation of the material was all-important, there were no classes offered in how to make these garments, practice these rituals, or tell these enchanting stories. Bailey was transfixed with the inherent intertwining of craft and folktales, the inclusion

of whole communities participating in dance and song: "That's the power of a living culture that really enhances your life."[3]

In Seattle in the 1960s, one did not see this integration of craft and culture within the daily lives of African Americans. Bailey remembers the Seafair festivals where, as a child, she saw diverse cultural communities present and sell objects including food, textiles, and jewelry. She recalls the booths of the Scandinavians and the Chinese, but there was no African American booth. The Seafair queens, each representing a different community, took pride in their native cultural presentations, but the African American queen hardly represented any region of Africa; her gown reflected popular Western style, her hair was straightened, her heritage quashed, not celebrated. As Bailey saw it, "We didn't have a cultural community like the others had. They all had their own food, their own festivals. That's when I realized, 'I don't have a culture.' There was a constant 'something' inside of me that made me want more of a presence."[4]

Bailey was not alone in what she was observing. African American women had long been made to feel inferior, made to believe that assimilation and white ways and aesthetics were the only acceptable American goal. From the time that Africans were brought to America as slaves, European Americans sought to suppress and obliterate traces of Africa, from language and beliefs to adornment and hairstyles.[5]

Racism lingered in America well beyond the Civil Rights era and prevented an African American aesthetic from getting a foothold. Even the skills descended from Africa were channeled for European use. Plantation owners often chose African slaves for their particular trade skills. Prized for adeptness at weaving, carving, or other handiwork, slaves were often ordered to abandon their native styles and motifs and instead reproduce European designs. Calling this forced assimilation "Post Traumatic Slave Syndrome," Bailey believes this condition went untreated from generation to generation.[6] African American women had forgotten how to dye their fabrics with rich colors and patterns or how to twist, tuck, braid, and adorn their hair, choosing instead to straighten it in the Western style. As Bailey puts it, "We had a mask on that we didn't even agree to. A mask was put on us. We have to figure out what that original face is."[7]

As Bailey felt this absence of culture, the "Black is Beautiful" movement began to surge in America. In the early 1970s, African Americans were just beginning to awaken to the same emotions she was feeling, to embrace themselves and cottage crafts, and to express their budding repossession of confidence and lifestyle in a number of ways. A form of resistance to hair straightening and general negativity toward African Americans, the Afro was widely adopted as the hairstyle of choice. Athletes and entertainers such as Wilt Chamberlain and Sammy Davis Jr. popularized the wearing of dashikis, a traditional, brightly patterned and embroidered West African garment that caught on as a fashion trend with the general public as well.[8] Beading, jewelry, and other crafts such as silkscreen and macramé became popular handmade items that people used to decorate their homes and bodies and to express their political views at the same time.

Swept up by the "Black is Beautiful" movement, Bailey left the University of Washington and started working in a local community theater, designing and making costumes by hand. Although she had no formal training in costume design, her garments were eventually mounted in the theater's gallery for exhibition. Upon seeing her creations, a stage manager suggested she look into applying to the art program at the Pratt Institute in New York to develop her style.[9]

In order to contribute to giving her community a presence, Bailey set out to create one herself. Having been accepted to the Pratt Institute in New York City, she left Seattle in 1974, determined to start over with her education. She enrolled in the industrial design program, intending to learn how to make products that could enrich African American culture. Specializing in woodworking with a goal of designing toys and furniture, Bailey set about "designing an African American utopia."[10] The program expanded her knowledge of materials, processes, and ways to design for mass production. She learned that the goal of design was to create practical products for specific markets; at the same time, she discovered that there was no market for the work she was developing. As her stylistic and aesthetic goals continued to diverge from her colleagues in design, Bailey came to realize that hers fit better within the realm of fine art. Ruminating on her experiences in art, craft, ethnomusicology, and

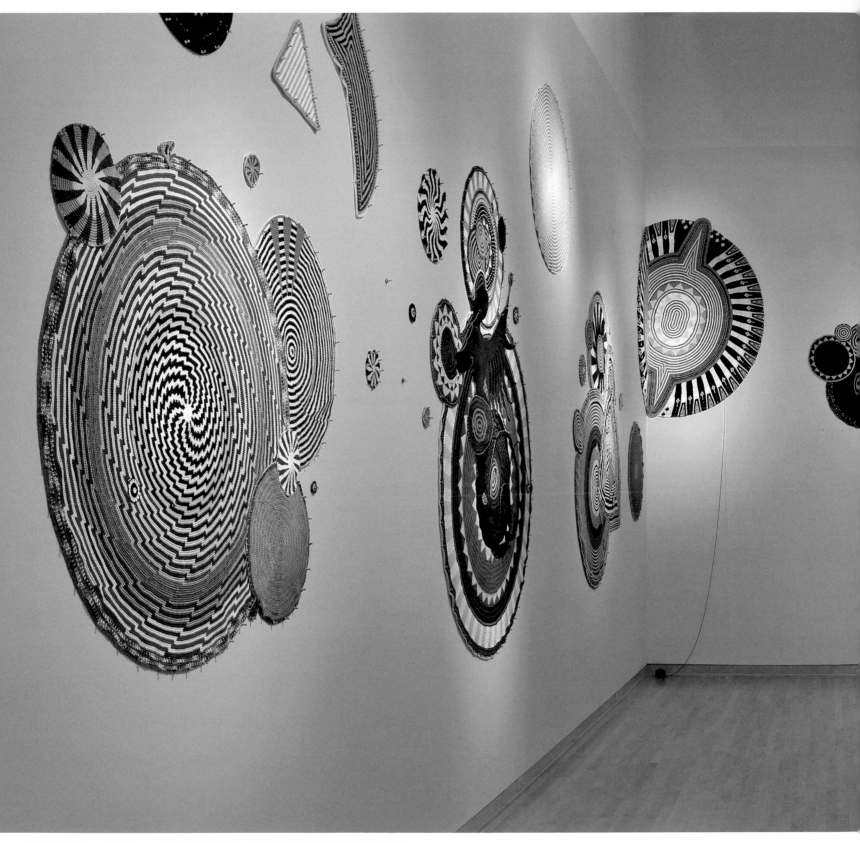

Xenobia Bailey, *(Re)Possessed* (installation view, John Michael Kohler Arts Center),
1999–2009; Courtesy of the artist.

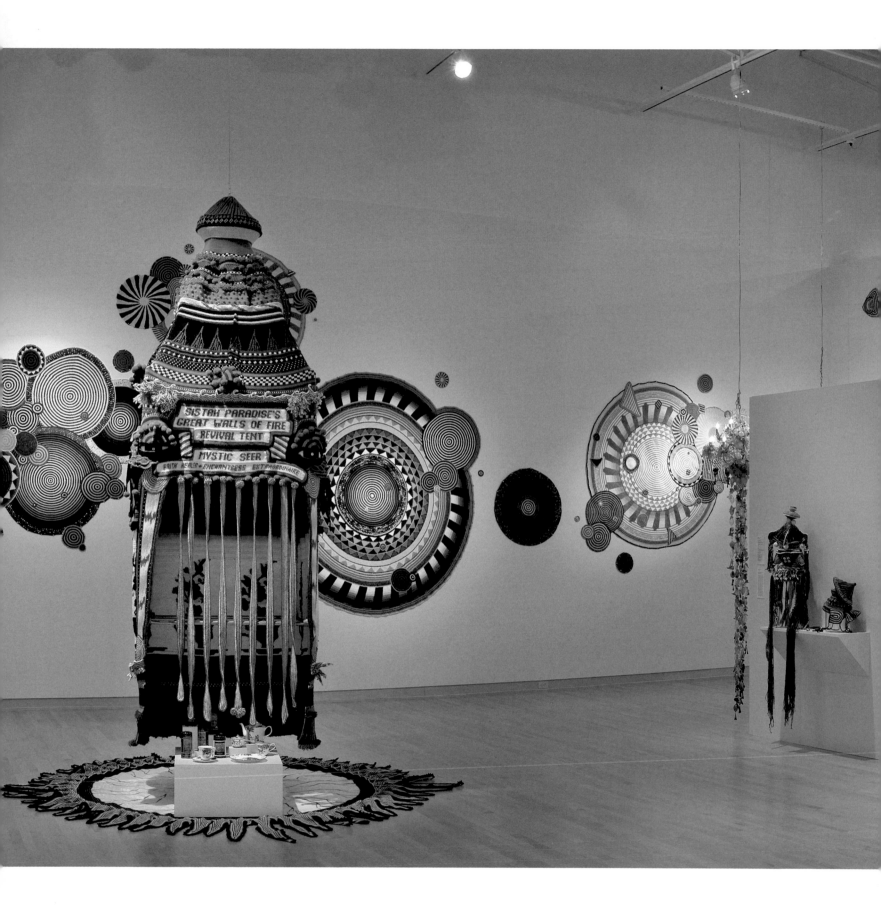

design, Bailey began to envision the whole thing coming together. She shifted her momentum to create installations and environments and, finally, her artistic vision began to thrive.

A pivotal moment for Bailey came not long after graduation. While teaching at a community art center, she met a fellow teacher named Bernadette Sonona who created beautiful needlework without using a pattern. Sonona shared her knowledge of crochet, teaching Bailey in just three days what would become the core technique of her artistic practice.[11] Bailey used this newfound understanding of crochet to create bright and eccentric hats and tailor-made wearables with vibrating hues and regal silhouettes that celebrate an African aesthetic. "Crochet is not high technology," Bailey explains. "It's easy, accessible; [for] under ten dollars you can start crocheting. But it's what you do with your imagination and your time that sets it apart."[12] For Bailey, this simple process opened up a world of creative possibilities. It was a meditative process, sitting and crocheting, creating an environment of liberation. It allowed her to develop and design craft objects for the African American home; moreover, it opened her up to the vast possibilities of creativity within herself.

Around 1980, Bailey began the artistic endeavor that consumes her to this day. Envisioning an environment of earthly delight for African Americans, she began a project that she calls *Paradise Under Reconstruction in the Aesthetic of Funk*. In *(Re)Possessed* (1999–2009), Bailey presents a core grouping, drawn from this larger whole, which she has been showing as a unit since the dawn of this century. In this organic, multilayered environment she addresses history, politics, folklife, ethnicity, music, tradition, and change. Her core idea is to present a mythical kingdom where others can connect with a deep-seated creativity, as she has done. She envisions drawing direction from chaos, empowerment from self-doubt, and joy from pain.

Crocheted revival tents anchor an environment resplendent with huge pulsating crocheted mandalas in an intense yellow room. One tent is the spiritual house of Sistah Paradise, a powerful seer who invites visitors in for an auspicious tea ceremony, African style. Her tent features a teacup releasing a vivid and flowery aroma,

symbolizing the positive fortune she promises to tell. The costumes and yarn crowns on view belong to Sistah Paradise, a woman who, like Bailey, defines herself through creative clothing. These elements appear to be the artifactual remnants that prove the existence of this resplendent kingdom. In the *Moon Lodge* (1999), children are invited to get lost in the age-old stories that inspire imaginings of who they might one day become. The sewing machine of her childhood—the vehicle of her personal transformation—sits nearby. At the foundation of the work is the funk aesthetic, which to Bailey is the wellspring of inventiveness and the basis of any culture: "Everything starts with funk. Funk comes from a passion, a personal taste, and not necessarily from training. It comes from not having the materials you need to make what you want to make. There are no rules."[13]

Bailey celebrates folk culture and a jazz and funk aesthetic by asking fellow artists to participate in the ever-evolving installation; their personal histories become intertwined elements that merge with the scene while simultaneously following their own trajectory, akin to an improvisational music session. Nine-foot-tall chandeliers by glass artist Dorian Webb flank the main tent, where a tea ceremony features an African reinvention of the European-style porcelain tea service, by ceramist Barbara Garnes, and canisters of African red bush tea designed and harvested by Doughba H. Caranda-Martin on his tea plantation in Liberia. An original score by jazz musician Renè McLean suffuses the room. All of these elements work in concert, bringing together multiple African American perspectives to build an environment of inspiration and joy for the viewer.

Bailey presents an open atmosphere, giving a sense of home and comfort, so that visitors do not feel alienated but rather inspired to create for themselves. In the top corner of the installation, Bailey places a magical "bag of funk," from which brightly colored mandalas spill forth and constellate the space. The mandalas, with their vibrating colors and pattern, mirror the music rhythms of jazz and are meant for meditation. They reference the circle, the most basic celestial form and reflect the supernatural. The smaller forms break away from their larger counterparts like free-form bursts of color that express and inspire. The revival tents, like giant

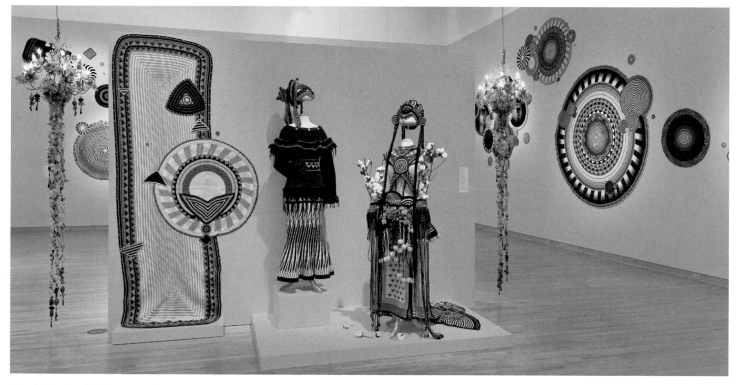

Xenobia Bailey, *(Re)Possessed* (installation view, John Michael Kohler Arts Center), 1999–2009; Courtesy of the artist.

headdresses, become the physical place to congregate for dialogue and idea sharing. The tea, lighting, and soundscape all complete this "house" of improvisation and escape. This is a space of possibility, not just for Bailey but for anyone who enters.

Bailey's work has become a synthesis of her life's experiences. Her early admiration and desire for the songs, stories, choreography, and costumes presented by indigenous cultures in her ethnomusicology classes have become her holistic work, in which she makes available to others "objects of jubilation."[14] Her work is a laboratory of craft, culture, sound, and ceremony, where she has repossessed the crown of her culture and wears it with pride. And like Tibetan monks who sweep away their sand mandalas and disperse them in water after the intense creation is completed, Bailey could pull a thread and unravel the whole thing, leaving the balls of yarn from which they came. Her act of cultural recovery is not aggressive or angry; rather it is an act of possibility and potential for the idea that remains, a reinvention that can now occur.

1. Xenobia Bailey, interview with Amy Chaloupka for the John Michael Kohler Arts Center, February 28, 2009; curatorial files at the John Michael Kohler Arts Center.
2. Joanna Rubiner, "Black Biography: Xenobia Bailey," www.answers.com/topic/xenobia-bailey, accessed April 18, 2009.
3. Bailey, interview with Amy Chaloupka.
4. Ibid.
5. Beverly Daniel Tatum, *Assimilation Blues: Black Families in a White Community* (Northampton, Mass.: Hazel-Maxwell, 1987), 125–30.
6. Bailey, "Artist's Statement," *(Re)Possessed* exh. cat. (Columbus, Ohio: Elijah Pierce Gallery, The King Arts Complex, 2008), 4.
7. Bailey, interview with Amy Chaloupka.
8. For a general background on the dashiki, see http://en.wikipedia.org/wiki/dashiki.
9. Rubiner, "Black Biography: Xenobia Bailey."
10. Bailey, interview with Amy Chaloupka.
11. Sahara Briscoe, "Xenobia Bailey's Intrepid Voyage," *Black Purl Magazine*, November/December 2007, 4.
12. Bailey, interview with Amy Chaloupka.
13. Rubiner, "Black Biography: Xenobia Bailey."
14. Bailey, "Artist's Statement," 4.

Additional information in this article was drawn from conversations between Xenobia Bailey and Amy Chaloupka in February 2009.

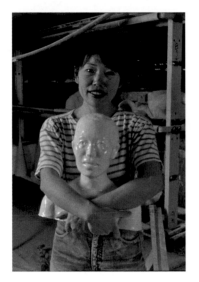

Yoshiko Kanai, 1998; photo: Rich Maciejewski.

OPPOSITE: Yoshiko Kanai, *Home Hunter* (detail), 1998; John Michael Kohler Arts Center Collection.

Complete object information is available in the Catalogue of Works.

YOSHIKO KANAI (born 1956)
Home Hunter
Beth Lipman and Leslie Umberger

Japanese-born Yoshiko Kanai is known for narrative autobiographical works that explore her experiences as an artist, woman, and immigrant. As a young artist, Kanai felt thwarted by the male-dominated arts community in Japan. Realizing that her art might never be accepted in her own country, Kanai sought a new land she could call home and moved to the United States in 1993.

Growing up in Yokohama, Kanai was nurtured and supported by a loving family. As a child, she loved to draw and dreamed of being a painter. Encouraged by her father, she enrolled in an after-school arts program, where an instructor advised her that her talents warranted further pursuit. Kanai revealed her desire to study painting in art school, but the well-meaning instructor, inherently biased toward men, warned her that painting was an especially competitive department and suggested that she follow a course more suited to her skills. He recommended textiles, where women were established and accepted in the traditional arts of weaving and surface design. Kanai took his advice and in 1978 enrolled in textile design at Tama Art University.

After six years of study, Kanai came to the disappointing realization that the skills she had learned did not meet the needs of her artistic vision. After graduation, she began to work with Gallery Lunami in Tokyo, which offered her an annual solo exhibition in addition to certain group invitationals. In *Why I Make*, her first solo exhibition after graduation in 1984, she presented two-dimensional tapestries. Gallery Director Emiko Namikawa recalled, "Her exhibited works were rattan framed relief-like objects on which silkworm guts were used as warp and embroidery threads were braided into them. I could see a kind of resistance to [both] traditional weaving and modern textural design in the beautifully colored

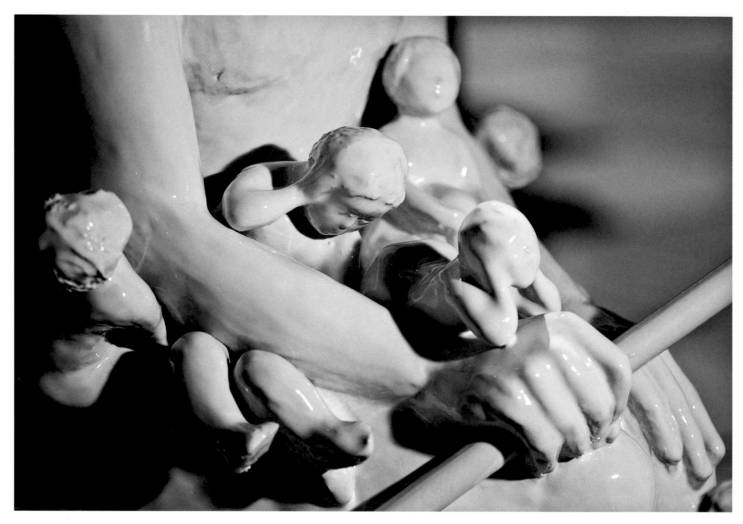

Yoshiko Kanai, *Home Hunter* (detail), 1998; John Michael Kohler Arts Center Collection.

organic forms."[1] Despite Namikawa's favorable reception to her work, Kanai knew that true self-expression still eluded her.

In a 1991 exhibition that Kanai titled *Boule de Suif*, referencing the complex female title character of the short story by Guy de Maupassant, the artist branched out into sculptural works that employed traditional materials in subversive ways, seeking to metaphorically mirror her own life and rebel against the stereotype of a discreet and reserved Japanese woman. Kanai accentuated her use of craft processes and materials inherently laden with connotations of a woman's role in the Japanese art world. Thread, fabric, sugar, water, and other materials alternately represented the domestic realm and the array of acceptable materials for women working in the arts. Their conflation spoke volumes about the artist's feelings. Through the fragility of her materials, Kanai deftly conveyed ideas of human mortality, the ephemeral nature of beauty, and the stark contrast to those materials considered acceptable for contemporary Japanese sculpture, namely stone and metal. Allying herself with de Maupassant's protagonist, Kanai cast herself as the righteous individual swimming upstream against the powerful current of the established social order. Her intimate renderings of the female nude explored and narrated her own experience—bringing her much closer to the artistic self-expression

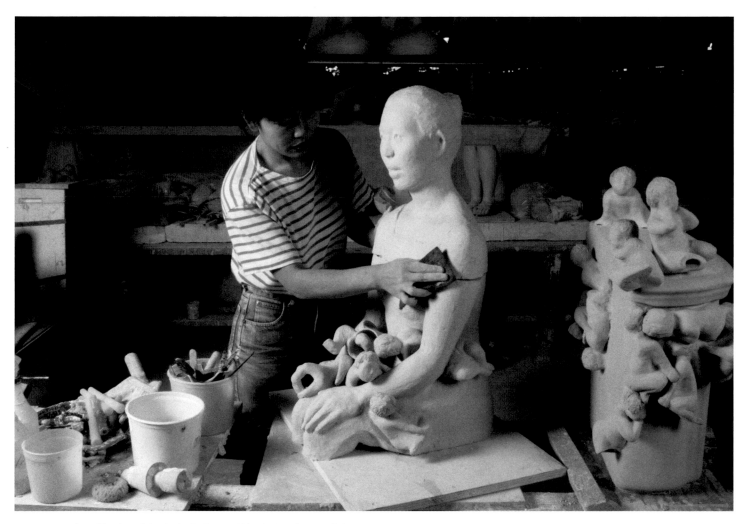

Yoshiko Kanai working in Arts/Industry Pottery, 1998; photo: Rich Maciejewski.

she had been seeking—yet, the exhibition drew negative criticism from the male-dominated arts community in Japan, which deemed them inappropriate, unsettling, and unworthy of attention. With such personal subject matter meeting with blatant rejection in her home country, Kanai felt she had to seek a new home. At the opening of *Boule de Suif*, Kanai had met American writer Nancy Shalala, whose feminist perspective deeply resonated with Kanai. This encounter convinced her to look toward the United States.

Shalala, writing for the *Japan Times*, noted that Kanai was struggling as a Japanese feminist artist, regularly denigrated by her male counterparts. Some accused her abstract representations of the nude as being explicitly sexual; others, citing her use of textile modes, tried to pin her within the realm of traditional women's work. Shalala observed, "Kanai's standing as a remarkably talented artist, an empathetic humanist and unyielding feminist rates her as an important figure in the feminist movement of Japan. With each exhibition, she contributes significantly to the definition of a feminist vision concordant with a Japanese context."[2] Shalala noted that Kanai never adapted a Western style of confrontational feminism but rather embodied her cultural center through work that, instead, was quietly personal and, in this way, sometimes discomfitingly revealing.

In 1993, Kanai was awarded a twelve-month fellowship through the Asian Cultural Council that enabled her to participate in New York City's renowned P.S.1's International Studio Program. Considering the decade that had passed since Kanai had left art school and sought her own expressive forms, Shalala wrote:

> In over ten years of work as an artist, Kanai
> has tirelessly sought to know the hearts of
> humankind, especially those of women. Over
> the years her works have unveiled, layer by
> layer, the gossamer garments that shield the
> soul in multitudinous folds of repression and
> denial. Looking at her work, one sees the human
> heart, naked and vulnerable in its yearnings, its
> fear, its shame, its sorrows and its joys. Though
> acutely aware of life's mocking cruelties, Kanai is
> unfailingly affirmative and refuses to succumb to
> despair.[3]

Moving to New York brought a new dimension to Kanai's sense of self: the identity of immigrant became layered onto that of Japanese woman. Living in America heightened her awareness of her role as one who is simultaneously part of and removed from her home culture. Notions of Japanese identity, femininity, and especially the idea of home became central to her work.

In New York, Kanai found a community of fellow artists and immigrants that embraced her. The city offered countless opportunities, international artists engaging in a wide variety of discourse, and enough psychological space to allow her to develop the nuances of her sculpture. She easily found other artists to engage in dialogue about women's issues—a welcome surprise after leaving Japan, where feminism was not openly discussed. For the first time, she found an enthusiastic audience for her own story; she found a home.

In 1998, Kanai was awarded a three-month stay in the John Michael Kohler Arts Center's Arts/Industry residency program at Kohler Co. There she made the iconic sculpture *Home Hunter*, a multiple component slip-cast vitreous china and cast-iron sculpture. *Home Hunter* features a woman who sits in a bathtub surrounded by tiny babies who play and romp. Perhaps referencing the seated Pueblo storyteller dolls similarly harboring their progeny, Kanai alludes to the impact that her decision to leave home will make on her children. Her seated position confers a necessary passivity; while the children are impatient and demanding, Kanai must wait patiently for the reward she seeks. The tub that holds them and the broom she holds are metaphorically transformed into boat and oar: the domestic realm turned into vehicle of voyage. Kanai explains: "[*Home Hunter*] symbolizes family and home. When I came to America I was moving around many places, I wanted to make a new family and my own home again. This work is about my dream while I was traveling."[4]

Kanai's work has continued to be a form of self-exploration, as she explains:

> Art shouldn't deviate from society. I don't intend
> to lead other people into some social ideology
> through my works. I want to appeal directly to
> others' feelings. I want to express yearnings and
> fear, misery and ecstasy, joy and sorrow, and
> even the ever-present problems we cannot solve.
> I want to find symbolic qualities inherent in
> objects. I want to express feelings buried beneath
> the surface of everyday living that are difficult to
> put down with words.[5]

Still living in New York, Kanai's American experience has been that of finding her Japanese self, a feminine identity that had been suppressed in her home country. She hopes that other Japanese women will be able to find their own true voice without having to uproot their entire life to do so.

1. Emiko Namikawa, "A Comment of Ms. Yoshiko Kanai," in *Yoshiko Kanai*, unpublished exhibition brochure, 1993; curatorial files at the John Michael Kohler Arts Center.
2. Nancy Shalala, "Feminist Artist Aims for Soul with Symbolic Assemblages," *Japan Times*, June 6, 1993.
3. Ibid.
4. Yoshiko Kanai, interview with Beth Lipman for the John Michael Kohler Arts Center, February 16, 2009; curatorial files at the John Michael Kohler Arts Center. General information in this article was drawn from this interview unless otherwise cited.
5. Kanai, quoted in Shalala, "Feminist Artist Aims for Soul with Symbolic Assemblages."

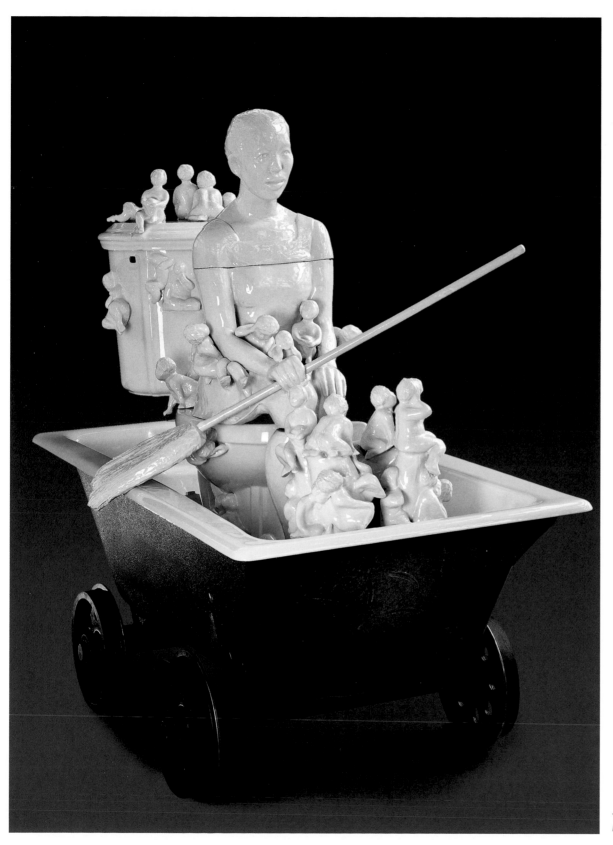

Yoshiko Kanai, *Home Hunter*, 1998; John Michael Kohler Arts Center Collection.

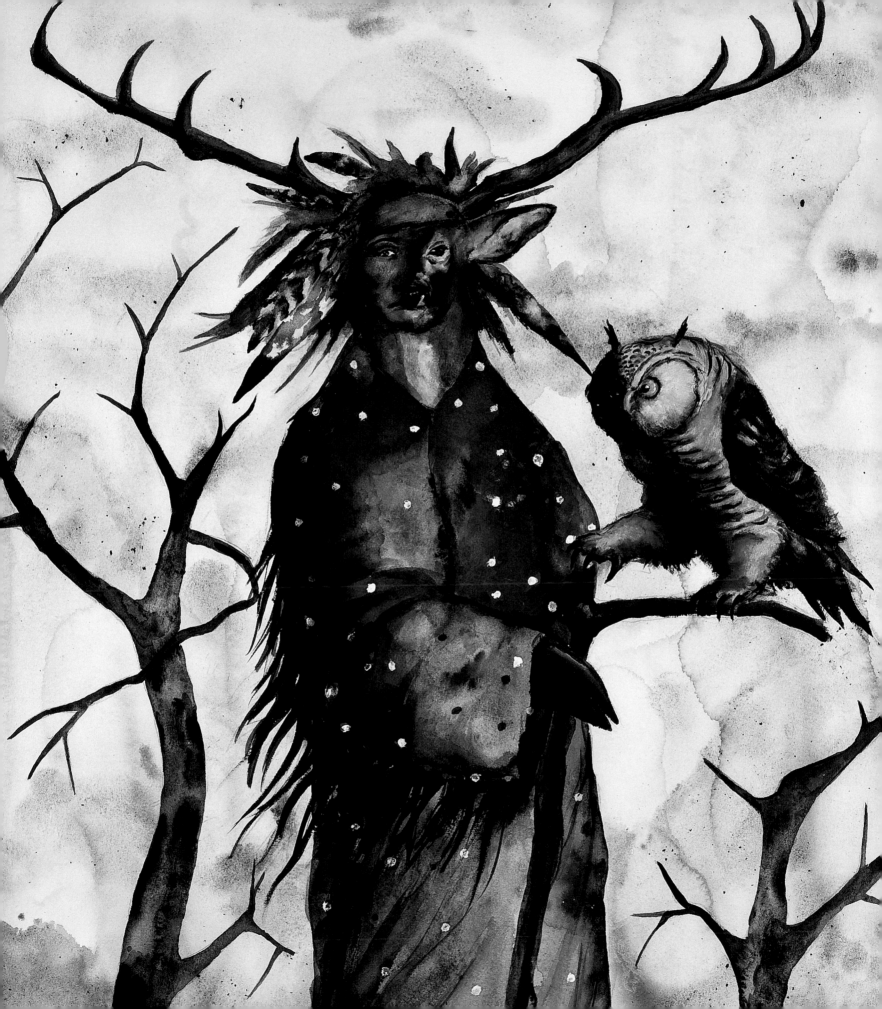

Lisa Fifield, 2008; photo: Courtesy of Veronica Davison and the Centers for Disease Control.

OPPOSITE: Lisa Fifield, *Manitou*, 2003; Collection of Bobbi Lewandowski and Kathy Regan, MN.

Complete object information is available in the Catalogue of Works.

LISA FIFIELD (born 1957)
Ancient Affinities
by Leslie Umberger

Milwaukee-born artist Lisa Rusch Fifield draws on history and tradition to chart a course through the complexities of contemporary life. Fifield mines her Oneida heritage in watercolor paintings inspired by the Iroquois spirit world, native lore, and history. She explores a mythical realm in which women and animals enjoy a symbiotic relationship, creating a metaphor for Iroquois matrilineal clanship and a deep-seated relationship with the natural world.

Fifield's parents met and married in Milwaukee, her father a German American and veteran of the Korean war; her mother an Oneida, working in the city as a nurse. The family's mixed ethnic heritage, however, was never discussed, and Fifield grew up unaware of her mother's—and by extension her own—Native American blood. Fifield was set apart from her elder sisters, both blonde and blue-eyed like their father, and while she could not put a name to the racial tensions that haunted their extended families, she sensed them from the time she was young.

Fifield's father was an aeronautical engineer whose work took the family (by then with six children) to Seattle, Washington, and later to San José, California. While in the third grade, in Seattle, Fifield saw a documentary film about an Inuit whale hunt, which made a deep impression on her. Some students were put off by the gory details of the slaughter, but Fifield had a different reaction. She was astonished to see how the tribe worked together in concert toward a goal that would sustain the group, that not one element of the kill went to waste, and that ceremony, tradition, and respect for the animal were integral to the process. Their group unity was foreign to her, and it engendered a feeling of deep respect and awe for Native American culture. In the Pacific Northwest, she became increasingly aware of the "quirky, eclectic, and

Lisa Fifield, *Bird Funeral*, 2002; Collection of Louis Allgeyer and Jane St. Anthony, MN.

beautiful Indian names" that marked places on maps and signs.[1] Names like Changes-Its-Face, Little Crossing-Over Place, Walla-Walla, and even Seattle (Seatlh), the Duwamish chief whose grave she visited, seemed to contain a mysterious secret, an untold story that captured her imagination. The lure of names, in fact, would become a lasting part of Fifield's artistic practice.

In San José, Fifield was exposed to a greater racial mix in daily life with a Japanese American teacher and Mexican American children in her class. Her sisters drew attention to the fact that she resembled the Hispanic kids more than her own family and Fifield's sense of alienation increased. They hinted that she looked like the primitive natives from a natural history display, a comparison that made her feel isolated, even inferior. Fifield recalled that her family, in general, seemed different from other American families in California. "The women of Silicon Valley wore lipstick, eye-shadow, had teased hair, wore pedal-pushers and sandals; they were gum-smacking women who drove cars and were independent. In contrast, our home was very somber. We were encouraged to be quiet and humble," Fifield recalls.[2]

Another relocation took the family to Eden Prairie, Minnesota, but not long after that, Fifield's father decided the marriage was over. Fifield recalls that her mother was devastated. She had six children to look after and had not worked in years. "In her day," Fifield explains her understanding of the Depression-era Oneidas, "there was a lot of poverty and oppression on the reservation. She never learned to swim or ride a bike or drive a car and there were none of the experiences like the Fourth of July."[3] Reviving her dormant nursing career, Fifield's mother walked two miles to and from work every day—a lasting memory for her children. As Fifield became more aware of the world around her, pieces of her own ethnic puzzle started to fall into place. When, during high school, she discovered her mother's birth certificate, it crystallized.

Fifield does not know precisely why her mother kept her Oneida identity from her children, but in the 1950s and 1960s, Native Americans were still struggling to combat racist attitudes. Multiculturalism and ethnic pride were not yet part of the American vocabulary, let alone fashionable, as journalist Karen Winegar notes:

Those were different times: before Dances with Wolves *and* The Last of the Mohicans, *before every upscale furnishings boutique started selling Edward S. Curtis prints of "The North American Indian." It was before rainforest tribes teamed up with rock stars to save forests, before shamanism and herbal healing boomed into view, before white people started attending sweat lodges, and before "multicultural diversity" became a corporate buzzword.*[4]

During Fifield's childhood, the tensions between her father's family and her mother's evidenced the reality that Native Americans were not widely accepted by the white culture and that mixed families walked a tightrope between two worlds.

By the late 1960s, the Oneida, or *Oneyoteaka*, culture, had been in a downward spiral for several hundred years. The Oneidas were one of six nations of the *Hodenosaunee* (the People of the Longhouse) also known as the League of the Iroquois, tribes who had banded together in solidarity and lived in the great expanse of land that is today upper New York State.[5] In the seventeenth century, when the Dutch, English, and French came to North America, the Iroquois were a force to be reckoned with and were respected as such. The League stayed strong until the 1770s when, in the American Revolutionary War, the tribes split into opposing factions. The Iroquois were no longer a desirable ally but rather a plain hindrance for American settlers ravenous for land.

The Oneida continued to weaken as they fought amongst themselves regarding how much they should accept or reject the white ways being pressed upon them. The majority was enticed by the myriad trade goods and persuasive religious teachings proffered by whites; some had become indebted through the trade system. The United States government increasingly exerted pressure on them to relinquish their land and move west into the frontier lands. By 1800, the Oneida had lost over ninety percent of their land, and in 1823, about half the tribe moved (with more to follow) to the territory west of Green Bay in what would become, twenty-five years later, the state of Wisconsin.

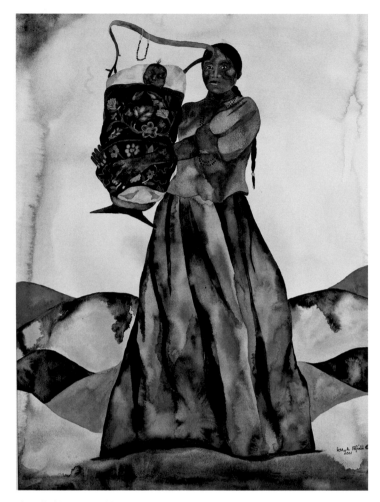

Lisa Fifield, *Blue Prairie Woman*, 2001; Courtesy of Louise Erdrich and Birchbark Books & Native Arts, MN.

The Oneida had lost much since pre-contact days. In Wisconsin, most of their traditional ways faded. Native religions had given way, in large part, to Christianity. Between 1880 and 1930, most Native American children were educated at boarding schools, separating children from families for extended periods of time. At the schools, native languages and dress were not allowed; assimilation was the overt goal. Oneida youth were among those who forgot their native tongues, and became culturally isolated from the older generations.

Historian Herbert S. Lewis has noted, "The moving frontier followed right behind the Oneidas."[6] As settlers moved into the Great Lakes region, demanding land and lumber, the government again tried to coerce the Oneida into moving farther west; this time

they refused. The land given to the Oneida tribe was protected from taxation, lien, and from individual sale. But in 1887, Congress passed the General Allotment Act, which removed these protections and left the Oneida prey to savvy land dealers and crooks. Most older Oneida did not speak or read English, but many were persuaded to put up their land as collateral for farm equipment, dealings that ultimately cost them their land. Others lost land when taxes came due that they could not pay. Lewis cites, "By the 1920s the Oneida owned 3,590 acres of their original 65,400."[7] With the loss of land came the loss of political power and tribal strength.

Yet, in spite of the dramatic change that had marked the tribe during the preceding several hundred years, the Oneida continued to have a strong group identity, as curator and professor Nancy O. Lurie asserts:

> *Indian people are aware of being different from Whites, and in the matters that count to themselves the differences are not equated with inferiority but with meaningful social identity. Their humor is different; their decision-making processes are different; their religious attitudes are different, even if based on Christianity and church membership; their canons of politeness are different; their attitudes toward land and material wealth are different; and their expectations of one another are different.*[8]

Cultural affinities at the heart of the tribe, in fact, played no small part in the group's ongoing tribal identity. Although the Oneida were plagued by poverty and unemployment through the 1960s, conditions began to improve as U.S. government attitudes about Native Americans became less oppressive and as Indians began increasingly to assert their rights. Drawing on Native American treaty status, they began to open smoke shops and bingo parlors that provided revenue for community development. Since the 1990s and the advent of full-scale gaming, the Oneida Nation has continued to regain strength, buy back reservation land, and reclaim their own culture.

Discovering her Oneida heritage was a revelation for Fifield, who began to immerse herself in learning about the tribe's history and traditional ways. She learned more about her maternal grandparents and her grandmother's attendance at a boarding school where "they took Indian kids and taught them to be white," Fifield says.[9] Always artistically inclined, Fifield began to explore her own Native American identity in watercolor paintings and in quilts. She enrolled in nursing school but did not finish, opting instead to marry and start a family. Fifield continued to pursue her artistic interests while working in the menswear industry. Her marriage came to an end in the late 1980s and not long after, she remarried. But those changes were accompanied by a grave downturn in her health that turned out to be lupus. The disease has been serious for Fifield, who had to leave the workforce and face multiple surgeries and hospitalizations. Her art became an important refuge as well as a vehicle for structure and balance in otherwise unpredictable days.

Her second marriage was short lived, but after its demise Fifield recalls feeling, for the first time, like she was truly free to explore herself. She enrolled in her first art classes at the Atelier LeSueur in Wayzata, Minnesota. Although she remained there only a few weeks, her instructor encouraged her to pursue her art. In the early 1990s, she submitted a few paintings to a gallery and was surprised to be asked for her tribal papers, something she had never possessed. In 1990, the Indian Arts and Crafts Act had been passed to prevent non-Indians from profiting from co-opted (but purportedly authentic) Native American art forms. This truth-in-advertising law, although controversial in a variety of ways, signaled the heightened consumer interest in Native American goods and culture.

Fifield obtained the documents that attested to her legal status as a member of the Oneida Tribe of Indians of Wisconsin (Black Bear Clan). To her surprise, the papers validated her in a way she had not realized she needed, conferring honor and privilege to the very traits that had stigmatized her as a girl. "They opened a very emotional door," Fifield recalls. "I realized I had missed out on being this person my whole life."[10] She knew that the days of trying to hide her differences were over, and that she wanted to

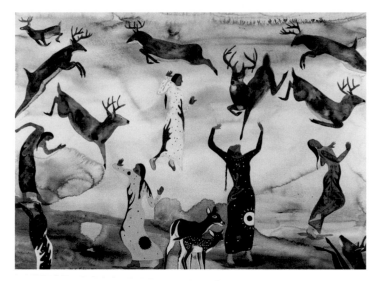

Lisa Fifield, *Dance of the Elk Women*, 2005; Collection of Malone & Atchison Attorneys at Law, MN.

move forward embracing her native identity in both her painting and her life.

Fifield's watercolors stem from personal vision but are inspired in large part by the histories, myths, and legends of the Oneida, other Woodland tribes, and Native Americans as a whole. *Lydia Looking Elk* (2003) harks back to Fifield's girlhood interest in names. Reading a history of the Wounded Knee Massacre, Fifield was taken with the evocative names of the deceased such as Stars in her Mouth, She Appears Many Times, and Lydia Looking Elk. She developed a visage for Looking Elk in her mind over some five years. When she finally painted her invented likeness, the symbols of the Elk Clan and the circles—suggesting the feminine representation of the continuity of life—offered themselves as part of her vision, a fusion of legend and imagination.

In *Blue Prairie Woman* (2001), Fifield brings to life a character from Ojibwe novelist Louise Erdrich's *The Antelope Wife*. Erdrich has become known for rich tales that explore Native American themes including reservation life, the balancing of American and Indian identity, and the ways in which tribal traditions are retained in Native American culture. In the novel, Blue Prairie Woman loses her baby daughter in the aftermath of a battle. The infant is raised for several years by a cavalry soldier who found the apparent orphan and, some years later, is found and reclaimed by her natural

mother. The character becomes a metaphor for Native American loss, acculturation, and reclamation—symbolism that struck a deep chord for Fifield.

At the core of Fifield's imagery is what she calls "clanology," the myths and folktales that encompass tribal traditions and daily life. Images such as *Dance of the Elk Clan Women* (1999) and *Heron Rookery* (n.d.) place women at the heart of tribal life, as they were in traditional Oneida society. The women interact with their animal totems, fusing with them in both body and spirit. Ritual and existence are one and the same, and a symbiosis defines the scene. In *Bird Funeral* (2002), a woman sits at the heart of the ceremonial circle, sewing the funeral shroud that will shelter the deceased bird's soul into the next world.

The Oneida tribe suffered great fracturing but remained a people of solidarity. Oneida Nation historian Anthony Wonderley points out that although the folktales of the Oneida are remote from their native tongues and removed from their original settings, the content ultimately has survived:

> *Especially in nonliterate settings, a culture's narratives are an important medium for conveying such premises of belief and perception, concepts often expressed in mythopoetic language favoring memorable comparison and evoking vivid imagery. Such stories serve as signposts for people navigating together through the richly symbolic language that is the human condition.*[11]

Fifield, in the tradition of all storytellers, seeks to keep cultural memories alive by recounting the old tales and telling new ones in her own way. Drawing on the Oneida tradition of using folklore as a vehicle for tribal unity and extending it to link all Native American peoples, Fifield's images resuscitate fading clan myths that honor women as the center of the life cycle and the keepers of tribal mythology, and at the same time, situate her firmly within this circle.

1. Lisa Fifield, artist's statement; www.lisafifield.50g.com, accessed May 7, 2009.
2. Fifield, interview with Leslie Umberger for the John Michael Kohler Arts Center, April 24–25, 2009; curatorial files at the John Michael Kohler Arts Center.
3. Fifield, in Karen Winegar, "Artist's Indian Heritage Emerges Along with First Exhibit of Drawings," *Minneapolis Star Tribune*, August 24, 1993.
4. Winegar, "Artist's Indian Heritage Emerges." Winegar refers to the 1992 film version of *The Last of the Mohicans*, not James Fenimore Cooper's 1826 novel.
5. These groups were the Seneca, Cayuga, Onondaga, Oneida, Mohawk, and Tuscarora; see "Oneida History," Milwaukee Public Museum, www.mpm.edu/wirp/ICW-156.html, accessed May 6, 2009. Oneida historian Anthony Wonderley cites the original five tribes in this league, excluding the Tuscarora; see Wonderley, *Oneida Iroquois Folklore, Myth, and History: New York Oral History from the Notes of H. E. Allen and Others* (Syracuse, New York: Syracuse University Press, 2004), 4.
6. Herbert S. Lewis, ed., "Introduction," *Oneida Lives: Long-Lost Voices of the Wisconsin Oneidas* (Lincoln: University of Nebraska Press, 2005), xxi.
7. Ibid., xxvi.
8. Nancy O. Lurie, in Lewis, xxxi. Also see Lurie, "The Oneidas of Milwaukee," in Jack Campisi and Laurence M. Hauptman, eds., *The Oneida Indian Experience: Two Perspectives* (Syracuse: Syracuse University Press, 1988), 101.
9. Fifield, in Winegar, "Artist's Indian Heritage Emerges."
10. Fifield, interview with Leslie Umberger.
11. Wonderley, *Oneida Iroquois*, xvii.

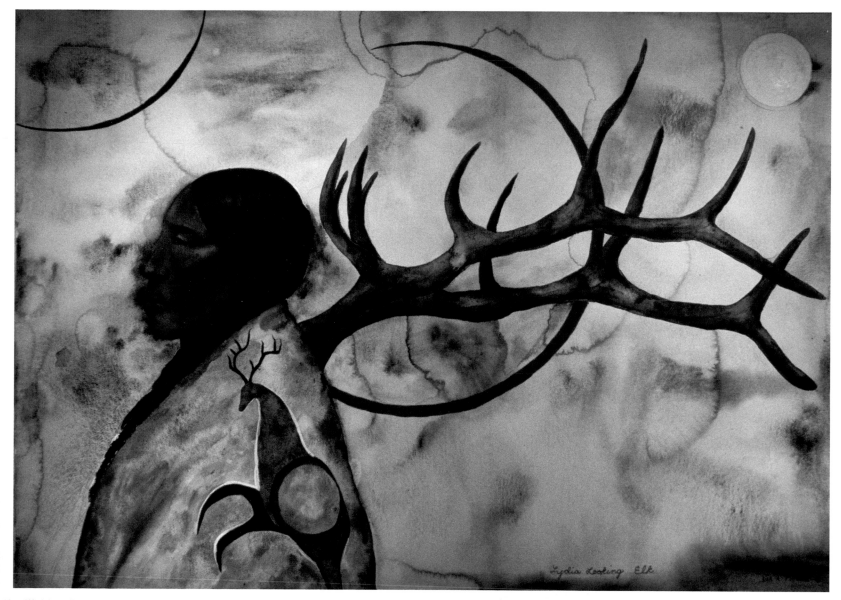

Lisa Fifield, *Lydia Looking Elk*, 2003; Collection of Elizabeth and Shel Danielson, MN.

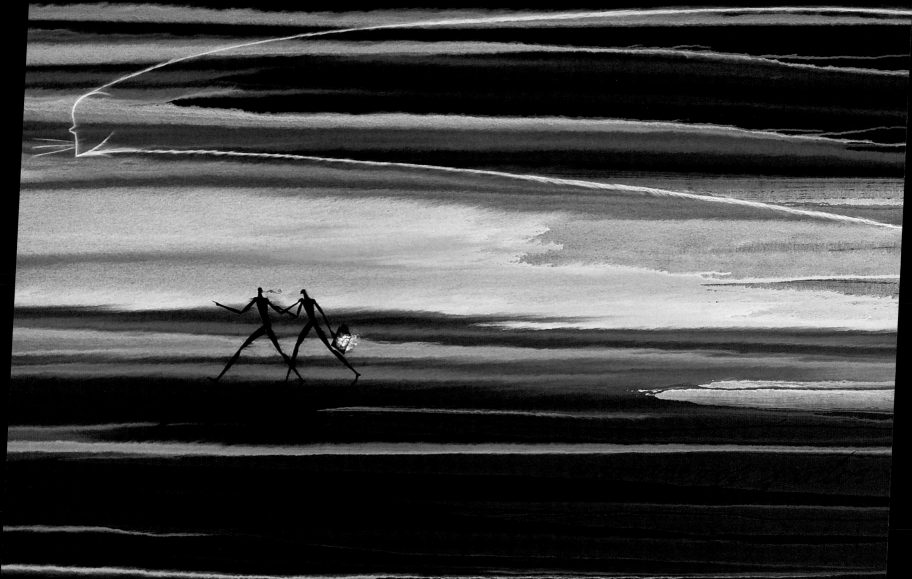

JOSÉ BEDIA (born 1959)
The Nomad's Tools
by Leslie Umberger

José Bedia, 2009; photo:
John Michael Kohler Arts Center.

OPPOSITE: José Bedia, *Caminemos Juntos* (Let's Walk Together) (detail), 2005; Courtesy of the artist.

Complete object information is available in the Catalogue of Works.

Begun just days after Fidel Castro's overthrow of Cuban dictator Fulgencio Batista, José Bedia's life would be rooted in the complex political landscape of the Cuban Revolution. Acumen and vision would shape Bedia into an artist of expansive awareness and universal insights, but Cuba would always serve as the backdrop for his worldview.

Bedia's parents were of modest means, and the family lived in a small Havana apartment. In the days preceding the revolution, Castro had promised to overthrow the dictatorship that had so hugely stratified the rich and poor and to pave the way for democratic prosperity. Within months of the overthrow, however, it was clear that Castro was simply a new brand of dictator. Resistance to him arose quickly, but Castro commenced a brutal campaign of harassment, imprisonment, and execution of anyone he perceived as a threat.

Immediately following the revolution, a great emigration began: hundreds of thousands of Cubans, largely members of the upper economic class, fled in hopes of salvaging their way of life. Castro's seizures of American commercial properties destroyed diplomatic relations, and in February 1962 the United States imposed a crippling trade embargo against Cuba.[1] Those who remained on the island suffered a scarcity of goods from shoes to milk, and, when Castro declared Cuba first a Socialist and subsequently a Communist state, many Cubans feared a life of struggle and looked toward U.S. shores. Between 1965 and 1980, another 375,000 Cubans were allowed to leave for America.[2]

Bedia recalls strife and discomfort emerging in his family's otherwise-happy home as fear and oppression began to mar everyday life. Although Cuba was a syncretic land—a fusion of indigenous peoples,

Africans, and Spanish Europeans—Castro had little tolerance for the various religions that infused the island, and he banned their practice and display. For centuries, Western colonists, imperialists, fascists, Christian leaders, and others had sought to suppress native and non-Western religions. Conquerors of many strains had understood that beliefs and ideals are central to a people's strength; to undermine those lifeways is to break the people's spirit and dominate them. Throughout Latin America and the Caribbean, efforts to quash native religions had succeeded only in part, for, while Catholicism became the overtly dominant religion, it was a unique and varied strain of the faith grounded in old-world ways, ideas, and spirits.

In Havana, Bedia's mother, Caridad Ena, kept a folk-Catholic altar in their home dedicated to Santa (Saint) Barbara. Although she practiced Catholicism, Caridad Ena raised José to respect and call upon the old religions as well. Together they made offerings to their special saint on a regular basis. Bedia recalls the confusion he experienced when his mother asked him to help her dispose of the altar one night. He was aware that his mother had started to present a false public face, realizing slowly that they could be in real trouble simply for the things they believed. She explained to her young son that although the visual display of the altar needed to disappear, the saint herself was safely tucked away at home and that the heart of their faith remained steadfast. This became a way of life for countless Cubans, disguising their Afro-Cuban religions with the

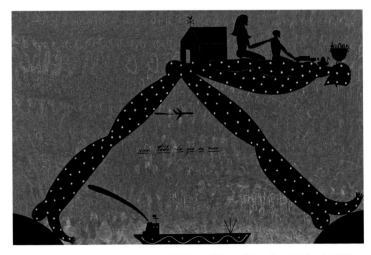

José Bedia, *Casi Todo lo que es Mio* (Almost Everything that is Mine), 1992; Courtesy of the artist.

face of Catholicism as they had done, in degrees, since the Spanish arrived in 1492. For a time, the family planned an escape, but Bedia's father changed his mind and instead joined the revolutionary militia, entrenching the family for good. Although Cubans loved their home country, their lives were marred by fear, and the possibility of leaving became a de facto part of the national consciousness.

Bedia knew from the time he was young that he wanted to be an artist. His parents were hesitant about this choice but allowed him to take the aptitude tests for art school when he was thirteen. When he easily passed, they sent him to the San Alejandro Academy of Fine Arts, which he attended for the next four years. The school's program was framed by the Spanish Academy tradition—still lifes, paintings from live models, landscapes, and genre painting. The material was simple for Bedia and he went on from there into a five-year program at the Superior Institute of Art in Havana. There, with the help of an insightful teacher, Bedia discovered Native American art, African and Oceanic art, and the art of other non-Western cultures the world over. He was swept away by their power and immediacy, and by their utter difference from Western art. From then on, Bedia became a devoted student of indigenous cultures, religions, and artistic practices, traveling and immersing himself in tribal experiences and deepening his own artistic vision.

Before beginning at the Superior Institute, Bedia and his mother met with a *Palero*, or practitioner of the Afro-Caribbean religion Palo Monte Mayombe, which is widespread in Cuba. Like most Catholic Cubans, Caridad Ena still drew heavily on the old religions of Santería (from the Yoruba tradition) and Palo Monte (from the Kongo tradition) in times of concern or life change. Although Bedia did not return to the *Palero* until after he finished his studies, the encounter made a lasting impression. When he did return, he was officially initiated and remains a practitioner of the faith today. Bedia would soon discover that Palo Monte had much in common with many other native and tribal belief systems, and he began to glean and be amazed by an interconnectedness that suffused countless cultures.

Bedia experienced Africa firsthand in 1985 when he was sent to Angola with the Cuban troops, supporting a war against South

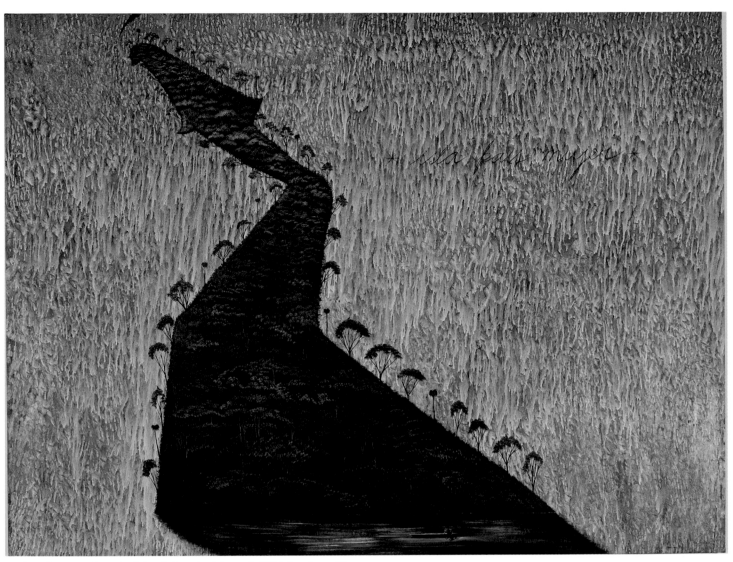

José Bedia, *Isla, Pais, Mujer* (Island, Country, Woman), 2007; Courtesy of the artist.

PAGES 102–103: José Bedia, *La Isla Sola* (The Lonely Island), 1994; Courtesy of the artist.

Africa. "In Cuba they say they don't force you to serve, but they really do. There is intense pressure," states Bedia.[3] He was first approached to go to the war in 1980. Believing that refusal was a viable option, he declined to go, explaining that he had a year left of school and was intent on finishing. The officials were furious and threatened to have him kicked out of the Superior Institute, but somehow that never came to pass. A few years later they returned. By then Bedia had graduated, married, and had a baby son. "I knew if I refused again my family would suffer, so I agreed to go."[4]

As it turned out, Army Chief Raul Castro had decided that the field troops were in need of entertainment, and Bedia was placed in a brigade of artists assigned not to combat missions but to morale boosting. Although most members of the brigade were content to stay in Luanda, the capital city, Bedia and poet Ramón Fernández Larrea made arrangements with troops of supply truckers to go into the heart of the country and really see what it was like. The poverty was intense, but Bedia was impressed by the dignity the Angolans possessed. He began to collect some of the baskets, pots, and carvings they made, and was struck by the way that art was an integral and a vibrant element of life and ritual, rather than a rational domain of training, theory, and philosophy.

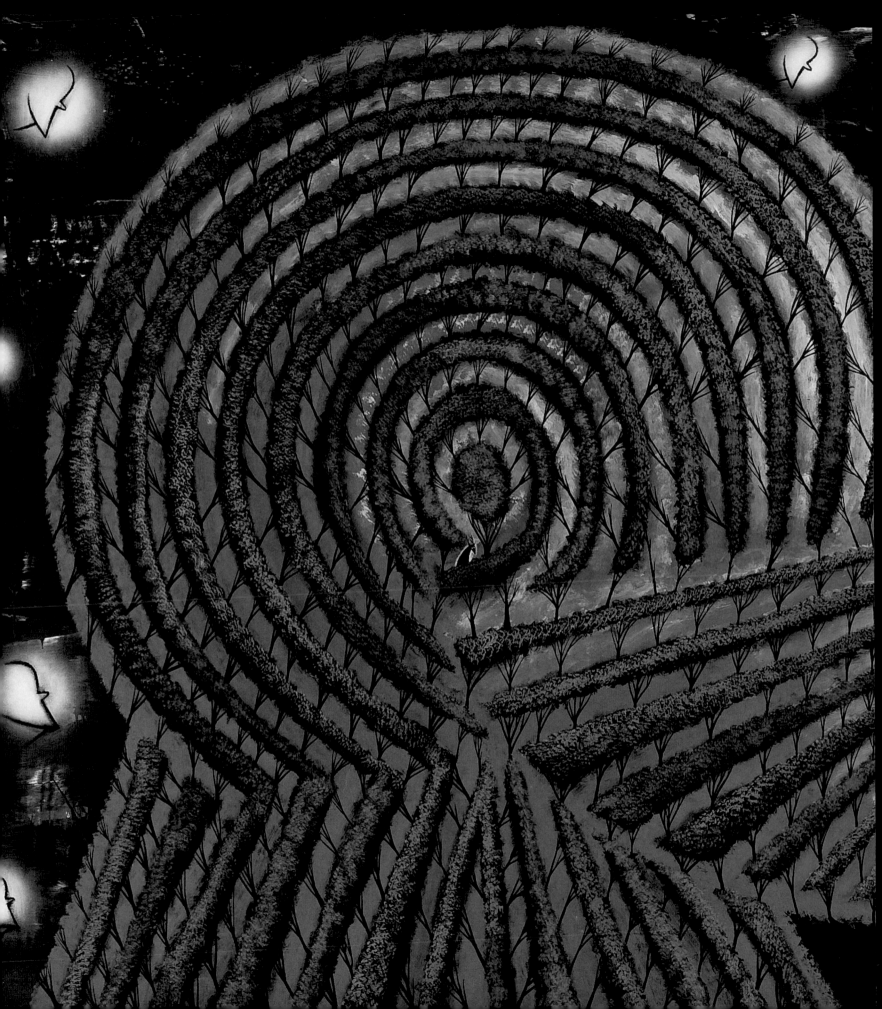

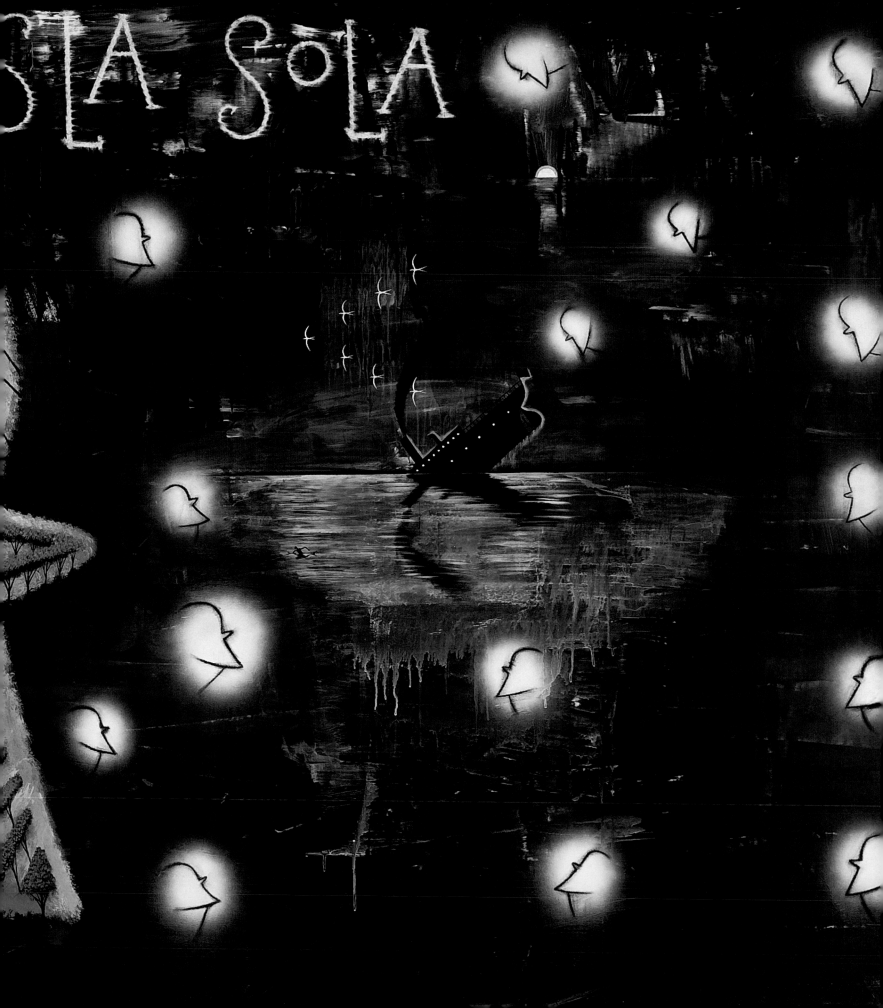

José Bedia, *Y Asi Fue Como Pasaron Los Cosas* (And That's How It Happened), 2008; Courtesy of the artist.

The war was a turning point for Bedia. While in Angola, he promised himself that if he made it through the experience alive, he would get his family out of Cuba. For several years the idea of flight germinated in Bedia's mind, but the time to act did not come until 1990. Several trips to the United States had provided opportunities, but they had not felt right until an artist's grant took Bedia and his family to Mexico City. Bedia speculates that he was intentionally given an opportunity to leave: "Normally they keep the families at home," he explains. "But sometimes they want problematic individuals to leave; they let me take my family and gave me no trouble about it, while others were definitely blocked from leaving."[5] In Cuba, Bedia had begun to experience censorship in art exhibitions. His themes focused largely on Native American

subjects, a re-examination of racist histories and a celebration of native ways. And while there was no overt relationship to Cuban politics, many people interpreted the work as incendiary. Bedia knew there was no turning back.

Leaving home had become a Cuban national endeavor, and by 1993 Mexico was overrun with Cuban immigrants and began deporting them back to Cuba. Bedia's wife had family in Miami, so they decided to join them. Miami echoed Cuba in countless ways, with only ninety miles of water dividing the two. The food, weather, and culture are largely the same, and over half the population in Miami speaks Spanish as a first language. Bedia says he never imagined participating in the typical American dream: "I am an American legally, but I am Cuban by culture," he explains.[6] Bedia

José Bedia, *Ojalá se Hundan los Cielos* (I Wish the Skies Would Fall), 2005; Courtesy of the artist.

appreciates that the United States contrasts with Cuba in countless ways. He enjoys the life he has built in Miami and appreciates that his family is free to believe what they want without persecution, bullying, or censorship from the government. Nevertheless, having moved to the country when he was thirty-six, Bedia does not fully self-identify as an American; Cuba will always be home ground yet he considers himself a sort of nomad who has learned how to bring home with him.

Bedia's large-scale paintings and installations radiate from the axial center of his Cuban identity, ranging thematically from the Native American topics that have always moved him to the African roots of Cuban and Caribbean culture. Time and again the ideas of quasi-exile—the nomad who seeks shelter—and the

wisdom of ancient ways and the folly of the power-hungry define his strongest works. Bedia has become adept at merging imposing scale, recognizable imagery, moody color, and a sense of mystery into enigmatic images that coyly lure, irresistible but never fully revealing all their secrets. Spanish texts overshadow Kongo symbols, alluding to the age-old ways in which dominant cultures dismiss—at their own peril—the knowledge of those they consider inferior. By entwining the familiar and the arcane into multilayered messages, Bedia positions himself as a sort of prophet.

Although those who left Cuba of their own volition are not exiles in the strictest sense—they were not banished by their country—the social and political climate of their native land impelled many of them to forsake the only home they had known,

José Bedia, *Ciertos Rumbos No Pueden Cambiarse* (Certain Routes Cannot Be Changed), 2005; Courtesy of the artist.

not fully comprehending what they might find elsewhere but only that they had to seek it. Bedia uses the Creole character of the Cimarrón to symbolize this state of being. In the lore of the Caribbean mixed-bloods, the Cimarrón is the domestic creature that has fled captivity to become wild again. Embedded in the concept of the runaway slave, the Cimarrón is deeply ingrained in the greater Cuban subconscious.

In pieces such as *Mbua-Ndoki* (Sorcerer Dog, 2004; 2009), Bedia depicts the Cimarrón as a kind of dog, a domesticated animal that has chosen to leave the relative safety of home in search of a better life, a metaphor for both slaves and exiles. Bedia loads the iconography with its African past; the dog itself is a power fetish or *nkisi*. The Kongo *nkisi* can come in many forms—a bundle, a

cauldron filled with items of magic and protection, a suitcase, or really any container wherein all of the ingredients for survival are symbolically contained. The *nkisi* represents the entire universe, a critical set of belongings for the nomad who must remain safe on a dangerous journey and arrive in a new land with the necessary ingredients to begin anew.[7]

By forming the Cimarrón itself as an *nkisi*, a shaped, wrapped, and bundled being, Bedia alludes to the notion that if we have been good students along life's path, we inherently carry within ourselves all the lessons, experiences, memories, skills, and beliefs that will carry us through life. The Cimarrón is symbolically chained to a giant shadow-self—that which will be left behind: island, home, memory, and identity.

José Bedia, *Al Pasito* (One Step at a Time), 2001; Courtesy of the artist.

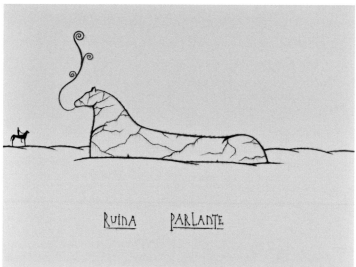

José Bedia, *Ruina Parlante* (Talking Ruin), 2001; Courtesy of the artist.

The looming two-dimensional image appears as a fusion of dog, man, and island. A figure traverses the quasi-landscape; he carries tools that symbolize the Cuban revolution, a machete to fight his way and a scythe to clear his path. Within the island-body, Kongo symbols are inscribed, negotiations for a balance between good and evil. Shaped as a single entity, the land and the culture embody a matrix of powerful beliefs.

As the figure moves toward his goal, he transforms into the dog, the Cimarrón. The Cimarrón moves toward his destination—the upraised finger—and all the powers against him will not deter his progression; his decision to leave has been made. The *ndoki* is a potentially dangerous character, a sorcerer of great will. Lending this spirit to the *mbua* (dog) or Cimarrón who is already laden with tremendous personal intent, the *Mbua-Ndoki* is a character to be reckoned with. Bedia metaphorically warns that the progress of the dog—determined to be free—should not be impeded lest he bite. Heightening the power of the piece, Bedia subverts the traditional Western (passive viewer) perspective and places the vanishing point of this piece behind the viewer, thus implicating her or him in the action. The viewer is unable survey the piece passively, seeming to be directly in the path of the inflamed animal.

The *nkisi* appears throughout Bedia's imagery. In *Caminemos Juntos* (Let's Walk Together, 2005), friends or brothers traverse an ambiguous landscape. A guiding spirit hovers above them and the *nkisi*, in this case a suitcase, is so loaded with the nomads' valuables and amulets that it glows, pulsates. In *Al Pasito* (One Step at a Time, 2001), the traveler carries a heavy load—an anvil. The shadow it casts, however, appears as a house—the home it will someday help him make. His heavy load requires the nomad to move slowly, taking the necessary steps to arrive with the tools of survival. Drawing on a Kongo proverb that says "Little by little, you'll go far," Bedia alludes to the investments one makes in the future. The iron anvil symbolizes not only the tool from which other tools are formed, but also the Yoruba god of iron, Ogun, who must be invited along on the journey to provide the strength needed to begin again.

Although Cuba and Miami have much in common and are relatively close in distance, for countless Cuban, Haitian, and Dominican families the Atlantic straits that divide the countries represent a partitioned world. In *Y Por Aqui Tambien Esta Lloviendo* (And It's Raining Here Too, 1996), Bedia recalls a phone call with his mother who was, at the time, still living in Cuba. It was raining on both shores and they mused about being under the same storm cloud. Close enough to share weather, but unable to touch or see one another, Bedia underscores the enormity of what immigrants must sometimes leave behind.

Mbua-Ndoki (Sorcerer Dog) (installation view, John Michael Kohler Arts Center), 2004; 2009; Courtesy of the artist.

PAGE 110: *Mbua-Ndoki* (Sorcerer Dog) (installation view, John Michael Kohler Arts Center) (detail), 2004; 2009; Courtesy of the artist.

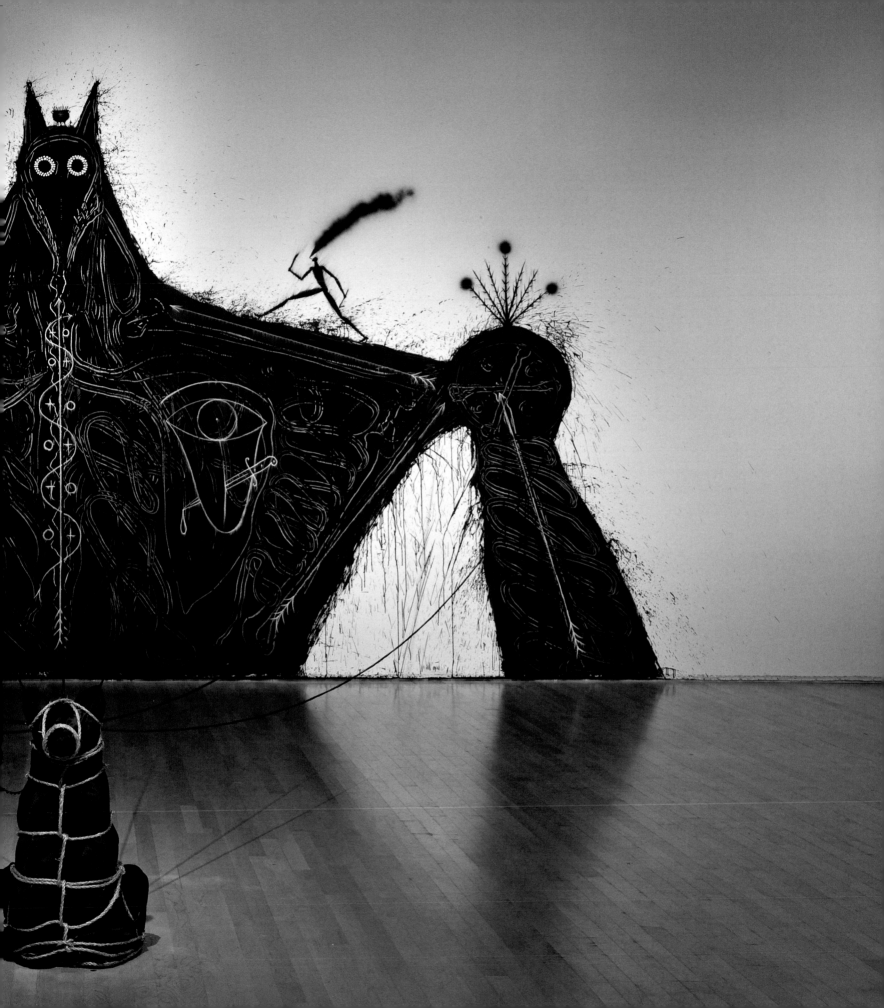

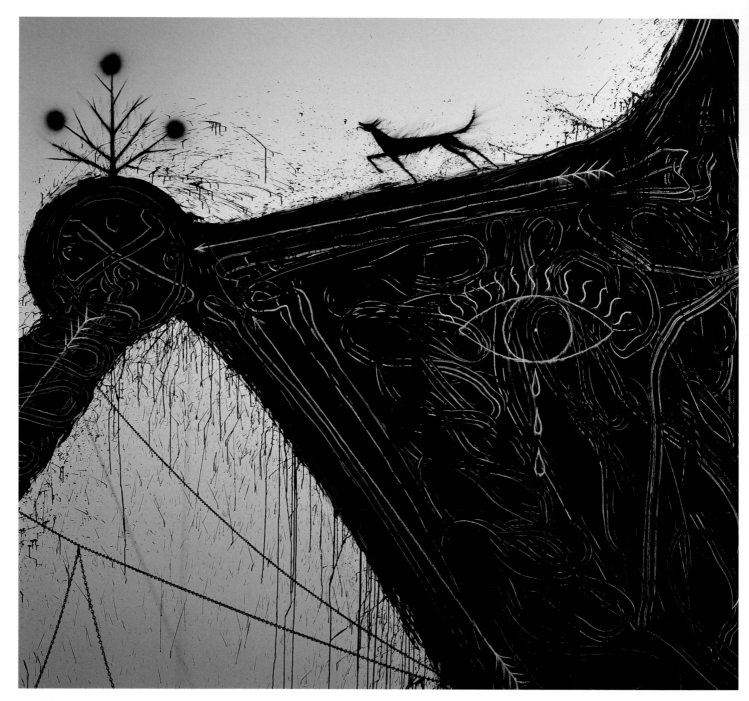

The waters that divide Cuba and the United States appear repeatedly in Bedia's imagery. In *La Isla Sola* (The Lonely Island, 1994), Bedia shows Cuba as a place that has isolated itself from the world and cast its own people into a state of alienation. A man who has tried to leave the island has fallen prey to a new disaster, a shipwreck. Spilled into treacherous waters, he has no choice but to return to Cuba, the endeavor a failure. The island, seeming to have a will of its own, pulls the would-be escapee back into the depths of its labyrinth, a place of frustration and dead ends, but also a place where perseverance can prevail—the truly determined person can find a way out.

Bedia worries that the cultural backlash of the revolution and

communism has resulted in successive generations who are only too happy to be detached from their roots rather than take pride in a rich and diverse history. Instead of looking at the heroes of their shared past and admiring the bravery, foresight, or devotion to the greater good, these contemporary Cubans share a pervasive cynical view of the past that engenders an individualistic nature and makes civic pride unfashionable. For Bedia, this is a dangerous path, further fracturing Cuban identity.

In *Destino Final del Prócer* (The Final Destiny of the Hero, 2007), a deteriorating stone monument peers with futile hope toward a horizon that seems to be forever moving out of reach. The hero peers into a book, lessons from the past being offered to the future, but the future foolishly rejects the past. Bedia's iconic trickster characters desecrate the monument that is already beginning to crack and crumble. In *Y Asi Fue Como Passeron Los Cosas* (And That's How It Happened, 2008) and *Ojalá Se Hundan Los Cielos* (I Wish The Skies Would Fall, 2005), the warmth and clarity of daytime is absent. Bedia's trickster character tells stories to another ancient monument. The ancient figure listens—the past being confronted by the present—and then explodes in frustration with the overwhelming reality of the things he is powerless to change. "Ojalá se Hundan los Cielos" comes from a folk song that pleads for a reversal of truths, a prayer to change things that are well beyond control.

In numerous images, Bedia's horned, cigar-smoking tricksters make the scene to cause trouble; they are the proverbial sand in the oyster, the irritants that bring something new to the fore, or the devil's advocate who, through adverse behavior illuminates an unseen truth. Eshu (Elegba), the Yoruba god of chaos and trickery, and his Palo Monte counterpart, Nkuyo or Lucero, are challenging but very effective teachers. Through provocative acts, they make individuals take careful stock of their own values. Protective spirits are also present throughout his imagery, a testament to faith but also sometimes an acknowledgment of its futility.

In all of his work, José Bedia draws on the past to illuminate the present. Writer Randall Morris has observed that, in this way, Bedia's art becomes a visual extension of oral culture:

He has never joined his contemporaries in the act of rejecting narrative; rather he has embraced it as one of his own folkways and used it as a universal translator of human culture. That narrative is at the very core of what he is and does. Cubans talk. Cubans talk all the time. The fabric of their social structure is held together by essential narratives.[8]

In traditional societies, the role of the storyteller is to serve as a moral compass, one who interprets the roadmap of the past in order to chart future paths. Bedia takes on the role of storyteller in the most powerful ways, finding balance between ancient and modern, good and evil, empowerment and futility, sacred and secular, magical and quotidian. Through his layered and powerful imagery, Bedia becomes a living *nkisi*, a powerful vessel that contains the universe and provides the nomad with all the tools of cultural survival.

1. This embargo remains in place today, although recent gestures suggest a rethinking of those restrictions and of Cuban diplomatic relations in general. For a brief overview of current events pertaining to U.S.-Cuban relations, see Sheryl Gay Stolberg and Damien Cave, "Obama Opens Door to Cuba, but Only a Crack," *New York Times*, April 13, 2009; and the following articles on the BBC online news service: "Clinton Admits Cuba Policy Failed," April 17, 2009, news.bbc.co.uk/2/hi/Americas/8005153.stm, and "Obama Offers Cuba 'New Beginning,'" April 18, 2009, news.bbc.co.uk/2/hi/Americas/8004798.stm.
2. General information on Cuban history is drawn from Lynn Geldof, *Cubans: Voices of Change* (New York: St. Martin's Press, 1992); José Cantón Navarro, *History of Cuba: The Challenge of the Yoke and the Star* (Havana: Si-Mar, 1998); and Richard Gott, *Cuba: A New History* (New Haven, Connecticut: Yale University Press, 2004).
3. José Bedia, interview with Leslie Umberger for the John Michael Kohler Arts Center, March 24, 2009; curatorial files at the John Michael Kohler Arts Center.
4. Ibid.
5. Ibid.
6. Ibid.
7. General information on *nkisis* can be found in Robert Farris Thompson, *Face of the Gods: Art and Altars of Africa and the African Americas* (New York: Museum for African Art, and Munich: Prestel, 1993).
8. Randall Morris, "Conversing with Culture: Paintings and Drawings by José Bedia," in *Tribal & Textile Arts* exh. cat. (San Francisco: Fine Art of Native Cultures, 2009), 20.

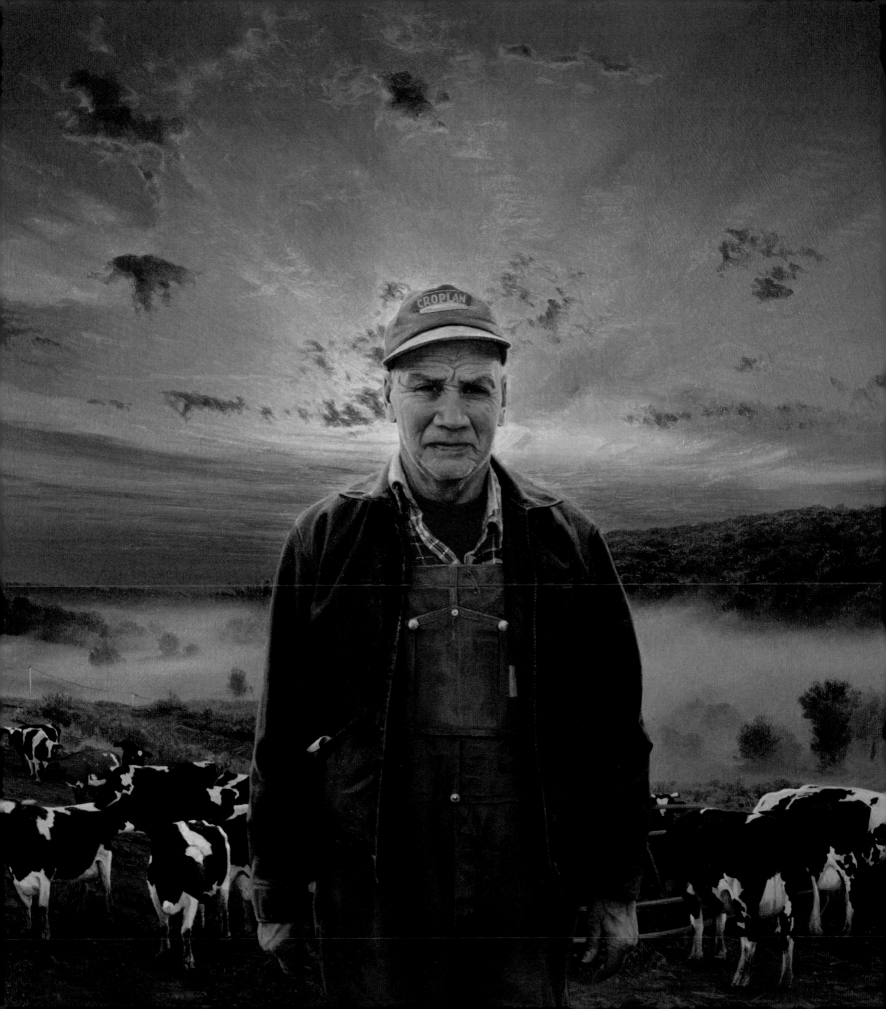

DAVID LENZ (born 1962)
The Unsung Heroes of our Worlds
by Jennifer Jankauskas

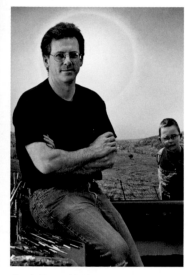

David Lenz, 2009; photo: John Michael Kohler Arts Center.

OPPOSITE: David Lenz, *Getting in the Cows*, 2001; Collection of Mr. and Mrs. John F. Monroe, WI.

Complete object information is available in the Catalogue of Works.

Luminosity, hope, joy, and inner strength emerge from Wisconsin artist David Lenz's canvases. Working in a precise figurative-realist style, Lenz carries on the traditions of American landscape painters, the Hudson River school painters, and the Regionalists. However, it is the subjects of his paintings that capture the imagination; to Lenz, they are the unsung heroes of our world, and he tells their stories in his works of art.

Lenz's story, and his connections to those that he portrays, is interesting in itself. Born in Milwaukee, Wisconsin—one of five brothers— Lenz grew up in the neighboring town of Brookfield. Art captivated him from an early age, as the love of art runs in his family. Lenz's grandfather was a painter who often created affordable replicas of famous works, and, as a boy, Lenz spent a great deal of time in his studio observing his grandfather and learning the craft. Lenz's father, an art dealer specializing in early Wisconsin art and nineteenth century American and European realism, often brought beautiful images into their home, creating an environment in which Lenz was surrounded by paintings.

On the advice of his high-school art teacher Lenz decided to pursue art at the University of Wisconsin-Milwaukee. Ever practical, Lenz studied visual communications and graphic design rather than fine art. Upon graduation he became an art director first for a publishing company and later in advertising. Only four years into his career, Lenz had saved enough to finance a one-year sabbatical from the commercial realm. He quit his job and boldly embarked on his dream of becoming a full-time painter.

Inspired by the Hudson River school of painting, particularly the work of Frederic Church (1826–1900), Lenz was at that time painting what he terms "Wisconsin Canadian-style landscapes."[1] With his decision to focus on painting as a career, he moved to the east side of Milwaukee, a place

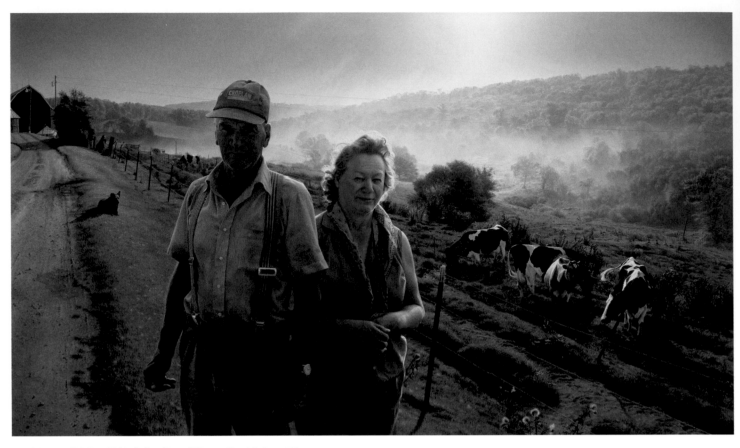

David Lenz, *Thistles*, 2001; Collection of Pieper Electric Inc., WI.

familiar to him from his time at the university. Here he realized that the pastoral landscapes he had been working on felt empty, and, as he looked out his apartment window, he became inspired by the city scenes around him.

One snowy winter day provided a turning point for Lenz's art. Visiting one of his favorite spots to view the city, the McKinley Reservoir at North Avenue, Lenz observed a group of children, apparently out of school on a snow day, playfully enjoying their spontaneous holiday. He began taking photographs of them sledding down the hill. Quickly after developing the images, Lenz was inspired to create his first city scene with children. This first image, *Riverwest* (1990), portrays the back view of a young boy holding a sled and contemplating which track down the hill to take. Lenz offers this image as a metaphor for discovering meaning in the multiple sled tracks and attempting to find and follow the right

one. From the beginning of sketching out the scene, he felt he was "on an artistic high" and realized that he had "found [his] life's work."[2] From that point on, the landscapes that had served as his own foundation would play a background role for his figurative representations.

Since that time, Lenz has focused his attention on those whom he considers to be the unsung heroes around us. He says they are just "ordinary people, yet they are the people I most admire and find interesting."[3] By portraying the quiet dignity and grace of Milwaukee's inner-city children at play, a farming couple from Sauk County, and people with intellectual disabilities, Lenz shines a light on diverse corners of our world and brings us in contact with people we might not ordinarily meet.

One of his first narrative series of paintings depicts children from Milwaukee's predominantly African American neighborhood,

Riverwest. Although Lenz's background in a suburban, white, middle-class neighborhood is very different from that of these subjects, his social conscience drew him to them. Lenz was driven to demonstrate that—contrary to the media attention on extreme poverty, social problems, and crime in the area—smart, hard-working people live here. Lenz also tried to illustrate that despite being the richest country of the world, we have pockets of extreme poverty in the heart of every city in America. To him, these youths—from varied backgrounds and situations, and despite challenging circumstances—are openhearted participants in a universal story of childhood.

The inner-city children series is not about portraiture per se; instead, Lenz was interested in revealing the openness and joy of youth. Working with a number of children from the Boys and Girls Clubs and the YMCA, Lenz selected which subjects to paint based upon their facial expressions in the photographs. Often, as he was snapping photographs, kids would mug for the camera, but, as he surveyed his pictures, it was the children who had more introspective expressions that caught his eye. In those looks, he saw a complexity that hinted at the fuller story he wanted to convey.

After ten years of painting children, Lenz decided to move more deeply into portraiture, while keeping the landscape an integral part of the narrative. He started to paint people he knew personally, whose stories were, he thought, important to tell. Moving from the city into rural scenes, Lenz's next body of work reveals the strength of independent dairy farmers Erv and Mercedes Wagner, who struggled to hold on to their fifteen-cow farm in the face of growing agri-industry.

Lenz first met the Wagners in 1992 when he bought a piece of land in Sauk County, Wisconsin. Interested in the history of the area, Lenz immediately introduced himself to his neighbors, the Wagners. Erv was very welcoming and from their first encounter demonstrated a protective, paternal instinct for Lenz. To Lenz, part of the enjoyment of spending time in Sauk County was visiting the Wagners and getting to know them. Their history with farming, Erv's character, personality, and the experiences that had etched his face fascinated Lenz and fueled his desire to tell their story. In 2000,

eight years after meeting Erv and Mercedes, Lenz finally asked if he could paint them. Lenz recalls that interesting conversation:

> *I had never talked about my work—we always talked about their farm. And what I do is so separate from what they do. So I said, "Well, you know I'm a painter, I'm an artist and I've been painting in the city but I want a change and I wonder if it would be all right to paint pictures of your farm and of you two?" And they both kind of blushed. And said, "Well, we think that would be all right." And then Erv said, "You just come here whenever you want, walk around like a place like it is yours, take all the pictures you want."* [4]

While the Wagners may not have understood why Lenz wanted to paint their portraits and felt a bit embarrassed by it, the resulting images show them to be hard workers who epitomize the steadfast labor of farming. One piece from the series captures their story particularly well: *Thistles* (2001) was the first large painting Lenz created depicting the couple together. In this image, the Wagners

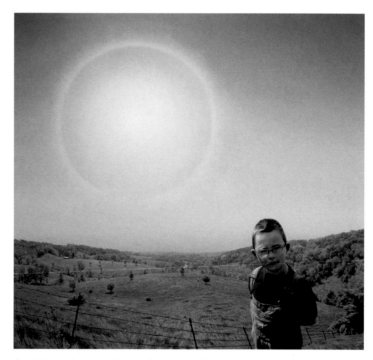

David Lenz, *Sam and the Perfect World*, 2006; Collection of David Lenz, WI.

stand in the foreground, on their farm, and cows from their small herd graze behind them. Separating the cows from the rest of the land is a line of thistles, which are a perpetual problem for Wisconsin farmers. Classified as noxious weeds, thistles can take over a pasture if they are not cut down and can reseed in areas where the cows have walked and broken the ground. The cyclical nature of this phenomenon is symbolic of the never-ending manual labor of dairy farming and farming in general. Lenz illustrates the daily toil of this lifestyle, depicting it in worn clothing and bodies, even in Mercedes' and Erv's labor-swollen knuckles. Lenz captures the humbleness of this long-time team who pragmatically go about their routine of caring for their farm and producing food. He believes that the Wagners, and other farmers like them who barely get by, are the backbone of modern society and that it is through their efforts that city life exists, that people can go to stores to pick up food rather than grow or raise it themselves.

Another life-changing moment, one that ultimately would have a great effect on Lenz's art, was the birth of his son Sam.

David Lenz, *Dairyland*, 2003; Collection of Mr. and Mrs. Daniel J. Bader, WI.

Certainly, becoming a father has an impact on any man's life, yet Lenz's experience was different in that Sam was born with Down syndrome. Lenz says that having Sam "definitely changed my view on the world and opened me up to almost a whole culture that I did not know anything about."[5] His son has also become the most personal subject of Lenz's art. The first major piece, *Sam and the Perfect World* (2006), had been germinating in Lenz's mind for a while, but it was a portrait competition hosted by the Smithsonian National Portrait Gallery in Washington, D.C., that provided the "final little nudge I need[ed] to paint a picture exclusively about Sam and his role, his place in the world."[6] This depiction of Sam won first prize at the 2006 Outwin Boochever Portrait Competition and earned Lenz serious recognition as a painter.

Sam and the Perfect World portrays Sam against an idealized Wisconsin landscape. Based on a view from his family's land, Lenz renders the fertile earth in rolling hills reminiscent of works by Regionalist painter Grant Wood, one of Lenz's influences. The perfectly manicured landscape shows the brush cut down for pasture use. To Lenz, this obsessive pruning back of nature symbolizes the way that humans have subverted nature into a vehicle for their own endeavors. "You look at it and [it] seems

David Lenz, *Lone Tree*, 2004; Collection of Barbara Applegate, WI.

David Lenz, *Sunrise*, 1998; Collection of Barbara Stein, WI.

Lenz accomplishes this by first photographing his subjects living their lives. He is not concerned with the background when he photographs people; his work is all about capturing the lighting, the angle, and the expression. Often his paintings are a composite of multiple photographs. Taking the imagery beyond photo-realism, Lenz adds layers of metaphor. For example, the luminosity depicted in all of his paintings symbolizes a heavenly presence while simultaneously paying homage to the art historical influences that sustain him: Frederic Church and the American Hudson River school.

Painting is a long, intense process for Lenz, but it is a joyful endeavor allowing him to compassionately illuminate ordinary people living extraordinary lives. With his sensitive portrayals, Lenz aims to capture people's attention, to bring an enhanced understanding of the world, to shift attitudes, and hopefully enrich— in small some way—the life of the viewer.

idealized, but it is also tortured."[7] The idea of highly valued perfection is particularly problematic for Lenz and it hit hard when Sam was born. His son will never live up to the standard of perfection hoped for, expected, and demanded by mainstream culture and thus there is a barrier separating Sam from full participation in the rest of the world. Lenz depicts this aspect with a barbed wire fence dividing Sam from all that lies beyond.

This painting is also about hope and what Sam can teach us. Lenz uses the sunlight as a metaphor for the divine, and emphasizes this by incorporating a halolike ring around the sun. The bright sunshine hits the side of his face, yet, through the glare, he looks straight out at us to question what role we play in this scene. Leaning forward, Sam is both observer and critic, challenging our ideas of perfection.

All of Lenz's paintings—which he describes as journalistic—not only illustrate the individual stories of his subjects but also depict the universal. Through these meticulously detailed paintings, imbued with metaphor and luminosity, Lenz provides a glimpse into the lives of others by trying "to capture the personality of the people, the situation that they're in with the nitty-gritty details of their everyday life, in an honest and straightforward way."[8]

1. David Lenz, interview with Jennifer Jankauskas for the John Michael Kohler Arts Center, March 9, 2009; curatorial files at the John Michael Kohler Arts Center.
2. Ibid.
3. Lenz, interview with Jeffrey R. Hayes, "Painting the Unsung: An Interview with David M. Lenz," *David M. Lenz: Urban and Rural Paintings of Wisconsin* exh. cat. (Milwaukee, Wisc.: Charles Atlas Art Museum, 2004) 12.
4. Lenz, interview with Jennifer Jankauskas.
5. Ibid.
6. Lenz, quoted in Laurie Arendt, "David Lenz's Perfect World," *Milwaukee Journal Sentinel,* January 9, 2007, accessed online www.gmtoday.com/contents/NSL?2006/December/83.asp.
7. Lenz, interview with Jennifer Jankauskas.
8. Ibid.

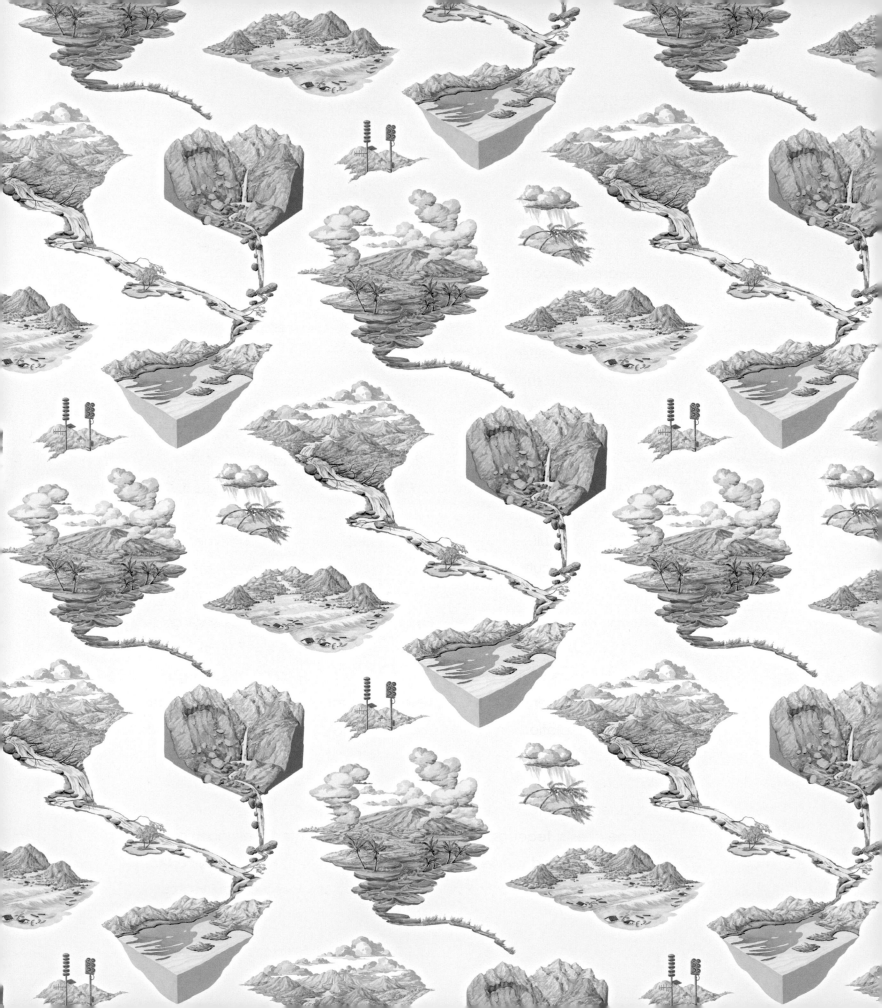

ALISON MORITSUGU (born 1962)

Paradise Revisited

by Elsa Lenz Kothe

Alison Moritsugu, 2004; photo: Chris Ramirez.

OPPOSITE: Alison Moritsugu, *Early Warning Repeat* (wallpaper), 2009; Courtesy of the artist.

Complete object information is available in the Catalogue of Works.

When Alison Moritsugu makes the trip back home to her native Hawai'i, she habitually travels around the perimeter of the island of O'ahu. These visits trigger childhood memories of sugar cane and pineapple fields seen from the backseat of the family car on drives to 'Ewa Beach or the beaches on Kaua'i.[1] They also bring back memories of her mother's and grandparents' keen ability to spot wild fruits and shellfish, traits honed as part of the "generation [that] lived off the land more."[2] During these drives, her father shared information about the sugar cane industry— something he knew well. These days, the drive is markedly different, and Moritsugu is more likely to see housing and resort developments than sugar cane and pineapple fields. These changes are at the core of Moritsugu's body of work, *Paradise Revisited*, in which she explores the natural and cultural landscape of her childhood home.

Born in Honolulu, Moritsugu grew up in the 1960s and 1970s when Hawai'i still "felt culturally isolated" and had not yet become as globally connected as it is today.[3] Her great-grandparents emigrated from Japan, although their Japanese heritage was a limited part of her upbringing; Hawai'i was home. Her family history is intertwined with the industries that shaped the economy and image of Hawai'i, particularly the sugar industry. Her father was a career research chemist for the Hawaiian Sugar Planters' Association, and her grandmother, great aunts, and great uncles worked for the Wilcox family on the Grove Farm sugar plantation on Kaua'i. Moritsugu's grandmother emulated the world of the Wilcox family by gathering the few precious material possessions she could afford, such as hope chests, teacups, and spoons that "represented the wealth and status that she had no means of attaining."[4] Moritsugu was introduced to the sugar industry through early visits to her father's research lab, where

she helped sort individual sugar crystals with tweezers for research projects. Her mother, an art teacher, introduced her to the arts by keeping a closetful of materials on hand for Alison and her brother to use anytime they wished.

Moritsugu spent her childhood exploring her natural surroundings: hiking along the streams near her home, exploring the slick rocks and darting fish, and watching the weather in case of rainfall that could lead to flash floods. When she left the islands at age eighteen to attend college at Washington University in St. Louis, and later at the School of Visual Arts in New York City, her parents supported her decision to "get off the rock" and pursue her education on the mainland, just as they themselves had done.[5]

Moritsugu settled in New York state, first in the city, and later in Beacon, north of Manhattan along the Hudson River. Moritsugu's need to remain grounded in the land followed her from Hawai'i to the mainland. Early on, her sense of land was situated in directional points, such as mauka, makai, 'Ewa, and Diamond Head. She explains that points of reference in Hawai'i are always centered on natural features—one might be directed to travel toward the mountains or toward the ocean—which made it difficult to adjust to the cardinal orientations of the mainland: north, south, east, and west. Regardless of where she finds herself, Moritsugu feels compelled to discover and comprehend, in detail, the topography of the land and how she "physically fits into the landscape."[6]

During her visits home, Moritsugu increasingly noticed dramatic changes to the land she had once known so intimately. There were outbreaks of leptospirosis in the streams she had regularly played in as a child. The monkeypod trees, once common in their neighborhood, started to disappear. The view from her parents' home, which used to extend to the ocean, was now interrupted by a wall of concrete created by real estate developments. As these changes increased, Moritsugu's growing sense that she needed to address these transformations in her art accelerated. Since 1993, Moritsugu had critically examined historical topics of American landscape and development, but suddenly those issues were personal, and Moritsugu decided to address the issue of Hawai'i's pronounced changes. Not interested

in "selling more of the tourist image of Hawai'i," she chose to explore the state's transformation in a way that addressed the historical trajectory of Hawai'i's land, culture, and economy.[7]

Paradise Revisited, a body of work resulting from Moritsugu's exploration of Hawai'i's landscape, is thoroughly steeped in the hybrid nature of Hawa'i's culture. The only options for the islands' inhabitants and their environment were to "be isolated ... or to take part in this global world."[8] Considering the Polynesians who originally traveled from the Marquesa and Society Islands, Captain James Cook's arrival on the islands and subsequent introduction of Europeans, and waves of Chinese, Japanese, Filipino, Portuguese, as well as immigrants from other countries, Hawai'i's "landscape is a collective and interactive production [with] the land affecting those who land on it, and vice versa, offering clues to the cultures that have formed it."[9] The early landscape of Hawai'i evolved from one of harsh volcanic rock (in which only hardy plants survived) to a place of introduced Polynesian species. It later became a land defined by the internationally marketable crops developed by Europeans—sugar cane and pineapples—and the lush, non-native, exotic flora that were introduced by various travelers and that today are ubiquitous in imagery of Hawai'i. These botanical transformations reflected the islands' cultural changes.

Paradise Revisited is composed of a variety of paintings and sculptures that Moritsugu designed to be conceptually and visually cohesive. A fountain, ornate wallpapers printed from original gouache paintings, two landscape paintings, and an elaborate sculptural sconce, address—individually and as a group—the changes in Hawai'i's natural, cultural, social, and economic landscape. Intentionally adopting forms traditionally associated with the decorative arts, particularly those that mark status, while visually incorporating elements native to the islands, Moritsugu references Hawai'i's hybrid culture. She notes that her use of these specific forms draws upon their capacity to "show something about the culture and the time in which they were created."[10]

OPPOSITE: Alison Moritsugu, *Lava Flow* (detail), 2009; Courtesy of the artist.

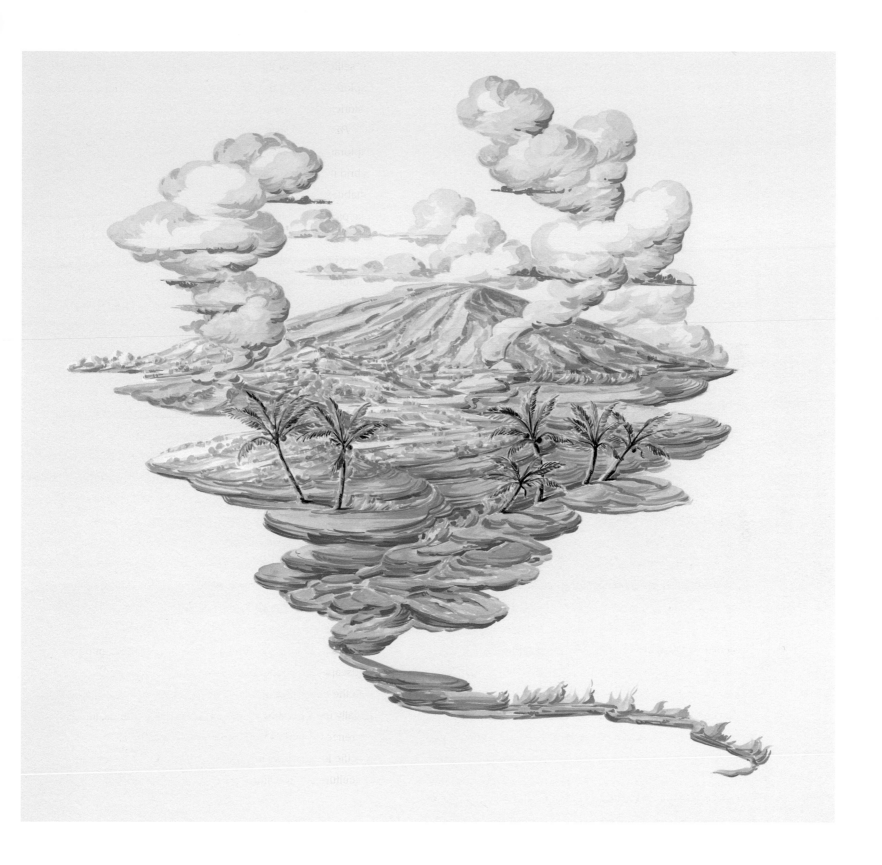

Alison Moritsugu, *Banana Poka*, 2007; Courtesy of the artist.

The ornate koa wood frames that surround the landscape paintings *Big Pineapple* and *King Cane* (both 2007) allude to the power those industries had on the islands. The frames echo both the crowns of the Kalākua monarchy and the pineapple top. Moritsugu uses this crown reference to represent the near-royal status that the cane and pineapple industries held in the island economy and culture. The frames also reference historical Hawaiian objects, specifically wooden furniture and decorative objects that Hawaiʻi's last king, David Kalākaua, commissioned for his palace.[11] Although Kalākaua's furniture incorporated Hawaiian elements, such as native woods like koa, it was built and carved by European artisans who incorporated elements of European pageantry. By referencing this hybridization, Moritsugu suggests that the royal furniture itself foreshadowed the fall of the Hawaiian kingdom to American statehood and the dramatic, irrevocable change that entailed.

Moritsugu's paintings mark the decline of the pineapple and sugar cane industries. In *Big Pineapple*, the seemingly tranquil scene captures a snapshot of economic conversion as the pineapples are left unharvested and the land awaits the next cash crop or resort development.[12] The complex layers of historical, cultural, and economic meaning embedded in these paintings portray not just a landscape but a site of human intervention and will, a landscape that critic and writer Lucy R. Lippard describes as embodying "the results of the ways that land is formed by social relations and the ways social relations are formed by the land."[13]

Central to the notion of landscape as a collision of nature and culture is *Invasive Repeat* (2007), the meticulously designed wallpaper that acts as a grounding element in *Paradise Revisited*. In each section of *Invasive Repeat*, a non-native species visually consumes an embedded image of a native species. Lantana infringes on *kokiʻo* (a relative of the hibiscus tree); banana poka devours lobelia; and the octopus tree envelops *ʻakūʻakū* (cyanea platyphylla). Also hidden among the invasives are native bird species that are either endangered or extinct, such as the *ʻōʻō* (black honey eater), *ʻelepaio* (a species of flycatcher), and *ʻoʻo-nuku-mu* (black mamo honeycreeper). Moritsugu uses what is a seemingly innocuous decorative form—wallpaper—to turn these invasive acts that have transformed the landscape of Hawaiʻi into a hypnotic repetition of pattern and foliage.

Moritsugu created a new wallpaper piece especially for the installation of *Paradise Revisited* at the John Michael Kohler Arts Center. In *Early Warning Repeat* (2009), she subverts the notion of Hawaiʻi as a tame and welcoming paradise by presenting vignettes of natural disasters that are common to the islands and are entwined with her family's stories and her own childhood—including flash floods, hurricanes, lava flows, landslides, and tidal waves. She explains that while people in Hawaiʻi do not live in constant fear of these natural occurrences, the possibility of a life-changing natural disaster is always present in the background, much as it is quietly present in the inconspicuous backdrop of her wallpaper. Moritsugu designed *Early Warning Repeat* in such a way that the threats recede visually to the background, much as her family's recollections of danger retreat from the foreground of their everyday concerns in stories such as the 1946 tsunami that killed

159 people in Hawai'i or rockslides they encountered while hunting along the Nā Pali coast.

Moritsugu explains that, in Hawai'i, looming natural disasters are embodied in a general sense of concern, rooted in a watchfulness of and respect for the land. For instance, television coverage of lava flows threatening towns on the Big Island and the sound of sirens signaling a practice alert for tsunamis were constant in Moritsugu's childhood. Similarly, a boulder that sits in her parent's backyard is a tangible reminder of potentially fatal rockslides that may occur without warning. *Early Warning Repeat* highlights the precarious balance of Hawai'i's renowned temperate weather with its history of treacherous natural disasters; it also comments on an inherent native awareness of the land and weather, something largely absent among the tourists who might themselves be in danger.[14]

Moritsugu developed her wallpaper pieces with an educational purpose in mind, to make it possible for the viewer to learn more about Hawai'i's changing environment by inspecting the details of the wallpaper. She also addresses the idea that seemingly passive elements of home décor were often highly politicized. In particular, Moritsugu references and critiques the exoticized wallpapers created by French entrepreneur Joseph Dufour (1744–1829) that portrayed Captain Cook's voyages.[15] He designed scenic panoramas showing the European "discovery" of the Hawaiian islands— arguably propaganda pieces that portrayed the native populations as curiosities. Moritsugu notes that they "are so interesting because they are so wrong."[16] Couched as "historical," the seemingly innocent decorative wallpapers subtly disguised the underlying colonial presumptions of a foreign land that is ripe for social, cultural, and economic transformations. Alternately, Moritsugu uses *Invasive Repeat* to show the results of this cultural and natural invasion, namely, the loss of endemic species to invading flora and fauna, and she uses *Early Warning Repeat* to challenge the notion of Hawai'i as a passive paradise.

While the loss of native species is apparent to Moritsugu in her visits home, she has found that *Paradise Revisited* serves an educational function for those less cognizant of these changes.

Alison Moritsugu, *Octopus Tree*, 2007; Courtesy of the artist.

During an exhibition of *Paradise Revisited* in Hawai'i, Moritsugu was surprised by the lack of awareness—even among local residents— about threatening invasive species. Similarly, many visitors were unaware of the historic references of the *Candlenut Sconce* (2007), which incorporates spires of *kukui* nuts. These nuts were once used in Hawai'i as a source of light by stringing several nuts together and burning the oily meat. Now, they are mainly used in tourist kitsch items such as necklaces. Moritsugu recalled, "It was surprising that all the references in my work which I had assumed to be obvious were just the opposite. My work took on an added educational component."[17] She was concerned that viewers would presume she was an outsider commenting on commonly known information about Hawai'i's endemic and invasive species. But those fears proved to be unfounded: the feedback she received, instead, indicated that most visitors were unaware that species so ubiquitous on the island—and thought of as quintessentially Hawaiian—are often parasitic and invasive.

Since her early days in landscape painting, Moritsugu has

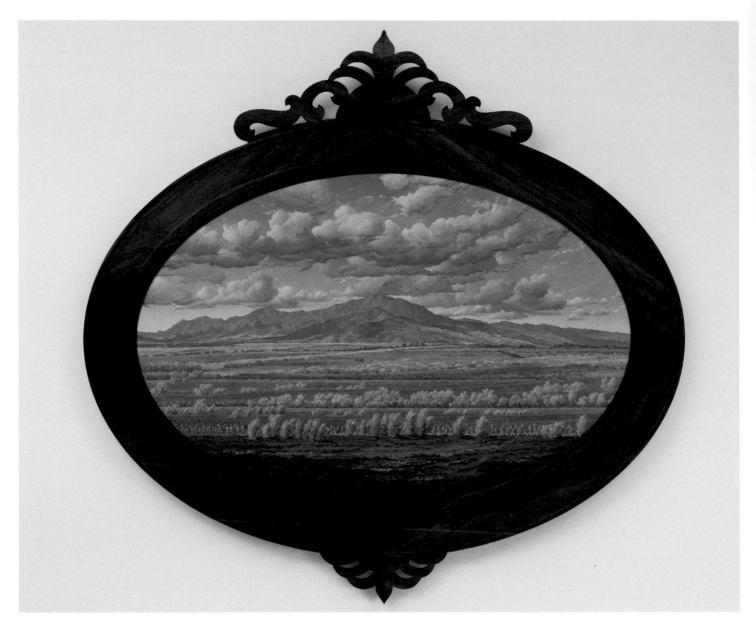

Alison Moritsugu, *Big Pineapple*, 2007; Courtesy of the artist.

used techniques that reference well-known landscape painters. Lucy R. Lippard has noted that landscape images similar to Moritsugu's include "an awareness of power relations as the agent of spatial production."[18] Beginning as a printmaker, Moritsugu launched her personal investigations in landscape painting as a result of frustration with the lack of depth achievable with ink. Her search for a technique that could reproduce a realistic sense of depth and a luminous quality of light led her to look at the Barbizon school, the Hudson River school, and the Luminist painters. Moritsugu notes that although she loved painting, she did not "want a painting to be *just* a painting," so she started using log slices, stumps, and branches instead of canvas.[19] Curator Leslie Umberger has observed that by breaking her landscapes into fragments of imagery on wood pieces, "Moritsugu intimates that in the large sweeping vistas of the romantic landscape, the greater picture was missed, a picture that included the ravaging of the land and its occupants."[20]

In *Paradise Revisited*, Moritsugu again plays with the traditional idea of "landscape," using images and shapes of the land to question its ravaging by both natural and social forces. By creating beautiful objects, Moritsugu entices the viewer, who, once engaged, begins to apprehend the unraveling of the beauty that is embedded therein. Through images and objects, Moritsugu creates a metaphor for the loss of the native environment and the social structures that have long protected the land in Hawai'i. The inviting beauty of *Paradise Revisited* belies, as Lippard notes, the "looming shadow of an ominous future imposed by forces uncontrollable or uncontrolled" that threatens the land in Hawai'i.[21]

Moritsugu hopes that just as *Invasive Repeat* heightened her own understanding of threatened and endangered flora and fauna—not just in Hawai'i, but around the world—her work may bring a similar awareness to viewers. She sees the inherent irony in the idea of returning to "paradise," all too aware that as a landscape changes, the paradise once cherished will never truly be available again. Nevertheless, by raising consciousness about natural and cultural changes in Hawai'i's landscape, Moritsugu hopes that she can effect positive change in a variety of environments and let new generations discover their own version of paradise.

1. Alison Moritsugu, unpublished notes about the work included in the *Paradise Revisited* series, June 25, 2007; curatorial files at the John Michael Kohler Arts Center.
2. Moritsugu, interview with Elsa Lenz Kothe for the John Michael Kohler Arts Center, February 28, 2009; curatorial files at the John Michael Kohler Arts Center. General information is taken from this interview unless otherwise noted.
3. Moritsugu, interview with Elsa Lenz Kothe.
4. Moritsugu, e-mail correspondence with Elsa Lenz Kothe, February 27, 2009.
5. Moritsugu, interview with Elsa Lenz Kothe.
6. Ibid.
7. Ibid.
8. Ibid.
9. Lucy R. Lippard, "Undertones: Nine Cultural Landscapes," *The Pink Glass Swan: Selected Essays on Feminist Art* (New York: The New Press, 1995), 311. For information on immigrants in Hawai'i, see www.hawaiian-roots.com/immigrants.htm.
10. Moritsugu, interview with Elsa Lenz Kothe.
11. King Kalākaua was the last reigning king of Hawai'i from 1874 to his death in 1891. Kalākaua was succeeded by his sister, Queen Lili'uokalani, but the monarchy lost much of its power during Kalākaua's reign; this was viewed by many as the beginning of the end for the kingdom. See Ralph S. Kuykendall and A. Grove Day, *Hawaii: A History, From Polynesian Kingdom to American State* (Englewood Cliffs, N. J.: Prentice-Hall, 1961).
12. Allison Wong, "Paradise Revisited: Recent Works by Alison Moritsugu" exh. brochure (Honolulu: The Contemporary Museum at First Hawaiian Center, 2008).
13. Lippard, "Undertones," 311.
14. Moritsugu, interview with Elsa Lenz Kothe; and e-mail correspondence with Elsa Lenz Kothe, April 24, 2009.
15. For a history and sample images of Dufour's *Les Sauvages de la Mer Pacifique [The Voyages of Captain Cook]* (1805), see www.nga.gov.au/Conservation/Paper/LesSauv.cfm.
16. Moritsugu, interview with Elsa Lenz Kothe.
17. Moritsugu, written correspondance to Elsa Lenz Kothe, May 6, 2009.
18. Lippard, "Undertones," 311.
19. Moritsugu, interview with Elsa Lenz Kothe.
20. Leslie Umberger, "Alison Moritsugu: A Landscape of Promise" exh. brochure (Sheboygan, Wisc.: John Michael Kohler Arts Center, 1999).
21. Lippard, "Undertones," 312.

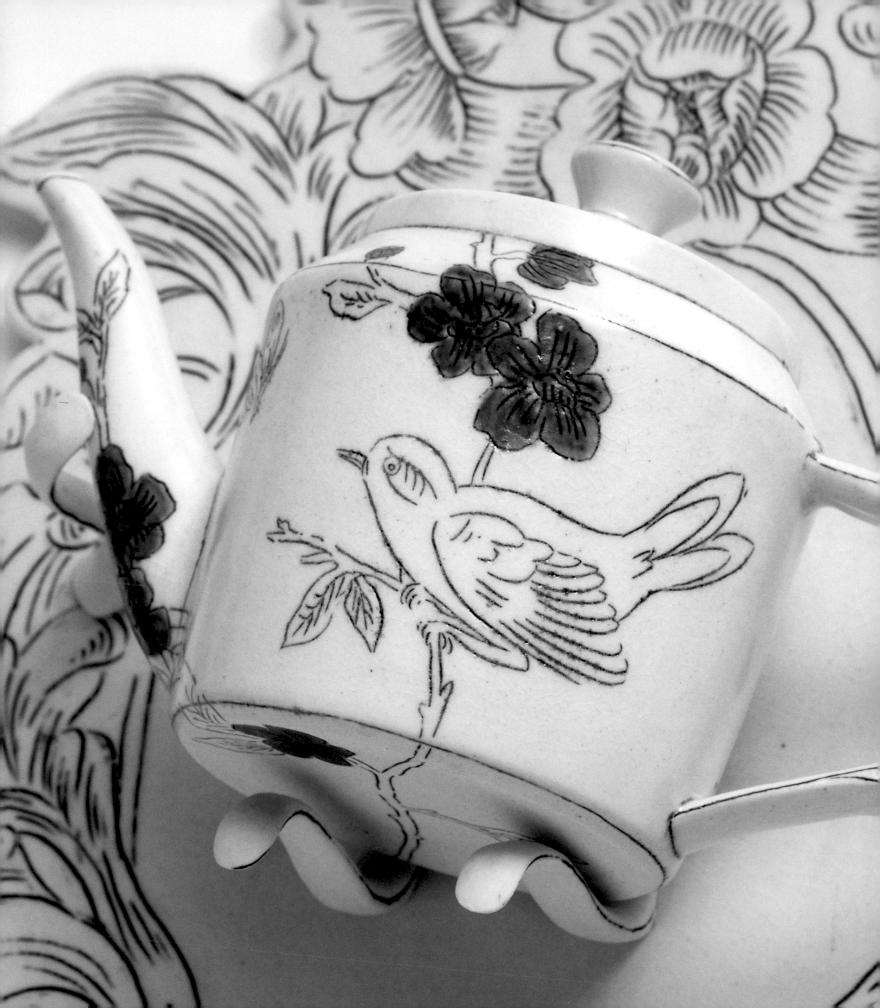

Molly Hatch, 2009; photo:
Rich Maciejewski

OPPOSITE: Molly Hatch, *Tête à Tête:
Tea for Two* (detail), 2009; Courtesy
of the artist.

**Complete object information is
available in the Catalogue of Works.**

MOLLY HATCH (born 1978)
Patterns of Infulence
by Amy Chaloupka

Raised in Vermont on an organic dairy farm and later in Quaker
communities, Molly Hatch "grew up doing."[1] Driving the tractors, putting
up hay, feeding the cows, weeding the garden—Hatch realized as a
child that her ability to work hard and contribute to the family business
was all-important. The task-oriented labor that drove farming became the
foundation of her life as a maker of useful objects.

The rural lifestyle of Hatch's childhood—complete with second-
hand clothes and dirty fingernails—greatly contrasts with her family's
wealthy Bostonian heritage. The generations preceding Hatch's parents
maintained large estates, summer homes, and heirlooms passed down
from early English explorers and sea merchants who settled in New
England. Hatch's maternal grandmother raised seven children on the
family's prosperity but Hatch's mother chose to abandon formality and
family legacy in favor of a hardworking way of life.

During Hatch's teen years, her parents became interested in
educating others about the benefits of organic farming and took
positions as resident farmers at the Farm and Wilderness camps, a
Quaker-founded organization in Plymouth, Vermont.[2] Along with the
requisite chores that came with farm life, Quaker traditional beliefs were
deeply ingrained: simplicity, self-reliance, constructive work, sustainability,
relationship to the land, and service to the community. Hatch's family
lived communally, year-round, with twenty other camp workers and
hosted large groups of camp residents during the summer months. They
participated in breeding and raising animals, maintaining the grounds,
repairing buildings, tapping maple trees for sugar, and pulling ice blocks
from frozen lakes for refrigeration. Televisions, recorded music, and
electronics were prohibited at the camp, and an emphasis was put on

Molly Hatch, *Dinner Service for Twelve: Blue Willow* (detail), 2009; Courtesy of the artist; photo: Rich Maciejewski.

Molly Hatch, *Dinner Service for Twelve: Blue Willow* (detail), 2009; Courtesy of the artist; photo: Rich Maciejewski.

quiet introspection. If Hatch needed or wanted something that she did not have access to or could not afford, it was understood that she would have to make it or find it for herself. "The activity of making milk or making a garden or making a painting—it all comes from the same place," Hatch explains.[3]

On childhood visits to her grandmother's home, Hatch came to love the delicate antiques that filled every room as well as the air of civility and propriety that was so far removed from her life on the farm. Hatch recalls that, at the age of ten, she devoted hours of her time and effort to polishing the eighteenth century silver repoussé mirror that hung on the wall of the elegant residence. Observing the love and care that her granddaughter had for this object, Hatch's grandmother gave the mirror to her to keep in her bedroom. Upon hearing of this luxurious gift, Hatch's mother was beside herself. The extreme wealth and extravagance—so exotic and enchanting to Hatch—clearly embarrassed her mother.

Although there was a major divide in lifestyle between Hatch's mother and grandmother, one family trait that persisted through the generations was a passion for making art. Hatch's great-grandmother, grandmother, and mother were all painters. As a young woman of high society, her great-grandmother learned to paint as a leisurely pastime. Her grandmother painted portraits for commission, and her mother began to study painting at the Rhode Island School of Design before giving up school to become a dairy farmer's wife. Thinking it was her birthright to continue in this tradition, Hatch started out in painting at the Museum School in Boston but soon discovered that the medium conveyed her mother's language, not her own.[4] She transitioned to drawing, lured by the idea of illustration but needing a personal avenue.

As an undergraduate, Hatch also found that she enjoyed working in ceramics. She thought this more of a hobby, finding novelty in the idea of making something useful such as a bowl or a cup. But believing that functional ceramics lacked the conceptual depth that could be attained through drawing, she did not take the medium seriously. It was not until her final year in school that a visiting artist, Kathy King, led her to think about ceramics' potential to convey powerful ideas. "[King] was young, she came in with these black biker boots, Bettie Page hairdo, and all of my professors up to that point had been stodgy old men ... and she was making radical feminist pottery. And she was drawing on her [ceramic] work."[5] This revelation opened a door for Hatch, who melded her two skills together in the technique of sgrafitto, a

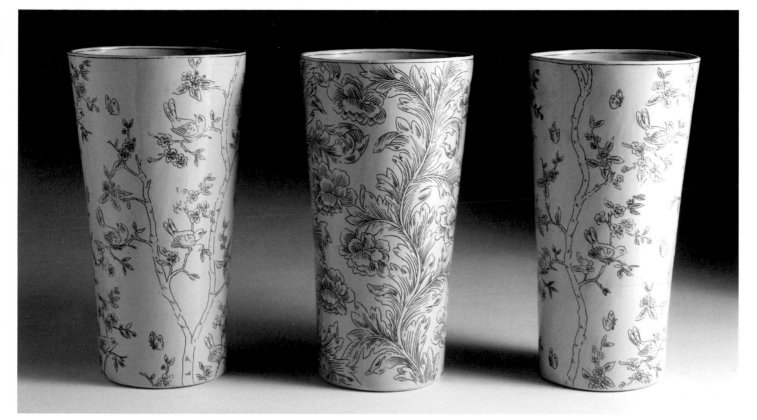

Molly Hatch, *Chinoiserie Vases* I–III, 2009; Courtesy of the artist; photo: Rich Maciejewski.

process similar to the reductive printmaking procedure of woodcut, in which the outer layer of clay is carved away to create an image in the surface. Combining drawing with pottery allowed Hatch to take the sometimes-precious two-dimensional image off of the wall and put it into the hands of someone who could use it. "A drawing was no longer just this thing that was experienced in one facet. It was moving, turning, it was on the surface of an object, it could be licked by somebody."[6]

To further develop her technical skills after completing school, Hatch began working as a full-time production potter for Miranda Thomas Pottery in Bridgewater, Vermont. Here, she was introduced to traditional English ceramic styles coming out of the Michael Cardew and Alan Caiger Smith studios. She became intrigued with the complex floral patterns of English Arts and Crafts designer William Morris (1834–1896). Although Hatch was throwing pots on behalf of another artist, it was here that she developed a taste for pattern and the English aesthetics that began to creep into her own

work. These historical influences also called to mind the styles and décor that Hatch remembered from her grandmother's home. It seemed natural to reference an aesthetic that was integral to her family history. The silver repoussé mirrors, chinoiserie vases, and English wallpapers that adorned her grandmother's life—but not her own—are items that Hatch now reclaims by making her own contemporary versions in ceramic. Hatch creates these works using the Japanese Mishima technique, a slip inlay process that achieves a look similar to etching, with finer line detail than sgrafitto.[7]

In several recent pieces made in the John Michael Kohler Arts Center's Arts/Industry residency program at Kohler Co., Hatch continued to explore the idea of merging the disparate worlds of her upbrining with pieces that could simultaneously adorn the walls and be put to use. In *Dinner Service for Twelve: Blue Willow* (2009), Hatch appropriated the classic and ubiquitous Blue Willow pattern, illustrating the general narrative on each of the individual platters. In the frame surrounding the plates, Hatch references the cherished

Molly Hatch, *Tête à Tête: Tea for Two*, 2009; Courtesy of the artist; photo: Rich Maciejewski.

OPPOSITE: Molly Hatch, *Tête à Tête: Tea for Two* (detail), 2009; Courtesy of the artist; photo: Rich Maciejewski.

silver repoussé mirror of her youth, but more importantly, she contextualizes the ceramic plates as works of art worthy of display and admiration.[8] Taking it one one step further, Hatch made the "hardware" on which the dinner plates hang equally decorative, so that when the plates are off the wall and in use, new works of art are revealed on the wall behind.

The Blue Willow pattern holds special meaning for Hatch; it is a reminder of the china that her merchant ancestors carried with them to New England and kept within the family through the generations, but it is also a pattern that, Hatch explains, has "a long history of ... being interpreted and reinterpreted from one culture to another," originating in China and remaining widely copied throughout Europe and the United States.[9]

Although her delicate porcelain forms and their embellished patterns recall etiquette and formality, Hatch's philospohy of function is much more practical. Hatch views her work as "domestically destined" as she merges the aesthetic and utilitarian in her designs for everyday use in the home.[10] Much like the contrast of farm and aristocratic life that have marked so many of her own experiences, this work commemorates Hatch's diverse personal histories into one finely crafted collection.

1. Molly Hatch, "Salon Familiar" (master's thesis, University of Colorado, Boulder, 2008), 3.
2. For more information about the Farm and Wilderness philosophy and activities, see www.farmandwilderness.org, accessed May 6, 2009.
3. Molly Hatch, interview with Amy Chaloupka for the John Michael Kohler Arts Center, March 13, 2009; curatorial files at the John Michael Kohler Arts Center.
4. Ibid.
5. Ibid.
6. Ibid.
7. Ibid.
8. Hatch, "Salon Familiar," 8
9. Ibid., 10
10. Hatch, interview with Amy Chaloupka.

Additional information in this article was drawn from conversations between Molly Hatch and Amy Chaloupka in March and April 2009.

BIBLIOGRAPHY

Allen, Paula Gunn. *The Sacred Hoop: Recovering the Feminine in American Indian Traditions.* Boston: Beacon Press, 1986.

Another Face of the Diamond: Pathways Through the Black Atlantic South. New York: INTAR Latin American Gallery, 1989. An exhibition catalogue.

Arendt, Laurie. "David Lenz's Perfect World." *Milwaukee (Wisconsin) Journal Sentinel,* January 9, 2007.

Arnett, Paul and William Artnett, eds. *Souls Grown Deep,* vols. 1–2. Atlanta: Tinwood Books, 2000.

Avignone, June. "The Cure We Wait For." *Sun Magazine* 327 (March 2003).

Baraka, Amiri (LeRoi Jones), Thomas McEvilley, Paul Arnett, William Arnett, et al. *Thornton Dial: Image of the Tiger.* New York: Harry N. Abrams, in association with the Museum of American Folk Art, The New Museum of Contemporary Art, and the American Center, 1993.

Begay, Shonto, et al. *Collective Willeto: The Visionary Carvings of a Navajo Artist.* Santa Fe: Museum of New Mexico Press, 2002.

Benton, Janetta Rebold, and Robert DiYanni. *Arts and Culture: An Introduction to the Humanities.* Upper Saddle River, N.J.: Prentice Hall, 1999

Bieder, Robert E. *Native American Communities in Wisconsin, 1600–1960: A Study of Tradition and Change.* Madison: University of Wisconsin Press, 1995.

Briscoe, Sahara. "Xenobia Bailey's Intrepid Voyage." *Black Purl Magazine.* November/December 2007, 3–6.

Broder, Patricia Janis. *Earth Songs, Moon Dreams: Paintings by American Indian Women.* New York: St. Martin's Press, 1999.

Bronner, Simon J. *The Carver's Art: Crafting Meaning from Wood.* Lexington, Ky.: University Press of Kentucky, 1985.

Brown, David J., ed. *Lesley Dill: Tongues on Fire: Visions and Ecstasy.* Winston-Salem, N.C.: Southeastern Center for Contemporary Art, 2001. An exhibition catalogue.

Campisi, Jack and Laurence M. Hauptman, eds. *The Oneida Indian Experience: Two Perspectives.* Syracuse, N.Y.: Syracuse University Press, 1988.

"Clinton Admits Cuba Policy Failed." *BBC News.* April 17, 2009. Accessed online: news.bbc.co.uk/2/hi/Americas/8005153.stm,

Do, Anh, Tran Phan, and Eugene Garcia. "Millions of Lives Changed Forever with Saigon's Fall." *Orange County* (California) *Register.* April 29, 2001.

Earl, Jack. *Jack: Just fer the Fun and the Wonder of It.* Lima, Ohio: Fairway Press, 2007.

8 Artists in Industry. Sheboygan, Wisc.: John Michael Kohler Arts Center, 1977. An exhibition catalogue.

Erdrich, Louise. *The Antelope Wife.* New York: Harper Collins, 1998.

Faderman, Lillian and Ghia Xiong. *I Begin My Life All Over: The Hmong and the American Immigrant Experience.* Boston: Beacon Press, 1998.

Feest, Christian F. *Native Arts of North America.* London: Thames and Hudson, 1992.

Findlay-Brown, Ian. "A Culture in Doubt." *Asian Art News* 4, no. 4, Japan Supplement (July/Aug 1994).

Gallery Lunami (Tokyo), "Yoshiko Kanai." An exhibition pamphlet. n.d.

Geldof, Lynn. *Cubans: Voices of Change.* New York: St. Martin's Press, 1992.

Genocchio, Benjamin. "Mixed (Media) Messages," Review. *The New York Times.* May 20, 2007.

Gott, Richard. *Cuba: A New History.* New Haven, Conn.: Yale University Press, 2004.

Gundaker, Grey and Judith McWillie. *No Space Hidden: The Spirit of African American Yard Work.* Knoxville: University of Tennessee Press, 2005.

Harrison-Konz, Jennifer. "Willa Cather: The Author of the Human Experience." *Suite 101.com.* http://americanfiction.suite101.com/article.cfm/willa_cather#ixzz0BWkASRNR.

Hatch, Molly. "Salon Familiar." Master's thesis, University of Colorado-Bolder, 2008.

Hayes, Jeffrey R., ed. *David M. Lenz: Urban and Rural Paintings of Wisconsin.* Milwaukee: Charles Atlas Art Museum, 2004. An exhibition catalogue.

Hmong Art: Tradition and Change. Sheboygan, Wisc.: John Michael Kohler Arts Center, 1986. An exhibition catalogue.

Hoy, Pat C. II and Robert DiYanni. *Encounters: Readings and the World.* New York: McGraw-Hill, 1997.

Iverson, Peter. *The Navajos.* New York: Chelsea House and Arizona State University, 1990.

Jestice, Nandini Makrandi, ed. *I Heard a Voice: The Art of Lesley Dill.* Chattanooga, Tenn.: Hunter Museum of American Art, 2009. An exhibition catalogue.

Josephy, Alvin M., Jr. *500 Nations: An Illustrated History of North American Indians.* New York: Random House and Pathway Publications, 1994.

Kassovic, Julius Stephen. "Junk and its Transformations." *A Report from the Center for Folk Art and Contemporary Crafts* 3, no. 1 (1992).

Kuykendall, Ralph S. and A. Grove Day. *Hawaii: A History, From Polynesian Kingdom to American State.* Englewood Cliffs, N.J.: Prentice-Hall, 1961.

Les Sauvages de la Mer Pacifique: Made in Mâcon: Investigations into the production of wallpaper. National Gallery of Australia. www.nga.gov.au/Conservation/Paper/LesSauv.cfm, (accessed March 20, 2009).

Lewis, Herbert S., ed. *Oneida Lives: Long-Lost Voices of the Wisconsin Oneidas.* Lincoln: University of Nebraska Press, 2005.

Lippard, Lucy R. *Mixed Blessings: New Art in a Multicultural America.* New York: Pantheon Books, 1990.

——. "Undertones: Nine Cultural Landscapes." In *The Pink Glass Swan: Selected Essays on Feminist Art.* New York: The New Press, 1995.

Low, Stewart. "Vietnam War Firefight Brings Out The Spirit of an Artist." (Rochester, New York) *Democrat and Chronicle,* February 1, 2009.

MAKE. Documentary by Scott Ogden and Malcolm Hearn, 2008.

Manley, Roger. *Signs and Wonders: Outsider Art Inside North*

Carolina. Raleigh: North Carolina Museum of Art, 1989.

——, ed. *A Stranger to Himself*. Unpublished manuscript of writings by and about Robert Lynch (1947–1989).

Moritsugu, Alison. *Paradise Revisited*. Unpublished notes about the work, June 25, 2007. Sheboygan, Wisc.: curatorial files at the John Michael Kohler Arts Center.

Morris, Randall. "Conversing with Culture: Paintings and Drawings by José Bedia," in *Tribal & Textile Arts*. San Francisco: Fine Art of Native Cultures, 2009. An exhibition catalogue.

——. "Gregory Van Maanen: The Wolf Survives." *Chemical Imbalance Magazine* 2, no. 2 (1990).

The Myth That is True: An Exhibition of Art by Native American Women. St. Paul, Minn.: University of St. Thomas, 2001. An exhibition catalogue.

Navarro, José Cantón. *History of Cuba: The Challenge of the Yoke and the Star*. Havana: Si-Mar, 1998.

Next Generation: Southern Black Aesthetic. Winston-Salem, N.C.: Southeastern Center for Contemporary Art, 1990. An exhibition catalogue.

Nordness, Lee. *Jack Earl: The Genesis and Triumphant Survival of an Underground Ohio Artist*. Chicago: Perimeter Press, 1985.

O'Brien, Tim. *The Things They Carried*. New York: Broadway Books, 1990.

Ohio Boy: The Ceramic Sculpture of Jack Earl. Sheboygan, Wisc.: John Michael Kohler Arts Center, 1987. An exhibition catalogue.

Obama, Barack. "A More Perfect Union." Speech delivered at the Constitution Center, Philadelphia, Pa. *National Public Radio*. March 18, 2008. Accessed online: www.npr.org/templates/story/story.php?storyId=88478467.

"Obama Offers Cuba 'New Beginning,'" *BBC News*. April 18, 2009. Accessed online: news.bbc.co.uk/2/hi/Americas/8004798.stm,

Patcher, Marc, Dave Hickey, and Ruth Kassinger. *The Outwin Boochever Portrait Competition 2006*. Washington, D.C.: Smithsonian National Portrait Gallery, and Seattle: University of Washington Press, 2006.

Rafferty, Rebecca. "'The Happy Survivor' Exorcising the Demons of War." *Rochester* (New York) *City Newspaper*, February 4, 2009.

Reidel, Mija. "Karen Johnson Boyd and the Art of Stealth Philanthropy." *American Craft*, December/January 2009.

(Re)Possessed. Columbus, Ohio: Elijah Pierce Gallery, The King Arts Complex, 2008. An exhibition catalogue.

Rubiner, Joanna. "Black Biography: Xenobia Bailey." *Answers.com*. www.answers.com/topic/xenobia-bailey (accessed March 26, 2009).

Schumacher, Mary Louise. "In a Father's Experience, Perfection. Shorewood Artist's Work Earns Top Award in National Contest." *Milwaukee* (Wisconsin) *Journal Sentinel*, June 24, 2006.

Shalala, Nancy. "Feminist Artist Aims for Soul with Symbolic Assemblages," *Japan Times*, June 6, 1993.

——. "Japanese Women Artists Face Extraordinary Challenges in Overcoming the Conservative Notions of a Male-dominated Art World. A Number of Women's Art Groups are Initiating Significant Changes. Nancy Shalala Discusses Two of Them." *Asian Art News*

4, no. 4 Japan Supplement (July/August 1994): 18.

Sinaiko, Eve, ed. *Vietnam: Reflexes and Reflections*. New York: Harry N. Abrams, with the National Vietnam Veterans Art Museum, 1998.

Spriggs, Lynne E. *Local Heroes: Paintings and Sculpture by Sam Doyle*. Atlanta: High Museum of Art, 2000.

Stephenson, Crocker. "From the Friendship Between an Artist and a Farmer, a Portrait of a Way of Life Emerges." *Milwaukee* (Wisconsin) *Journal Sentinel*, January 28, 2001.

——. "Love and Loss, Courage and Commitment Color Life with Meaning." *Milwaukee* (Wisconsin) *Journal Sentinel*, February 4, 2001.

——. "Postscripts." *Milwaukee* (Wisconsin) *Journal Sentinel*, December 30, 2001.

——. "Summer: Afternoon Haying." *Milwaukee* (Wisconsin) *Journal Sentinel*, January 21, 2001.

——. "A Wisconsin Elegy: A Portrait of our Loss." *Milwaukee* (Wisconsin) *Journal Sentinel*, January 14, 2001.

Stolberg, Sheryl Gay and Damien Cave. "Obama Opens Door to Cuba, but Only a Crack." *New York Times*. April 13, 2009.

Tatum, Beverly Daniel. *Assimilation Blues: Black Families in a White Community*. Northampton, Mass.: Hazel-Maxwell, 1987.

Thompson, Robert Farris. *Face of the Gods: Art and Altars of Africa and the African Americas*. New York: Museum for African Art and Munich: Prestel, 1993.

Treuer, David. *Native American Fiction: A User's Manual*. St. Paul, Minn.: Graywolf Press, 2006.

Umberger, Leslie. *Sublime Spaces & Visionary Worlds: Built Environments of Vernacular Artists*. New York: Princeton Architectural Press, in association with the John Michael Kohler Arts Center, 2007.

——. "Alison Moritsugu: A Landscape of Promise." Sheboygan, Wisc.: John Michael Kohler Arts Center, 1999. An exhibition brochure.

Vandertie, Adolph and Patrick Spielman. *Hobo & Tramp Art Carving: An Authentic American Folk Tradition*. New York: Sterling, 1995.

We Are Animals of Language. Documentary film. Directed by Ed Robbins. Pounding Glass Productions, 2007.

Westbound. Documentary film. Green Bay, Wisc.: Arketype, 2009.

Witherspoon, Gary. *Language and Art in the Navajo Universe*. Ann Arbor, Mich.: University of Michigan Press, 1997.

Wong, Allison. "Paradise Revisited: Recent Works by Alison Moritsugu." Honolulu: The Contemporary Museum at First Hawaiian Center, 2008. An exhibition brochure.

Young, Dede and Tom Patterson, eds. *Lesley Dill: Tremendous World*. Purchase, N.Y.: Neuberger Museum of Art, 2007. An exhibition catalogue.

* Artist interviews conducted by the John Michael Kohler Arts Center are listed in the notes following individual chapters only.

CATALOGUE OF WORKS

height precedes width precedes depth

XENOBIA BAILEY

(Re)Possessed, 1999–2009
mixed media environment
dimensions variable
Courtesy of the artist

Components include the following:

Mandalas, 1999–2009
acrylic and cotton yarn and mixed
media

Sistah Paradise's Formal Regalia,
2000–06
yarn and mixed media

Moon Lodge: Trance Former, 1999
acrylic and cotton yarn and mixed
media

*Sistah Paradise's Great Wall of Fire
Tent*, 1993
acrylic and cotton yarn and mixed
media

Conjure Woman Dolls, 1986–87
mixed media

Doughba H. Caranda-Martin
Teas, 2008
tea and mixed herbs

Barbara Garnes
Tea Service, 2006
glazed porcelain

Renè McLean
Original Score for Re(Possessed), 2008
musical soundtrack
78 minutes 31 seconds (loop)

Dorian Webb
chandeliers and sconces: *Fiori, Massa,
Speraza I*, and *Speraza II*, 2008
glass, copper wire, mixed media

JOSÉ BEDIA

Contemplativo (Contemplative), 2009
acrylic on canvas
72 x 119 in.
Courtesy of the artist

Mbua-Ndoki (Sorcerer Dog), 2004;
2009
mixed media installation
144 x 432 x 252 in.
Courtesy of the artist

*Todos por el Pais Hembra Rebelde y
Caprichoso* (All for the Country the
Rebellious and Capricious Female),
2008
acrylic on canvas
115 1/2 x 80 in.
Courtesy of the artist

Y Asi Fue Como Pasaron Los Cosas
(And That's How It Happened), 2008
acrylic on canvas
71 3/4 x 110 1/4 in.
Courtesy of the artist

El Retorno de Aquela Furia Ciega (The
Comeback of the Blind Fury), 2007
acrylic on canvas
71 1/4 x 175 1/2 in.
Courtesy of the artist

Destino Final del Prócer (Final Destiny
of the Hero), 2007
acrylic on canvas
71 1/2 x 115 1/2 in.
Courtesy of the artist

Ejecución del Venao de Manicaragua
(Execution of the Deer [Rebel] of
Manicaragua), 2007
acrylic on canvas
34 3/4 x 130 1/4 in.
Courtesy of the artist

Isla, Pais, Mujer (Island, Country,
Woman), 2007
acrylic on canvas
71 1/4 x 94 3/4 in.
Courtesy of the artist

A Ti Me Encomiendo (I Put Myself in
Your Hands), 2006
acrylic on canvas
82 x 82 in.
Courtesy of the artist

La Brecha (The Breach), 2005
acrylic on canvas
71 1/2 x 104 1/4 in.
Courtesy of the artist

Caminemos Juntos (Let's Walk
Together), 2005
acrylic on canvas
71 1/4 x 92 3/4 in.
Courtesy of the artist

Ciertos Rumbos No Pueden Cambiarse
(Certain Routes Cannot Be Changed),
2005
acrylic on canvas
70 1/2 x 107 in.
Courtesy of the artist

Ojalá se Hundan los Cielos (I Wish the
Skies Would Fall), 2005
acrylic on canvas
71 x 97 1/2 in.
Courtesy of the artist

De Regreso (The Return), 2005
acrylic on canvas
71 1/4 x 113 in.
Courtesy of the artist

Si Ayer Maravilla Fui... (Yesterday I
Was a Marvelous Thing...), 2004
acrylic on canvas
71 1/4 x 90 3/4 in.
Courtesy of the artist

Todo Bajo Control (Everything Under
Control), 2004
acrylic on canvas
71 1/4 x 110 1/4 in.
Courtesy of the artist

Torre Del Silencio (Tower of Silence),
2004
acrylic on canvas
81 1/4 x 71 3/4 in.
Courtesy of the artist

Pretende Que Son Alas (Pretend They
Are Wings), 2003
acrylic on canvas
34 3/4 x 155 1/4 in.
Courtesy of the artist

Los Vinculos Entre el Cielo y la Tierra
(The Links Between the Heavens and
the Earth), 2003
oil pastel on paper
33 x 46 in.
Courtesy of the artist

Animal Prudente (The Prudent
Animal), 2002
acrylic on canvas
71 1/4 x 95 3/4 in.
Courtesy of the artist

Al Pasito (One Step at a Time), 2001
oil pastel on paper
38 1/4 x 50 1/4 in.
Courtesy of the artist

No Temas (Don't Be Afraid), 2001
oil pastel on paper
38 1/4 x 50 1/4 in.
Courtesy of the artist

Otros Senderos (Other Trails), 2001
oil pastel on paper
38 1/4 x 50 1/4 in.
Courtesy of the artist

Ruina Parlante (Talking Ruin), 2001
oil pastel on paper
38 1/4 x 50 1/4 in.
Courtesy of the artist

Viejas Voces (Old Voices), 2001
oil pastel on paper
38 1/4 x 50 1/4 in.
Courtesy of the artist

*Y Deja en Paz a la Pobre Criatura
de Dios* (Leave in Peace the Poor
Creature of God), 2001
oil pastel on paper
38 1/4 x 50 1/4 in.
Courtesy of the artist

Naufragios (Shipwrecks), 1996
tempera and oil pastel on paper
38 x 49 3/4 in.
Courtesy of the artist

Oyá En Lo Suyo (Oyá Doing What She
Does), 1996
tempera and oil pastel on paper
38 x 49 3/4 in.
Courtesy of the artist

Y Por Aqui Tambien Esta Lloviendo
(And It's Raining Here Too), 1996
acrylic on canvas
70 1/2 x 118 in.
Courtesy of the artist

La Isla Sola (The Lonely Island), 1994
acrylic on canvas
70 1/2 x 134 1/4 in.
Courtesy of the artist

Casi Todo lo que es Mio (Almost
Everything that is Mine), 1992
acrylic on canvas
23 3/4 x 35 3/4 in.
Courtesy of the artist

HAWKINS BOLDEN

untitled (scarecrow assemblage with
metal strainer) , c. 1965–2005
mixed media; 49 1/2 x 16 1/2 x 4 in.
Collection of Susann Craig, IL

untitled (assemblage with cooking pot
and carpet), c. 1965–2005
mixed media; 18 x 11 x 12 in.
Collection of Harvey and Marjorie
Freed, IL

untitled (assemblage with blue oil
drum lid), c. 1965–2005
mixed media; 28 x 27 x 4 in.
Collection of Scott Ogden, NY

untitled (assemblage with rake head and pipe), c. 1965–2005
mixed media; 33 1/2 x 14 x 4 1/2 in.
Collection of Scott Ogden, NY

untitled (assemblage with wheel cover and hoses), c. 1965–2005
mixed media; 32 x 33 x 6 3/4 in.
Collection of Scott Ogden, NY

untitled (assemblage with boiling pot and boot parts), c. 1965–2005
mixed media; 11 1/2 x 13 x11 in.
Collection of Scott Ogden, NY

untitled (scarecrow assemblage with blue jeans and bowl), c. 1965–2005
mixed media; 43 x 13 1/2 x 6 in.
Collection of Scott Ogden, NY

untitled (scarecrow assemblage with enamel pail), c. 1965–2005
mixed media; 70 x 23 1/2 x 11 in.
Collection of Scott Ogden, NY

untitled (scarecrow assemblage with blue jeans), c. 1965–2005
mixed media; 43 x 13 x 7 in.
Collection of Scott Ogden, NY

untitled (assemblage with paint can and garland), c. 1965–2005
mixed media
19 1/2 x 6 1/2 x 10 1/2 in.
Collection of Scott Ogden, NY

untitled (assemblage with flattened pot and carpet), c. 1965–2005
mixed media
14 1/2 x 11 1/2 x 4 1/2 in.
Collection of Scott Ogden, NY

untitled (assemblage with tea kettle and fake fur), c. 1965–2005
mixed media; 16 x 7 x 5 1/2 in.
Collection of Scott Ogden, NY

untitled (assemblage with skillet and hoses), c. 1965–2005
mixed media; 14 1/2 x 16 1/2 x 4 in.
Collection of Jan Petry, IL

untitled (scarecrow assemblage with green hoses), c. 1965–2005
mixed media; 55 x 25 x 5 in.
Courtesy of Ricco/Maresca Gallery, NY

untitled (assemblage with tree branch and tin cans), c. 1965–2005
36 x 10 x 7 1/2 in.
Courtesy of Ricco/Maresca Gallery, NY

untitled (scarecrow assemblage with cooking pans and fabric),
c. 1965–2005
mixed media
49 x 11 x 7 1/2 in.
Courtesy of Ricco/Maresca Gallery, NY

untitled (assemblage with baking sheet and shoe soles), c. 1965–2005
18 x 16 x 2 in.
Courtesy of Ricco/Maresca Gallery, NY

untitled (scarecrow assemblage with upholstery scraps), c. 1965–2005
48 x 20 x 4 in.
Courtesy of Ricco/Maresca Gallery, NY

untitled (assemblage with cake pan and garlands), c. 1965–2005
mixed media
17 x 19 x 3 1/2 in.
Courtesy of Ricco/Maresca Gallery, NY

untitled (assemblage with cake pan and carpet), c. 1965–2005
mixed media
31 x 16 x 4 1/2 in.
Courtesy of Ricco/Maresca Gallery, NY

untitled (assemblage with wash tub and garlands), c. 1965–2005
mixed media
22 x 28 x 3 in.
Courtesy of Ricco/Maresca Gallery, NY

untitled (assemblage with pan and garland), c. 1965–2005
mixed media
13 x 13 x 3 1/2 in.
Courtesy of Ricco/Maresca Gallery, NY

untitled (skillet with cut out features), c. 1965–2005
mixed media
17 x 11 x 2 1/2 in.
Courtesy of Ricco/Maresca Gallery, NY

untitled (assemblage with tree limb and orange cooking pot), 1990
mixed media; 50 x 21 x 11 in.
Collection of William Arnett, GA

untitled (scarecrow assemblage with hubcap), 1989
mixed media; 39 x 25 x 4 in.
Collection of William Arnett, GA

untitled (scarecrow assemblage with gutter pipe), 1988
mixed media
51 x 36 x 8 in.
Collection of William Arnett, GA

untitled, (scarecrow assemblage with chair), c. 1987
mixed media
36 x 19 x 29 in.
Collection of William Arnett, GA

untitled (scarecrow assemblage with enamel bedpan), 1987
mixed media
78 1/2 x 46 x 9 in.
Collection of William Arnett, GA

untitled (scarecrow assemblage with blanket scraps), 1987
mixed media
48 1/2 x 23 x 8 in.
Collection of William Arnett, GA

untitled (scarecrow assemblage with chamber pot and boots), 1986
mixed media
36 x 21 x 10 in.
Collection of William Arnett, GA

untitled (assemblage with suspended blue jeans), 1986
mixed media
51 1/2 x 28 x 9 in.
Collection of William Arnett, GA

untitled (assemblage with yellow oil drum lid), c. 1980
mixed media
29 1/2 x 25 x 5 in.
Collection of William Arnett, GA

untitled (scarecrow assemblage with coffee pot), c. 1970
mixed media
81 x 8 x 6 in.
Collection of William Arnett, GA

untitled (assemblage with coffee pot and green hose), c. 1970
mixed media
14 x 6 x 7 in.
Collection of William Arnett, GA

untitled (assemblage with rubber straps), c. 1970
mixed media
8-10 in. diameter
Collection of William Arnett, GA

VERNON BURWELL
untitled (leopard), c. 1982
concrete, paint, mixed media
19 x 9 1/2 x 32 in.
John Michael Kohler Arts Center Collection, Gift of Cavin-Morris Gallery, NY

LESLEY DILL
Upside Down Silver Girl, 2005/2009
silver leaf on cast paper, aluminum (as reworked)
85 x 14 x 18 in. overall, 42 x 14 x 18 in. figure/chair
Courtesy of George Adams Gallery, NY

Shimmer, 2006–07
wire, metal foil
180 x 732 x 14 in.
Courtesy of George Adams Gallery, NY

Dress of War and Sorrow, 2006
metal foil, organza, thread
77 x 77 x 69 in.
Collection of Richard Harris, IL;
Courtesy of George Adams Gallery, NY

Tear Lick, 2001
photo silkscreen, ink, oil, thread, gold leaf, wax on paper
2 works: 65 x 50 in. each
Courtesy of George Adams Gallery, NY

Tongues on Fire, 2001
photo silkscreen, ink, oil, thread, silver leaf, wax on paper
9 works: 58 x 50 x 1/4 in. each
Courtesy of George Adams Gallery, NY

JACK EARL
Bill in the Light and Bill in the Dark, 1981
white earthenware with china paint
14 1/2 x 8 1/2 in.
Collection of the Racine Art Museum, WI, Promised gift of Karen Johnson Boyd

Carrot Finger, 1981
white earthenware with china paint
27 x 8 x 6 in.
Collection of the Racine Art Museum, WI, Gift of Karen Johnson Boyd

The Midway Diner, 1981
white earthenware with china paint
11 x 23 x 26 in.
Collection of the Racine Art Museum,
WI, Gift of Karen Johnson Boyd

The Story of Carrot Finger Plaque, 1981
white earthenware with china paint
and lustres
12 x 12 x 1 1/4 in.
Collection of the Racine Art Museum,
WI, Gift of Karen Johnson Boyd

Ohio Boy, 1977
vitreous china
16 x 18 x 9 in.
John Michael Kohler Arts Center
Collection

Saturday Night in Ohio, 1976
vitreous china and glaze
12 1/2 x 25 x 10 1/2 in.
John Michael Kohler Arts Center
Collection

Be Right There!, 1975
porcelain with clear glaze
4 1/8 x 8 3/4 x 5 in.; Collection of the
Racine Art Museum, WI, Promised gift
of Karen Johnson Boyd

Dog Descending the Staircase, 1975
porcelain with clear glaze
9 1/2 x 5 x 5 1/8 in.; Collection of the
Racine Art Museum, WI, Promised gift
of Karen Johnson Boyd

Love in the Arbor, 1975
porcelain with clear glaze
7 1/4 x 6 x 9 in.; Collection of the
Racine Art Museum, WI, Promised gift
of Karen Johnson Boyd

LISA FIFIELD
Dance of the Elk Women, 2005
watercolor on paper
21 3/4 x 29 3/4 in.
Collection of Malone & Atchison
Attorneys at Law, MN

Three Egrets, 2005
watercolor on paper
29 3/4 x 22 1/4 in.
Collection of Malone & Atchison
Attorneys at Law, MN

Lydia Looking Elk, 2003
gouache and watercolor
40 x 50 in.
Collection of Elizabeth and Shel
Danielson, MN

Manitou, 2003
gouache and watercolor
22 x 30 in.
Collection of Bobbi Lewandowski and
Kathy Regan, MN

Birch Tree Woman, 2002
watercolor on paper
29 1/4 x 22 1/4 in.
Courtesy of Louise Erdrich and
Birchbark Books & Native Arts, MN

Bird Funeral, 2002
watercolor on paper
29 1/2 x 32 1/2 in.
Collection of Louis Allgeyer and
Jane St. Anthony, MN

Blue Prairie Woman, 2001
watercolor on paper
29 x 21 1/2 in.
Courtesy of Louise Erdrich and
Birchbark Books & Native Arts, MN

Ghost Dancers Ascending, 1995
watercolor on paper
30 x 22 in.
Private Collection

Clanswomen/Shapeshifting, 1994
watercolor on paper
22 x 30 in.
Courtesy of the artist

Heron Rookery, n.d.
watercolor on paper
19 1/2 x 29 in.
Collection of Steve and Tristen
Lindemann, MN

MOLLY HATCH
Beaker Service: Blue Peony, 2009
porcelain
55 x 55 x 4 1/2 in.
Courtesy of the artist

Chinoiserie Vases I–IV, 2009
porcelain
23 x 11 1/2 in. ea.
Courtesy of the artist

*Dinner Service for Twelve: Blue
Willow*, 2009
porcelain
67 x 79 3/4 x 2 1/4 in.
Courtesy of the artist

Tête à Tête: Tea for Two, 2009
porcelain
36 x 72 x 5 in.
Courtesy of the artist

YOSHIKO KANAI
Home Hunter, 1998
slip-cast vitreous china and cast iron
60 x 70 x 60 in.
John Michael Kohler Arts Center
Collection

XAO YANG LEE
untitled storycloth (escape from
Laos), c. 2000–09
embroidery on cotton cloth
65 x 97 1/2 in.
Collection of Miroslav "Mick" Anic, WI

untitled *paj ntaub* (blue and black
flower cloth), c. 2000–09
reverse appliqué and embroidery on
cotton cloth
60 3/4 x 36 1/4 in.
Courtesy of the artist

untitled *paj ntaub* (blue and orange
flower cloth), c. 2000–09
reverse appliqué and embroidery on
cotton cloth
21 x 21 3/4 in.
Courtesy of the artist

untitled storycloth (map of Laos),
c. 2000–09
embroidery on cotton cloth
47 1/2 x 47 in.
Courtesy of the artist

untitled storycloth (with animals),
c. 2000–09
embroidery on cotton cloth
31 x 33 1/2 in.
Courtesy of the artist

untitled *paj ntaub* (cream and white
flower cloth), c. 2000–09
reverse appliqué and embroidery on
cotton cloth
44 1/2 x 30 3/4 in.
Courtesy of the artist

untitled *paj ntaub* (cream and white
flower cloth), c. 2000–09
reverse appliqué and embroidery on
cotton cloth
67 x 47 3/4 in.
Courtesy of the artist

untitled *paj ntaub* (cream and white
flower cloth / geometric), c. 2000–09
reverse appliqué and embroidery on
cotton cloth
43 1/4 x 26 1/4 in.
Courtesy of the artist

untitled *paj ntaub* (green and black
flower cloth), c. 2000–09
reverse appliqué and embroidery on
cotton cloth
46 1/2 x 30 5/8 in.
Courtesy of the artist

untitled *paj ntaub* (red and yellow
flower cloth), c. 2000–09
reverse appliqué and embroidery on
cotton cloth
25 1/4 x 25 1/4 in.
Courtesy of the artist

untitled *paj ntaub* (red and black
flower cloth), c. 2000–09
reverse appliqué and embroidery on
cotton cloth
61 1/2 x 36 in.
Courtesy of the artist

DAVID LENZ
Ervin Walter Wagner, 2006
oil on linen
38 x 50 in.
Collection of Mr. and Mrs. Dennis
Wallestad, NY and WI

Sam and the Perfect World, 2006
oil on linen
44 x 46 in.
Collection of David Lenz, WI

Slippery Sidewalks, 2006
oil on canvas
12 x 18 in.
Collection of Donna and Jonathan
Moberg, WI

Lone Tree, 2004
oil on canvas
14 x 14 in.
Collection of Barbara Applegate, WI

Massey Ferguson 285, 2004
watercolor on paper
13 x 14 in.
Collection of Jane and Steve
Chernof, WI

Moon Halo, 2004
oil on linen
15 x 16 in.
Collection of Craig and Lisa Zetley, WI

Dairyland, 2003
oil on linen
30 x 36 in.
Collection of Mr. and Mrs. Daniel J.
Bader, WI

Erv's Haven, 2003
oil on linen
28 x 48 in.
Collection of Mr. and Mrs. Richard R.
Pieper Sr., WI

Faded Blaze Orange, 2002
watercolor on paper
7 1/2 x 10 5/16 in.
Collection of Barbara Stein, WI

Looking South, 2002
oil on linen
12 x 18 in.
Collection of Techstaff Inc., WI

The Sick Cow, 2002
oil on board
11 x 9 1/4 in.
Collection of Mr. and Mrs. Dennis
Wallestad, NY and WI

Getting in the Cows, 2001
oil on linen
17 x 19 in.
Collection of Mr. and Mrs. John F.
Monroe, WI

She Looks Like Rain, 2001
oil on linen
8 x 10 in.
Collection of Lori Rosenthal, WI

Thistles, 2001
oil on linen
32 x 54 in.
Collection of Pieper Electric Inc., WI

Navigation Light, 1998
oil on linen
34 x 46 in.
Collection of Helen and Ned
Bechthold, WI

Sunrise, 1998
oil on linen
20 x 24 in.
Collection of Barbara Stein, WI

Tugboat, 1998
oil on board
11 1/4 x 18 in.
Collection of Mr. and Mrs. Daniel J.
Bader, WI

Near Cambridge Avenue, 1996
oil on linen
16 x 29 in.
Collection of Techstaff Inc., WI

Looking Back, 1995
oil on linen; 44 x 54 in.
Collection of Mr. and Mrs. Daniel J.
Bader, WI

*Peace in Our Neighborhood / Girl with
Inner Tube*, 1993
oil on board
19 x 22 in.
Collection of Barbara Stein, WI

Snowy Day, 1993
oil on linen
20 x 22 in.
Private Collection, WI

ALISON MORITSUGU

Early Warning Repeat (wallpaper),
2009
ink on enhanced adhesive synthetic
wallpaper
96 1/2 x 194 in., as installed at the
John Michael Kohler Arts Center
Courtesy of the artist

Lava Flow, 2009
gouache on paper
18 x 26 in.
Courtesy of the artist

Big Pineapple, 2007
oil on panel with koa frame
41 1/4 x 43 1/4 in.
Courtesy of the artist

Candlenut Sconce, 2007
kukui nuts, wood, metal
24 1/2 x 48 x 24 in.
Courtesy of the artist

Invasive Repeat (wallpaper), 2007
ink on enhanced adhesive synthetic
wallpaper
96 1/2 x 58 in., as installed at the John
Michael Kohler Arts Center
Courtesy of the artist

King Cane, 2007
oil on panel with koa frame
40 1/2 x 43 1/4 in.
Courtesy of the artist

Wai Hookahe, 2007
fountain; foam, epoxy, plastic tubing,
pump, water
38 x 46 5/8 x 46 5/8 in.
Courtesy of the artist

ADOLPH VANDERTIE

The Losers, c. 1928–2004
mixed media assemblage
20 1/8 x 16 1/8 x 3 1/4 in.
John Michael Kohler Arts Center
Collection

untitled (mobile), c. 1960–2000
cedar, basswood, metal, poplar, wire
39 x 10 x 10 in.
John Michael Kohler Arts Center
Collection

untitled (chip-carved box), c. 1960–
2000
glue, cedar, basswood, metal, varnish
9 3/4 x 9 1/2 x 6 1/2 in.
John Michael Kohler Arts Center
Collection

untitled (chip-carved box), c. 1960–
2000
cedar, basswood, metal, varnish
11 1/2 x 7 5/8 x 5 1/4 in.
John Michael Kohler Arts Center
Collection

untitled (chip-carved box), c. 1960–
2000
cedar, basswood, metal, varnish
17 x 8 1/4 x 7 1/2 in.
John Michael Kohler Arts Center
Collection

untitled (chip-carved chest),
c. 1960–2000
cedar, basswood, metal, varnish
8 3/4 x 9 3/4 x 7 3/4 in.
John Michael Kohler Arts Center
Collection

untitled (chip-carved chest),
c. 1960–2000
cedar, basswood, metal, varnish
10 x 9 7/8 x 8 7/8 in.
John Michael Kohler Arts Center
Collection

untitled (chip-carved cigar-shaped
box), c. 1960–2000
cedar, basswood, metal, varnish
5 1/4 x 10 5/8 x 2 3/4 in.
John Michael Kohler Arts Center
Collection

untitled (chip-carved double-decker
box), c. 1960–2000
cedar, basswood, mahogany, metal,
paper
13 3/4 x 11 x 8 1/2 in.
John Michael Kohler Arts Center
Collection

untitled (chip-carved double-decker
box), c. 1960–2000
basswood, metal, paper, varnish
17 x 9 x 11 in.
John Michael Kohler Arts Center
Collection

untitled (chip-carved frame with
whimsy sticks), c. 1960–2000
basswood, fabric, glass, mahogany,
metal, varnish
21 1/2 x 49 x 5 in.
John Michael Kohler Arts Center
Collection

untitled (chip-carved frame with
whimsy sticks), c. 1960–2000
cedar, basswood, fabric, glass, metal
17 7/8 x 18 x 4 in.
John Michael Kohler Arts Center
Collection

untitled (chip carved frame with
whimsy sticks), c. 1960–2000
cedar, basswood, fabric, glass, varnish
25 3/4 x 29 1/2 x 5 1/2 in.
John Michael Kohler Arts Center
Collection

untitled (chip-carved frame with
whimsy sticks), c. 1960–2000
cedar, basswood, fabric, glass, metal
18 1/4 x 22 x 5 1/2 in.
John Michael Kohler Arts Center
Collection

untitled (chip-carved frame with
whimsy sticks), c. 1960–2000
cedar, basswood, fabric, glass,
mahogany, metal, varnish
17 3/8 x 14 3/4 x 3 3/4 in.
John Michael Kohler Arts Center
Collection

untitled (mobile), c. 1960–2000
cedar, basswood, metal, poplar, wire
38 x 23 1/4 x 10 in.
John Michael Kohler Arts Center
Collection

untitled (mobile), c. 1960–2000
cedar, basswood, metal, poplar, wire
32 x 10 x 10 in.
John Michael Kohler Arts Center
Collection

untitled (mobile), c. 1960–2000
cedar, basswood, poplar, metal, wire
36 1/4 x 12 x 12 in.
John Michael Kohler Arts Center
Collection

untitled (model for carving a whimsy
stick), c. 1990
basswood, metal
17 3/4 x 16 1/4 x 8 in.
John Michael Kohler Arts Center
Collection

untitled (chip-carved frame with photo of 25th Machine Gun Battalion), c. 1920–50
wood, glass, metal, photo
21 3/4 x 36 3/4 x 2 1/4 in.
John Michael Kohler Arts Center Collection

untitled (whimsy sticks), c. 1960–2000
cedar and basswood
129 objects: 6 3/4 x 5/16 x 5/16 in. to 18 3/4 x 7/8 x 7/8 in.
John Michael Kohler Arts Center Collection

untitled (chip-carved frame with whittled chain and whimsy sticks), 1976
basswood, fabric, glass, mahogany, metal, varnish
41 1/4 x 32 x 6 1/2 in.
John Michael Kohler Arts Center Collection

Scott M. Geem
untitled (crown-of-thorns style cross), 1995
unidentified wood and varnish
12 1/2 x 7 1/4 x 2 1/2 in.
John Michael Kohler Arts Center Collection

Maker Unknown
untitled (chip-carved frame), c. 1930
19 3/4 x 27 1/2 x 4 in.
inside frame:
Adolph Vandertie
untitled (whimsy sticks), c. 1960–2000
cedar, basswood, fabric, glass, mahogany, metal, and varnish
John Michael Kohler Arts Center Collection

Maker Unknown
untitled (chip-carved frame) with image of Maury "Steam Train" Graham, c. 1950
gelatin silver print, unidentified wood, glass, metal, varnish
22 1/4 x 20 3/4 x 3 1/4 in.
John Michael Kohler Arts Center Collection

Maker Unknown
untitled (crown-of-thorns style frame) with image of Adolph Vandertie, n.d.
gelatin silver print, unidentified wood, metal, varnish
15 3/4 x 12 3/4 x 4 in.
John Michael Kohler Arts Center Collection

Maker Unknown, c. 1950–70
untitled (smoker's stand)
unidentified wood and varnish
32 1/4 x 6 x 6 in.
John Michael Kohler Arts Center Collection

Maker Unknown
untitled (table), c. 1950–60
unidentified wood, metal, paint, varnish
29 1/2 x 16 3/4 x 16 1/2 in.
John Michael Kohler Arts Center Collection

Maker Unknown
untitled (chain with anchors), c. 1910–30
unidentified wood and paint
29 1/2 x 77 1/4 x 3/4 in.
John Michael Kohler Arts Center Collection

Maker Unknown
untitled (double box), c. 1880–1900
mahogany, metal, paper, varnish
9 x 11 1/2 x 7 1/4 in.
John Michael Kohler Arts Center Collection

Maker Unknown
untitled (hexagonal box), c. 1880–1900
mahogany, metal, paper, porcelain, varnish
11 1/2 x 8 x 9 in.
John Michael Kohler Arts Center Collection

Maker Unknown
untitled (double box with handle), c. 1880–1900
mahogany, metal, varnish
9 x 9 x 5 3/8 in.
John Michael Kohler Arts Center Collection

Maker Unknown
untitled (box), c. 1900–20
mahogany, metal, varnish, velvet
7 1/2 x 13 1/4 x 8 1/4 in.
John Michael Kohler Arts Center Collection

Maker Unknown
untitled (double box with handle), c. 1880–1900
fabric, mahogany, metal, paper, varnish
6 3/4 x 10 1/4 x 6 1/2 in.
John Michael Kohler Arts Center Collection

Maker Unknown
untitled (box), c. 1920
gelatin-silver print, glass, mahogany, metal, paint, paper, varnish
3 3/4 x 10 x 7 in.
John Michael Kohler Arts Center Collection

Maker Unknown
untitled (dresser with crown), c. 1900
mahogany, metal, paint, varnish
43 x 31 3/4 x 15 1/2 in.
John Michael Kohler Arts Center Collection

GREGORY VAN MAANEN
untitled (altar), c. 1983–2007
mixed media
21 x 21 x 14 in.
John Michael Kohler Arts Center Collection

untitled (bones, found objects, stones, and shells), 1983–2007
mixed paints on bones, mixed media, shells, stones
159 objects: 3/4 x 1/2 x 1/8 to 8 1/2 x 6 x 4 in.
John Michael Kohler Arts Center Collection

untitled (coconut shell skull), c. 1983–2007
mixed media
7 x 3 x 2 in.
John Michael Kohler Arts Center Collection

untitled (pile of magic symbols), 1983–2007
ink on paper
variable
John Michael Kohler Arts Center Collection

untitled (small paintings and small painted objects), 1983–2007
mixed paints on board, mixed media, paper
122 objects: 2 x 1 x 3/4 in. to 13 1/2 x 5 1/2 x 4 in.
John Michael Kohler Arts Center Collection

untitled (small drawings), 1983–2007
graphite on paper, board
10 drawings: 1 1/4 x 1 1/4 in. to 6 x 4 in.
John Michael Kohler Arts Center Collection

Two Spirits (Male + Female) with Crescent Moon and Stars, 2006
mixed paints on board
22 1/4 x 18 1/4 in.
John Michael Kohler Arts Center Collection

Devotion, 2005
mixed paints on board
17 3/4 x 13 3/4 in.
John Michael Kohler Arts Center Collection

Infinity, 2005
mixed paints on board; found frame
20 x 16 in.
John Michael Kohler Arts Center Collection

Luna Mountain, 2005
mixed paints on paperboard
9 1/8 x 9 in.
John Michael Kohler Arts Center Collection

Spirit Flower, 2005
mixed paints on paperboard
8 3/4 x 8 1/2 in.
John Michael Kohler Arts Center Collection

Memorial Painting, 2004
mixed paints on canvas; found frame
28 x 24 in.
John Michael Kohler Arts Center Collection

Existence / Validation, 2003
mixed paints on board; found frame
17 1/2 x 14 1/2 in.
John Michael Kohler Arts Center Collection

Effigy / Bruja / Fetish, 2002
mixed paints on board
10 x 8 in.
John Michael Kohler Arts Center Collection

Floating Talisman, 2002
mixed paints on board
11 1/2 x 9 5/8in.
John Michael Kohler Arts Center Collection

Medicine Painting, 2002
mixed paints on board
13 1/4 x 10 3/8 x in.
John Michael Kohler Arts Center Collection

Recurring Mojo, 2002
mixed paints on board
11 1/4 x 11 1/4 in.
John Michael Kohler Arts Center
Collection

R.I.P. Columbia, 2002
mixed paints on board
16 1/2 x 16 1/2 in.
John Michael Kohler Arts Center
Collection

Survivor Formulation, 2002
mixed paints on board
12 1/8 x 12 1/8 in.
John Michael Kohler Arts Center
Collection

Assume Nothing; Fear Nothing;
Respect Everything, 2001
acrylic and mixed paint on canvas
66 x 47 1/2 in.
John Michael Kohler Arts Center
Collection

Full Moon Spirit Window, 2001
mixed paints on canvas; found frame
25 1/2 x 21 1/4 in.
John Michael Kohler Arts Center
Collection

Mojo: Ongoing Mantra, 2001
mixed paints on canvas
16 x 12 in.
John Michael Kohler Arts Center
Collection

Night Cloud Symbols, 2001
acrylic on board; 14 x 11 1/2 in.
John Michael Kohler Arts Center
Collection

Night Cloud Symbols, 2001
acrylic on board; 15 1/4 x 11 1/4 in.
John Michael Kohler Arts Center
Collection

Night Cloud Symbols, 2001
acrylic on board; 13 1/4 x 11 1/4 in.
John Michael Kohler Arts Center
Collection

Night Cloud Symbols, 2001
acrylic on board; 15 1/4 x 14 1/4 in
John Michael Kohler Arts Center
Collection

Night Cloud Symbols, 2001
acrylic on board; 15 1/4 x 11 1/4 in.
John Michael Kohler Arts Center
Collection

Spirit Mirror, 2001
acrylic, mirror, found frame
31 1/2 x 24 in.
John Michael Kohler Arts Center
Collection

Balance / Symbolic Majik, 2000
acrylic on canvas
48 x 47 3/4 in.
John Michael Kohler Arts Center
Collection

Familiar Spirit, 2000
mixed paints on board
12 1/8 x 10 1/4 in.
John Michael Kohler Arts Center
Collection

Red Bruja, 2000
mixed paints on canvas
16 x 12 1/8 in.
John Michael Kohler Arts Center
Collection

Spirit Catcher (Bust), In a Corner with
Symbols, 2000
mixed paints on board
38 1/4 x 26 1/4 in.
John Michael Kohler Arts Center
Collection

Spirit Catcher (Bust) / Red Full Moon
and Stars with Symbols / Green Light,
2000
mixed paints on canvas
31 1/2 x 25 1/8 in.
John Michael Kohler Arts Center
Collection

Spirit Head Doll, 2000
mixed paints on board
46 x 13 in.
John Michael Kohler Arts Center
Collection

Warrior of the Ashes / Night Spirit with
Red Full Moon, 2000
mixed paints on board
15 3/4 x 14 1/4 in.
John Michael Kohler Arts Center
Collection

Blessing, 1998
mixed paints on board
12 1/4 x 11 in.
John Michael Kohler Arts Center
Collection

Spirit Catcher (Bust), 1998
mixed paints on board
9 1/2 x 8 in.
John Michael Kohler Arts Center
Collection

untitled (cast-iron skulls), c. 1990–98
metal, paint, stones
8 skulls: 7 x 5 x 6 1/2 in. to
6 x 14 x 14 in.
John Michael Kohler Arts Center
Collection

You Find Your Way, 1998
mixed paints on board
14 5/6 x 14 1/2 in.
John Michael Kohler Arts Center
Collection

Portrait of a Young Woman, 1996
mixed paints on canvas
32 1/2 x 32 1/2 in.
John Michael Kohler Arts Center
Collection

The Returning Survivor, 1996
mixed paints on canvas
38 x 38 in.
John Michael Kohler Arts Center
Collection

Spirit Head (Hand) with Full Moon
and Stars, 1996
mixed paints on paperboard
8 3/4 x 8 1/2 in.
John Michael Kohler Arts Center
Collection

The Gray Monkey Always Gets Away
with It, 1995
mixed paints on canvas
30 1/4 x 24 1/4 in.
John Michael Kohler Arts Center
Collection

Survivor with Moon / Liberation, 1994
acrylic on canvas
50 1/4 x 32 5/8 in.
John Michael Kohler Arts Center
Collection

Night Cross (Spirit), 1993
mixed paints on paper
22 1/4 in. x 17 1/4
John Michael Kohler Arts Center
Collection

They Don't Know Unless You Tell
Them, 1993
acrylic on board
50 1/4 x 32 1/4 in.
John Michael Kohler Arts Center
Collection

untitled (toy spider), c. 1980–93
mixed media
2 x 5 x 6 in.
John Michael Kohler Arts Center
Collection

Bringer of Peace / Peace Spirit, 1992
mixed paints on canvas
34 x 28 in.
John Michael Kohler Arts Center
Collection

Live Now for Death Takes Care of
Itself, 1992
mixed paints on board
49 1/2 x 31 1/2 in.
John Michael Kohler Arts Center
Collection

The Majik Bullet, 1992
mixed paints on board
68 1/2 x 50 1/4 in.
John Michael Kohler Arts Center
Collection

Wolf / Bat / Loud Spirit with Moon,
Stars, and Symbol, 1992
mixed paints on board
49 3/4 in. x 31 1/2
John Michael Kohler Arts Center
Collection

Spirit Snake with Crescent Moon, 1991
mixed paints on board
49 1/2 x 25 1/2 in.
John Michael Kohler Arts Center
Collection

This is Separation, 1991
acrylic on canvas
50 1/2 x 41 3/4 in.
John Michael Kohler Arts Center
Collection

The Distance Beyond the Kill, 1990
mixed paints on canvas
62 1/4 x 50 1/2 in.
John Michael Kohler Arts Center
Collection

The Inner Shrine, 1990
mixed paints on board
30 1/2 x 30 1/2 in.
John Michael Kohler Arts Center
Collection

Reminder: Live, 1990
mixed paints on canvas
46 1/8 x 30 3/4 in.
John Michael Kohler Arts Center
Collection

Defiance Mechanism, 1989
mixed paints on board
50 1/4 x 50 1/4 in.
John Michael Kohler Arts Center
Collection

Monkey Head Altar, 1989
mixed paints on canvas
22 1/4 x 22 1/4 in.
John Michael Kohler Arts Center
Collection

Self Portrait: Alone, 1988
mixed paints on board
26 x 22 in.
John Michael Kohler Arts Center
Collection

Woman, 1987
mixed paints on board
12 x 9 in.
John Michael Kohler Arts Center
Collection

A Remembrance, 1986
mixed paints on board
34 1/8 x 17 1/8 in.
John Michael Kohler Arts Center
Collection

Night of Fright / Night of Light, 1986
mixed paints on canvas
32 1/2 x 32 1/4 in.
John Michael Kohler Arts Center
Collection

Self-Portrait / The Wolf, 1986
acrylic on canvas
25 in. x 20 1/8
John Michael Kohler Arts Center
Collection

Spirit Link / Fog Trail, 1986
mixed paints on canvas
37 3/4 x 37 3/4 in.
John Michael Kohler Arts Center
Collection

untitled, 1986
mixed paints on board
12 1/8 x 11 1/2 in.
John Michael Kohler Arts Center
Collection

Warning Spirit, 1986
mixed paints on board
28 1/2 x 28 in.
John Michael Kohler Arts Center
Collection

Clockwork War Matrix, 1985
acrylic on canvas
42 1/4 x 30 1/2 in.
John Michael Kohler Arts Center
Collection

Oracle, 1985
acrylic on canvas; 37 x 25 1/8 in.
John Michael Kohler Arts Center
Collection

untitled, 1985
mixed paints on paperboard
10 3/8 x 10 1/8 in.
John Michael Kohler Arts Center
Collection

untitled, 1985
acrylic on board; 27 1/8 x 21 1/4 in.
John Michael Kohler Arts Center
Collection

untitled (painting on found wood),
c. 1985
mixed paints on wood
26 1/4 x 5 1/4 in.
John Michael Kohler Arts Center
Collection

Image to be Put on Enemy's Wall, 1984
mixed paints on board
26 1/4 x 18 1/4 in.
John Michael Kohler Arts Center
Collection

Cross Speaks, 1983
acrylic on board; 28 x 24 in.
John Michael Kohler Arts Center
Collection

The Crusader, 1983
mixed paints on board
18 1/4 x 14 1/4 in.
John Michael Kohler Arts Center
Collection

The Torso Speaks, 1982
mixed paints on board; 19 x 14 1/4 in.
John Michael Kohler Arts Center
Collection

Collaborations:
Gregory Van Maanen and Katz
In a Flower Patch with Spirit Spheres,
2006
mixed paints on found painting
22 1/4 x 18 1/8 in.
John Michael Kohler Arts Center
Collection

Gregory Van Maanen and LJA
The Shamaness Comes to Mayberry,
2000
mixed paints on found painting
14 1/4 x 18 1/4 in.
John Michael Kohler Arts Center
Collection

Gregory Van Maanen and Anonymous
*Spirit Bust with Necklaces and Full
Moon*, 2000
mixed paints on found painting
14 1/4 x 11 1/4 in.
John Michael Kohler Arts Center
Collection

Gregory Van Maanen and Anonymous
Spirit Sisters with the Sun, 2000
mixed paints on found painting
38 1/4 x 26 3/8 in.
John Michael Kohler Arts Center
Collection

Gregory Van Maanen and Anonymous
3 Spirit Heads Over the Last Supper,
2000
mixed paints on found painting
18 1/4 x 22 1/4 in.
John Michael Kohler Arts Center
Collection

Gregory Van Maanen and Anonymous
Desert Road Spirit, 1997
mixed paints on found painting
21 3/4 x 25 3/4 in.
John Michael Kohler Arts Center
Collection

CHARLIE WILLETO
untitled (warrior figure), c. 1961–64
polychromed wood
32 x 11 1/2 x 3 1/2 in.
John Michael Kohler Arts Center
Collection

untitled (eagle), c. 1961–64
polychromed wood
7 x 17 x 12 in.
John Michael Kohler Arts Center
Collection

untitled (medicine man), c. 1961–64
polychromed wood
36 x 6 x 2 in.
John Michael Kohler Arts Center
Collection

untitled (medicine man with mountain
lion spirit), c. 1961–64
polychromed wood
14 x 4 x 1 1/2 in.
Collection of Marilyn and Orren
Bradley, WI

untitled (painting), c. 1961–64
polychromed wood
6 1/4 x 6 1/4 x 1/2 in.
Courtesy of Greg LaChapelle and
Phyllis Kind Gallery, NY

untitled (snake), c. 1961–64
polychromed wood
1 3/4 x 2 1/2 x 14 in.
Courtesy of Greg LaChapelle and
Phyllis Kind Gallery, NY

untitled (medicine man), c. 1961–64
polychromed wood
31 x 11 x 1 1/2 in.
Courtesy of Greg LaChapelle and
Phyllis Kind Gallery, NY

untitled (medicine man), c. 1961–64
polychromed wood
14 3/4 x 8 x 1 1/2 in.
Courtesy of Greg LaChapelle and
Phyllis Kind Gallery, NY

untitled (badger), c. 1961–64
polychromed wood
5 x 2 1/4 x 18 3/4 in.
Courtesy of Greg LaChapelle and
Phyllis Kind Gallery, NY

untitled (tiger), c. 1961–64
polychromed wood
4 x 3 1/2 x 18 3/4 in.
Courtesy of Greg LaChapelle and
Phyllis Kind Gallery, NY

untitled (Navajo figure), c. 1961–64
polychromed wood
23 1/4 x 3 3/4 x 3 1/4 in.
Courtesy of Greg La Chapelle and
Phyllis Kind Gallery, NY

untitled (owl), c. 1961–64
polychromed wood
16 x 5 1/4 x 2 1/2 in.
Courtesy of Greg LaChapelle and
Phyllis Kind Gallery, NY

untitled (owl), c. 1961–64
polychromed wood
15 3/4 x 9 x 3 1/4 in.
Courtesy of Greg LaChapelle and
Phyllis Kind Gallery, NY

untitled (owl), c. 1961–64
polychromed wood
13 x 6 x 4 in.
Courtesy of Greg LaChapelle and
Phyllis Kind Gallery, NY

untitled (owl), c. 1961–64
polychromed wood; 15 x 8 x 3 3/4 in.
Courtesy of Greg LaChapelle and
Phyllis Kind Gallery, NY

untitled (owl), c. 1961–64
polychromed wood
17 3/4 x 6 3/4 x 3 1/2 in.
Courtesy of Greg LaChapelle and
Phyllis Kind Gallery, NY

untitled (medicine man), c. 1961–64
polychromed wood
34 x 5 3/4 x 1 3/4 in.
Courtesy of Greg LaChapelle and
Phyllis Kind Gallery, NY

untitled (medicine man), c. 1961–64
polychromed wood
40 1/2 x 4 x 3 in.
Courtesy of Greg LaChapelle and Phyllis Kind
Gallery, NY

untitled (Navajo figure), c. 1961–64
polychromed wood
22 1/2 x 3 1/2 x 3 1/2 in.
Courtesy of Greg LaChapelle and Phyllis Kind
Gallery, NY

untitled (Navajo figure), c. 1961–64
polychromed wood
22 1/2 x 3 1/2 x 3 3/4 in.
Courtesy of Greg LaChapelle and Phyllis Kind
Gallery, NY

untitled (medicine man), c. 1961–64
polychromed wood
17 x 5 1/2 x 2 in.
Courtesy of Greg LaChapelle and Phyllis Kind
Gallery, NY

untitled (Navajo figure), c. 1961–64
polychromed wood
19 1/2 x 6 1/4 x 2 3/4 in.
Courtesy of Greg LaChapelle and Phyllis Kind
Gallery, NY

untitled (medicine man), c. 1961–64
polychromed wood
16 x 6 x 2 in.
Courtesy of Greg LaChapelle and Phyllis Kind
Gallery, NY

untitled (Navajo figure), c. 1961–64
polychromed wood
14 1/2 x 5 1/2 x 1 1/2 in.
Courtesy of Greg LaChapelle and Phyllis Kind
Gallery, NY

untitled (Navajo figure), c. 1961–64
polychromed wood
10 1/2 x 2 1/4 x 2 in.
Courtesy of Greg LaChapelle and Phyllis Kind
Gallery, NY

untitled (skunk), c. 1961–64
polychromed wood
6 x 2 x 13 3/4 in.
Courtesy of Greg LaChapelle and Phyllis Kind
Gallery, NY

untitled (medicine man), c. 1961–64
polychromed wood; 17 x 5 1/2 x 1 1/2 in.
Courtesy of Greg LaChapelle and Phyllis Kind
Gallery, NY

untitled (medicine man), c. 1961–64
polychromed wood
15 1/2 x 7 x 1 1/2 in.
Courtesy of Greg LaChapelle and Phyllis Kind
Gallery, NY

untitled (Navajo figure), c. 1961–64
polychromed wood
11 1/2 x 3 3/4 x 2 in.
Courtesy of Greg LaChapelle and Phyllis Kind
Gallery, NY

untitled (medicine man), c. 1961–64
polychromed wood
22 x 4 1/2 x 4 1/4 in.
Courtesy of Greg LaChapelle and Phyllis Kind
Gallery, NY

untitled (medicine man), c. 1961–64
polychromed wood
26 x 6 x 5 1/2 in.
Courtesy of Greg LaChapelle and Phyllis Kind
Gallery, NY

untitled (eagle), c. 1961–64
polychromed wood
6 1/4 x 12 x 13 in.
Courtesy of Greg LaChapelle and Phyllis Kind
Gallery, NY

untitled (eagle), c. 1961–64
polychromed wood
6 x 10 3/4 x 12 1/4 in.
Courtesy of Greg LaChapelle and Phyllis Kind
Gallery, NY

untitled (eagle), c. 1961–64
polychromed wood
7 x 11 1/4 x 15 1/4 in.
Courtesy of Greg LaChapelle and Phyllis Kind
Gallery, NY

untitled (Navajo figure), c. 1961–64
polychromed wood
11 1/2 x 2 1/2 x 2 1/4 in.
Courtesy of Greg LaChapelle and Phyllis Kind
Gallery, NY

untitled (Navajo figure), c. 1961–64
polychromed wood
11 x 3 1/2 x 1 1/2 in.
Courtesy of Greg LaChapelle and Phyllis Kind
Gallery, NY

untitled (owl), c. 1961–64
polychromed wood
13 3/4 x 6 x 1 1/2 in.
Courtesy of Greg LaChapelle and Phyllis Kind
Gallery, NY

untitled (owl), c. 1961–64
polychromed wood; 10 1/2 x 5 1/4 x 3 1/2 in.
Courtesy of Greg LaChapelle and Phyllis Kind
Gallery, NY

untitled (Russian figure), c. 1961–64
polychromed wood
26 x 5 1/4 x 1 3/4 in.
Courtesy of Greg LaChapelle and Phyllis Kind
Gallery, NY

untitled (Navajo figure), c. 1961–64
polychromed wood
18 1/4 x 6 x 2 in.
Courtesy of Greg LaChapelle and Phyllis Kind
Gallery, NY

untitled (medicine man), c. 1961–64
polychromed wood
28 x 21 x 2 in.
Courtesy of Greg LaChapelle and Phyllis Kind
Gallery, NY

untitled (medicine man), c. 1961–64
polychromed wood
16 1/2 x 5 x 1 1/2 in.
Courtesy of Greg LaChapelle and Phyllis Kind
Gallery, NY

Gregory Van Maanen, *The Distance Beyond the Kill,* 1990; John Michael Kohler Arts Center Collection.